LOVE CALL

She straightened in the water, her feet just brushing the rocky bottom. An almost imperceptible sound from the nearby boulders brought her instantly alert.

He stood tall and strong as the royal oaks that grew high on the mountain range, the long length of his burnished form held tautly. Sara could see the ripple of powerful muscles and the glitter of his onyx eyes as he watched her quietly.

He stepped gracefully into the water. A few quick strokes were enough to bring him to her side.

His hands brushed her shoulders gently, drawing her to him. Their legs entwined, velvet steel touching pliant softness. His lips moved slowly, savoring her lingeringly. His restraint was all the provocation Sara needed to tip her over the edge. Refusing to wait for him to deepen the kiss, she parted his lips with her own. Their tongues met in a rapturous duel that could have but a single end...

HEART SONGS

LAUREL WINSLOW

AVON
PUBLISHERS OF BARD, CAMELOT, DISCUS AND FLARE BOOKS

HEART SONGS is an original publication of Avon
Books. This work has never before appeared in book
form.

AVON BOOKS
A division of
The Hearst Corporation
1790 Broadway
New York, New York 10019

First Avon Printing, April, 1984

AVON TRADEMARK REG. U.S. PAT. OFF. AND IN
OTHER COUNTRIES, MARCA REGISTRADA, HECHO EN
U.S.A.

Printed in the U.S.A.

WFH 10 9 8 7 6 5 4 3 2 1

Chapter One

"DOWN THAT hallway, miss. Second door on the right. But I'd better tell you, the place is jammed. You'll be lucky to get a seat."

Nodding, Sara Gavin thanked the student and hurried on. She had hoped to get to the Phoenix Indian School sooner, but a busy morning at the gallery and a traffic jam had delayed her. She was relieved to have made it at all. Joseph Highrock was a hard man to pin down. He traveled frequently and when he was in the city, he guarded his privacy fiercely. If she had missed him that morning, it might have been months before another such opportunity arose.

Slipping into the classroom quietly, she managed to find a place far to the back. Several heads turned as she sat down, but she had expected that and wasn't disturbed. Among the dozens of Navaho, Hopi, Apache, and other Native American students attending the lecture, a non-Indian was bound to stand out. But the students were too polite to make her feel self-conscious. Only a few did more than glance at her.

A breeze drifting through the open windows momentarily flattened Sara's clothes, revealing high, firm breasts above a small waist, rounded hips, and long, shapely legs. Dark auburn hair worn loose to her shoulders fluttered gently. Large, turquoise eyes accentuated the sun-warmed smoothness of her skin. Her features were delicate: high cheekbones, a small, straight nose, and a generous mouth that looked accustomed to smiling.

Listening intently to the man at the podium, she unconsciously bit her lower lip, darkening its vermilion hue. She admired Joseph Highrock's work immensely. At thirty-

five, he had triumphed over the restrictive label of "native artist" to win worldwide recognition. His evocative abstracts, sensual nudes, and poignant sculptures made him a respected emissary between two vastly different cultures.

Joseph Highrock originals hung in museums, galleries, and the homes of wealthy collectors on every continent. He traveled widely, his current stay in Phoenix coming after a three-month international tour. Yet even as he took his place among the small group of truly world citizens, he never forgot his own people. The series of lectures he was delivering at the Phoenix Indian School was only a small example of his commitment.

Watching him, Sara felt the familiar excitement she always experienced at the thought of this man and his art. Some dozen years before, when Joseph Highrock's work could still be acquired fairly reasonably, her father bought one of the "Turquoise Woman" series of oils as a birthday present for her. She had it still, now heavily insured and hanging in a place of honor in her apartment. No matter how rough things might be financially, she would never consider parting with the painting. It was her link to the ancient, elusive world that had fascinated her from childhood.

Of course, now that she was older, there were other reasons to be fascinated by Joseph Highrock.

Well over six feet, he was taller and larger than most Navaho men. His thick, black hair was trimmed neatly at the collar of a well-worn work shirt. Beneath a broad forehead, deep-set onyx eyes gleamed intently. An artist's eyes, Sara thought, that missed nothing. High, prominent cheekbones set off his aquiline nose and firm, finely-etched mouth. As relaxed as he was, there was a suggestion of latent strength in the muscular shoulders, powerful chest, narrow hips and long, sinewy legs clad in faded jeans. As he spoke, his hands moved gracefully. Long, coppery fingers traced ethereal patterns in the still air of the desert morning.

Sara shook her head slightly, reminding herself that she was there on business. It was one thing to admire the man's talent and accomplishment. It was quite another to

be reduced to a dewy-eyed groupie. He undoubtedly encountered far too many of those.

Half an hour later when the lecture concluded and Joseph departed with several students in tow, Sara followed discreetly. It wasn't until he was finally outside and had good-humoredly dispersed the last of the entourage that she found an opportunity to speak to him.

Even then it wasn't easy. The sharp perception of his onyx eyes stripped away her defenses. Instinctively, she understood that this man saw far beneath the surface realities to truths other people did not have the courage to confront. She wondered what he was seeing in her as she introduced herself and explained why she had sought him out.

"I own a small gallery in Phoenix, Mr. Highrock. I'd like to talk to you about the possibility of representing your work."

Her voice was soft and respectful, her expression open and direct without being intrusive. Unconsciously, she spoke as she would to one such as old Johnny Bent Tree, the foreman on her father's ranch who was also an honored singer of the Navaho spirit songs.

From Johnny Bent Tree, Sara had learned much of the Indian view of man, nature, and the constant search for harmony between both. That search was the foundation of all Joseph Highrock's work. It was through her own understanding of it that she hoped to reach him. His initial response proved it was going to be every bit as hard as she had suspected.

His onyx eyes drilled into her as he said, "I already have a gallery representing me in Phoenix, Miss Gavin. Is there some reason I should be interested in changing?"

Sara took a deep breath. She had anticipated this question, and had prepared a careful answer.

"Your current representatives do not have good relations with gallery owners in the other major cities, so the exposure your work has received has been mainly through your own efforts. Despite their location here in Phoenix, they're not attuned to the most exciting and important developments in native art. I don't think I'm going too far to

say that they regard you as a successful artist *in spite of* your background, rather than because of it."

A slight smile softened her businesslike tone as she concluded, "And they charge very high fees. I work for less, but I'll do more for you. So you can't lose."

Joseph Highrock regarded her gravely, although she thought there was just a suggestion of amusement in the slightly upward tilt of his firm mouth. "You make an eloquent case for yourself, Miss Gavin, and I don't really disagree with anything you've said. But the fact remains that you have a small and presumably struggling gallery. Why should I subject myself to the risks inherent in such an enterprise?"

"Any new venture of this kind is bound to be a struggle at first. But it's precisely because of the uncertainty that you should be interested in my representation."

At the quizzical lift of his eyebrow, she hurried on: "If you came with my gallery, other, less well-known artists whom I represent would have a far greater chance of success. Your own reputation and prestige would help them, far more than you're able to do in the present situation. And I can promise that your sales wouldn't suffer. I'm good at what I do."

"I have no doubt of that," Joseph murmured, permitting himself a smile that stripped years off his age and absurdly—she told herself—made Sara's heart beat faster.

Annoyed by her reaction, she responded more sternly than she intended. "It's possible you just aren't interested in being represented by a woman. If that's the case, I'd appreciate your telling me so that neither of us wastes any more time."

Joseph's smile deepened. From the vantage point of half-a-foot's difference in height, he looked down at her challengingly. "If you know anything at all about Indians, Miss Gavin—and I rather suspect you do—then you are aware that as a Navaho, I was raised in a society where women own almost all the property and bring in most of the cash income. I'm thoroughly accustomed to independent, hardheaded businesswomen who know how to make a good deal."

"Then we should get along fine," Sara retorted, "because that describes me perfectly."

"I rather think there's a bit more to you," Joseph murmured. Gesturing toward a nearby picnic table set beneath a spreading piñon tree, he surprised her by saying, "I was about to have lunch. Care to join me?"

Sara agreed at once. Some of her nervousness about meeting Joseph Highrock was beginning to fade. Not that he wasn't every bit as impressive as she had expected. Any man who could triumph over poverty and prejudice to the extent that he had was bound to be a little daunting. But at least he seemed willing to tolerate her company, and to listen to what she had to say.

Seated across the picnic table from him, she accepted the sandwich he offered. Biting into crusty homemade bread and sweet ham, Sara smiled appreciatively. She felt a degree of victory in simply being there with him, knowing that he was at least thinking about her proposal.

Her large, blue-green eyes were vividly alive. Good bones, delicate but strong, lay under her smooth, glowing skin. She was a woman who would grow old gracefully. The years would strip away the lingering remnants of childhood softness to reveal her strength. Lines that would come around her eyes and mouth would only make her more attractive. The promise was already there, but only time—or an artist—could bring it out.

Joseph was studying her carefully as he asked, "How long have you had the gallery?"

"About three months. I started it when I came back to Phoenix."

"Where were you before then?"

"New York . . . San Francisco for awhile. I worked in galleries in both cities. It was a natural thing to do, since I majored in art in college. When I came back, I decided to take the chance on starting my own."

"You say you came back. Does that mean you were born here?"

Sara nodded. "On a ranch just outside the city. I enjoyed living in other places, but nowhere else ever seemed like

home." Concerned that he might think her inclined to drift, she added, "Now that I'm back, I can't imagine leaving again."

She hoped he would accept that. Certainly Joseph Highrock must know what it meant to love a place so deeply that it was impossible to be truly at peace anywhere else. The harshly beautiful home of his ancestors, the place the Navaho called simply "Land of the People," was the heart and soul of all his art. Only here did he do what had to be regarded as his best work.

"I've seen the collages you did in Paris last year," Sara said softly. "I don't have to tell you they're superb, but there's an element of discontent . . . agitation even . . . that isn't present in a lot of your other work."

A glimmer of pleasure at her perception shone in his dark eyes. "Why do you suppose that is?"

"Because you didn't do them here," Sara said at once, as though stating the obvious. "The work you do here is frequently angry, sorrowful, sometimes even despairing. But there's never any sense of being out of place. I suppose you go elsewhere because you need the challenge, or perhaps what you confront here just gets to be too much. Whatever the reason, you don't have any more choice about returning than I did."

The certainty—and the candor—with which she spoke surprised Sara. From childhood, she had grown accustomed to concealing her perceptions. Too much sensitivity to the needs and motives of others made people uncomfortable. But with this man she found she had no wish to hide herself. Somehow, it was important for him to really know her.

For a moment, she thought she had gone too far. Joseph was certainly accustomed to people talking to him about his work. He must even have met some with a gratifying grasp of what drove him. But the sudden veiling of his eyes made it clear he was not used to another person viewing the world through his own soul. The experience threw him off balance. He stared at her warily.

"How old are you?"

Surprised by the question, Sara hesitated. "T-twenty-eight . . ."

"Are you married?"

"No . . ." Did he imagine her too young for the responsibility of a gallery, or was he perhaps thinking of her as a bored wife seeking diversion?

"Do you consider yourself an artist?"

"Lord, no! I hate to even think what the results would be if I tried to paint or sculpt. Whatever talent I have lies in encouraging people who do have creative abilities, and bringing them together with other people who can appreciate their achievements."

She sensed this explanation of herself pleased Joseph. He would be glad she wasn't a frustrated artist, and relieved that she didn't view her involvement with Indian art as some sort of crusade to make up for the cruelties of the past.

Silently they continued to study each other in the age-old way that did not require language. Behind them, purple shadows moved over the distant hills. A white-winged dove darted skyward, seeking its nest in a saguaro. It was very quiet. Even in the midst of the city, the sounds of civilization were somehow held at bay. There was only the endless wind, nature's artist blowing century upon century to shape the desert.

Watching Joseph, sensing the barely restrained strength within him, Sara was reminded of the ancient Indian belief that it was best to move over the land as lightly as the wind, disturbing nothing. Yet given enough time, the wind not only disturbed but became the driving force of nature, force which came to life within the man facing her. What a challenge it must be, she thought suddenly, to release that force without destruction.

She wondered if he recognized his own potential for harm, to himself, to the people who admired him. To herself? Getting close to Joseph Highrock could be dangerous. He was not a man to be content with the polite superficialities. Nor, she suspected, would he be tolerant of weakness. As the desert challenged, so would he.

If they were to have any relationship, all her strength and honesty would have to be revealed. Such exposure frightened her, as much for itself as for where it might

11

lead. Yet the thought of walking away was unendurable. If she closed her life and spirit to Joseph Highrock, it would be a loss she would never forget.

The deep-set eyes revealed nothing when at last he spoke. Softly, Joseph said, "I'd like to think about your offer. Then I'd like to see you again. All right?"

Wordlessly, Sara agreed. She shivered slightly in the wind.

Chapter Two

THE SPRAWLING construction site was a study in organized chaos. Around the skeleton of a three-story building, cranes, bulldozers, and dump trucks creaked and coughed. Workers swarmed over the girders to which the outside walls were being rapidly attached. The floors were already completed and the roof sections with their solar heating panels waited to be hoisted into place.

According to the schedule Sara had seen posted on the wall of Don Campbell's office trailer, the entire superstructure of the building was due to be finished by the following week. It was an ambitious timetable which few architects would have even attempted to meet. But to Don, it was just one more in a long series of self-imposed challenges.

Parking a careful distance away from all the activity, Sara picked her way across ground strewn with stray bits of equipment and gored by the heavy wheels of trucks and tractors. The going was treacherous but her efforts did not go unappreciated. Barely had she reached the center of the site when a familiar voice rang out.

"Hey, gorgeous! Come on over here and give me a hug!"

Sara turned, shading her eyes. When she saw Don, she grinned broadly. He looked absolutely filthy. Stripped to the waist, wearing only ragged chinos and a smile, the highly respected architect of the Phoenix People's Center was busy helping a landscaper lay drainage pipe.

Immensely talented and boundlessly energetic, Don Campbell insisted on being involved in every aspect of the construction on his projects. He exhibited a boyish enchantment with mud and pipe, mortar and girder, glass

and steel. Despite his standing as one of the most respected members of his profession, he never looked anything at all like the crisp, aloof architects common on other sites. But neither had he ever seemed quite as disreputable as he appeared to Sara just then.

She backed off laughing. "No, thanks! I wouldn't get near you with anything except a big brush!"

Without taking his eyes from her, Don set down his end of pipe. Managing a look close to a leer, he advanced on her menacingly. Sunlight glinted off his thick, golden hair and the darker curls trailing down his lithe torso. His honey-toned skin glowed warmly. He hadn't shaved in several days, claiming he was too busy working. Sara suspected he wanted to grow a beard.

That might not be a bad idea, she reflected, remembering the rough silk texture of his cheek and throat against her own smooth skin when he kissed her the night before.

Even streaked with sweat and grime, he was an impressive man. At thirty-four, he exuded raw vitality and virility that drew her to him like a cat to a warm fire. Best of all, she had no fear of being burned. Beneath the rugged masculinity and occasional macho pose, Don was a tender, gentle man.

As she retreated, out of sheer feminine instinct, from his grease and grime, his deep hazel eyes filled with laughter. Doing a terrible Bogey imitation, he drawled, "A hard workin' man needs encouragement, shwee'heart."

"Not from me, you don't!" Trying hard to ignore the amused looks of the construction workers who had stopped to watch, she continued backing away. Her hands went up in a futile effort to hold him off. "Quit kidding around, Don! You're filthy."

"Isn't that just like a woman?" he teased, still advancing. "Here I thought you went for my beautiful soul. Now it turns out I'm just a body." Shrugging in mock regret, he reached for her.

Making one final effort to evade him, Sara lost her balance and almost tripped over a length of rubber. Her eyes lit on it mischievously. Seizing an opportunity too good to miss, she scooped up the hose, twisted the nozzle and let

Don have it full blast. Over the rush of water, she taunted "This should get you clean, Mr. Campbell! Not to mention cool you down!"

Momentarily stunned, Don reacted good-naturedly. Playing up to the hoots and catcalls of the construction workers, he turned round so that the water sprayed all over his powerful body. Only when he was thoroughly soaked, the chinos clinging to his long, hard legs, did he call a halt to the game.

The devilish gleam was back as his eyes wandered over Sara with an intensity that made her all too aware that they were not alone. She couldn't suppress a faint blush as, through the stream of water, he moved toward her. When there was no more than a foot of space left between them, Don murmured softly, "That's enough. You've had your fun. Now it's my turn."

So gently that she didn't even think to protest, he turned the hose off and let it drop to the ground before taking hold of her shoulders. All awareness of the watching construction workers faded as, very slowly, Don's burnished head bent to hers. At first, his lips only brushed against Sara's in the lightest caress. His touch tantalized her. Without conscious thought, she moved toward him.

The kiss deepened gradually. Sara's slender arms wrapped round Don as his embrace tightened. There was no precise instant when she knew the nature of the caress had changed, but what began as a slow, tentative tasting of each other became something far deeper.

In the three weeks or so they had been dating, Don had kissed her many times. But never like this. Dimly, Sara realized that their relationship was entering a new phase, heading toward some culmination. Locked in his arms, oblivious to anything but the beauty of his touch, she had no doubt what she wanted that culmination to be. Soon, she breathed silently, let it be soon.

Long, sweet moments later, Don raised his head reluctantly. "I'm sorry, Sara. I didn't mean . . . not out here in public . . ."

"It's all right," she whispered raggedly, still caught up in the power of his caress. "I understand."

Don smiled gently. For an instant, he hugged her so

tightly her ribs threatened to crack. "I believe you do, darlin'," he muttered huskily.

Sara half-expected to be kidded by the construction workers who had observed the torrid encounter. But it seemed even men who liked to appear brash and jocular sensed the depth of passion unleashed by that kiss. When she finally managed to glance up, a little surprised to find the site intact despite the tremors reverberating through her, she was relieved to see all the men busy elsewhere. Even those standing closest to them were suddenly distracted. No one so much as glanced at them as, keeping an arm around her waist, Don led her toward the office trailer.

He didn't release her until they were inside. Leaning against a paper-strewn desk, Don ran a hand through his hair shakily. "Sara . . ."

He looked so uncertain that her heart went out to him. What a complex man he was. Moments before, he had been tenderly aggressive, guiding her on a sensual exploration made all the more potent by its spontaneity. Now he seemed like a little boy who felt compelled to explain his behavior and didn't know where to begin.

"You don't have to say anything," she murmured reassuringly. "I told you I understood."

His eyes fastened on hers doubtfully. "Are you sure? I'm not even convinced I do. I've never . . . It's never been like this before . . ." He broke off, self-conscious at his inability to express his feelings.

Sara waited as he took a deep breath and went on. "I guess what I'm trying to say is that I don't feel casual about you. Something really big is happening to me. I don't want to run away from it, but I also don't want to rush it. The idea that it might go wrong really throws me."

Sara swallowed a sigh. She was ready, but clearly Don was not. And she couldn't even find it in her to blame him. Honesty forced her to admit that if she had come through a disastrous marriage and an intensely bitter divorce as Don had, she would also be more than a little reluctant to get involved in anything other than the most casual relationship. Torn between understanding and frustration, she struggled for patience.

"All I want to rush is a shower." With mock sternness, she glanced at her stained skirt and sweater. "I don't suppose you've got one here?"

Relieved by her unstated acceptance, he shot her an appreciative grin. "'Fraid not. Best I can offer is a wet paper towel and a cold lemonade."

When she was settled across the desk from him, in a ratty but comfortable chair, with the worst of the stains removed and a cool glass in her hand, Don asked quietly, "So how did it go?"

There was no need to ask what he meant. Don understood how important the meeting with Joseph Highrock was to her. His question was only a natural expression of his interest and concern. Yet the mention of the Navaho artist inexplicably made Sara uncomfortable. Shrugging, she murmured, "All right, I guess."

"Was he what you expected?"

"I suppose. He doesn't hide anything in his work, so if you know it, you know him. Or at least part of him. But he is even more . . . complicated . . . than I expected."

"What do you mean, complicated?"

"I'm not sure. He's very reserved. He doesn't reveal much about his thoughts or feelings. At least not in conversation. But he did seem willing to consider my proposal." Wistfully, she added, "I just wish I had some idea what he'll decide."

Don looked at her gently. "At least he's considering it. You were afraid he'd turn you down flat."

"It might almost have been better . . ."

Don didn't seem to have heard her. He was looking thoughtfully at the blueprints for the Center, tacked to a corkboard along one wall of the trailer.

"Highrock sure gave us a hell of a fight," he mused, almost to himself. "For a while there, I didn't think we'd ever get approval."

Sara nodded. She had vivid memories of the long, often bitter struggle between the business and civic interests, led by Don's architectural firm, and the environmentalists and artists who were unhappy with the original plans for the Center. Joseph Highrock had been their spokesman. His eloquence, determination, and reputation won over so

17

many that the Center was almost stopped dead. Only a last minute compromise, grudgingly accepted by Don's side, allowed construction to begin.

Now that some of the anger had faded, Don was willing to admit that the changes Highrock demanded would improve the Center. But bad feelings lingered. So Sara was surprised when he asked, "Do you think there's any chance the budget for artwork could cover one of his pieces? A Joseph Highrock original could be the focal point for everything we're trying to do here."

Sara shook her head regretfully. "We can't really afford him." It was her responsibility to acquire the artwork for the Center. She was determined to do an outstanding job, which meant she had to be realistic.

"Prices for his works have skyrocketed in the last few years," she explained, "partly because of increased interest in all aspects of Native American culture, but mainly because so many people are responding to what he expresses about our need for harmony with nature. Of course, some of those buying are just savvy investors who know a good thing when they see it. But he tries to avoid dealing with them. Most of his work goes to those who can genuinely appreciate it."

"The people who will use the Center would certainly appreciate it," Don insisted. "He bridges the gap between different cultures so effectively that I can't help but think he would help us do the same thing. And that's what this place is supposed to be all about."

Sara could sympathize with Don's desire to acquire a Joseph Highrock work for the Center. She didn't want to hold out false hope that they might be able to do so, but neither could she completely dismiss an idea which certainly had great merit.

Reluctantly, she said, "If I do see him again, perhaps I could arrange a meeting between you two. If your personal differences could be forgotten, he might agree to give the Center a break on one of his works. After all, so many of his suggestions were incorporated into the plans that he has a big stake in the results."

"That might be a good idea," Don agreed. "I sure can't

think of any other way to get through to him. He's a stubborn devil."

Sara made no comment, but privately she was a little disappointed that Don didn't reject her offer. He knew how important it was for her to convince the Navaho artist to be represented by her gallery. That task would be hard enough without unnecessary complications. Still, she had made the suggestion and would do her best to abide by it.

"I wish I could figure out what goes on behind those eyes of yours," Don murmured suddenly. She looked up, startled to find he had come to stand directly in front of her. Careful not to get her dirtier than she already was, he touched a gentle hand to her hair as he said, "With most people, I can at least make a guess at what they're thinking. But with you, I'm always left wondering."

His tone made it clear that he wasn't criticizing her. Rather Don was acknowledging a depth in her character that both fascinated and puzzled him. Sara supposed she should feel flattered. But instead, she caught herself remembering how easily Joseph Highrock had seemed to see into her very soul. It was disturbing to realize how close he came to touching something so fundamental in her that she herself had barely sensed it.

Only because he's an artist, Sara thought, though she knew there had to be a great deal more to the strange empathy that appeared to exist between herself and the tall, compelling Navaho. Even as she smiled up at Don, she was wondering what it would be like the next time she and Joseph Highrock met.

Chapter Three

THE FOLLOWING morning, Sara was precariously perched on a stepladder, struggling to hang a Navaho rug, when the gallery door swung open. The rug, handwoven in shades of terra-cotta, sand, and cobalt, was heavy. Its size made it awkward to handle. After twenty minutes of frustrating, muscle-wrenching effort, she had managed to secure only one corner to the wall. She didn't dare turn when the bell signaled a visitor.

"I'll be right with you. Feel free to look around."

"Oh, I do," a deep, faintly teasing voice assured her. "No one could fault the view."

Whirling, Sara caught Joseph Highrock's eyes wandering intently over the honey-toned expanse of her legs. Her suede skirt, normally a modest knee length, was hitched up to mid-thigh. Her exertions had twisted the fabric tight around her body, fully revealing the contours of her hips and bottom. As though that wasn't enough, the thin cotton blouse she wore had come undone at the top, giving him a more than ample glimpse of her gently rounded breasts.

In her dismay, Sara forgot the blanket. It slipped from the wall, the sudden weight catching her unprepared. She teetered dangerously and began to fall, only to be instantly steadied by Joseph's firm hands at her waist. His touch was warm and strong, his nearness potent enough to make her head swim even more. Before she could make any effort to stop him, he lifted her clear off the ladder and set her safely on the ground.

"You ought to have more sense than to pull a stunt like that. If I hadn't been here, you could have been badly hurt."

Sara stared up at him, about to say that if he hadn't so effortlessly distracted her, she would never have started to fall in the first place. Caution kept her silent. It was not a good idea to let Joseph see just how much he affected her.

Coolly, she said, "I appreciate your concern, but there's no need for it. I do this sort of thing all the time without any problem."

"Then you're luckier than you deserve." His eyes swept over her again, making her acutely aware of how disheveled she must look. A long morning in the gallery had mussed her hair and creased her clothes. Her skin shone from her efforts and her turquoise eyes seemed even larger than usual against her pale skin. The crisp lemon scent of her cologne mingled with her own headier fragrance. Her breasts rose and fell rapidly as she tried to catch her breath.

Joseph's frown deepened. "Surely you could have asked someone to help with this. A neighbor . . . or a boyfriend . . ."

The unaccustomed sense of vulnerability he evoked in Sara gave way to anger. Who was Joseph Highrock to treat her like a misbehaving child? Only the suspicion that he was as puzzled by his behavior as she was made her refrain from retorting sharply.

In an effort to ease the unexpected tension between them, she said softly, "I underestimated the weight of the rug. Otherwise, I wouldn't have tried to hang it by myself."

Smiling faintly she added, "And I guess I was anxious to see it in place. It really is magnificent, don't you think?"

Reluctantly, Joseph glanced at the rug he now held. Sara guessed the weaving would be familiar to him. It was even likely that he knew the artist, an old Navaho woman who had little contact with the world beyond the reservation and who had always been reluctant in the past to display her work.

Sara hoped her ability to win the woman's confidence might make it easier for Joseph to trust her in turn. But there was no sign of that as an expressionless mask slipped over his features.

"How did you get this?"

Sara sighed inwardly. She knew too much about the un-pleasant experiences many native American artists had suffered at the hands of unscrupulous dealers not to under-stand his suspicion. Gently, she said, "Bright Star gave it to me herself, along with several other rugs."

Joseph looked at her doubtfully as she explained, "We corresponded for several months; then I went out to see her. I stayed in her hogan for a couple of weeks. She taught me the rudiments of weaving and helped me to understand the spiritual significance of the motifs. By the time I had to leave, I guess she decided I could be trusted. Anyway, she let me have half-a-dozen pieces to sell."

Sara laughed softly, remembering, "I don't think Bright Star really believed me when I told her what her work could bring. But the small rug I sold last week went for even more than I'd expected. I'd love to see her face when she gets my letter and money order."

She was so caught up in memories of the old Navaho woman who had won her affection and esteem that Sara didn't notice the slight smile curving Joseph's firm mouth as his suspicions faded.

"This one," he said, gesturing to the rug he held, "should do even better. Provided you manage to get it on the wall."

The gentle mockery of his tone made Sara grin as much as the suddenly easier mood between them. "How about if you help? Then I can tell everyone the rug is an original Bright Star and the display is by Joseph Highrock. That should guarantee a fat sale."

Thick ebony hair fell across Joseph's broad forehead as he laughed. The image of some greedy art investor falling for such a ploy was irresistible.

"Let me loose on your pottery," he said, glancing at a collection of Hopi marriage jars. "I'll turn them all into Highrock displays. In a month, you'll be able to retire on the proceeds."

"No thanks," Sara snorted. "I have other things in mind for myself, and I don't think you really want to play deco-rator." More seriously, she added, "Why did you come here?"

"To see you," Joseph informed her matter-of-factly as he

busied himself securing the rug. Sara watched him covertly. Being so tall, he had no need of the ladder. Powerful muscles moved gracefully along his broad shoulders and back as he held the rug in place with one hand and fastened it with the other. When the weight was properly balanced, he stepped back. "That should do it."

Sara nodded her thanks. "You were saying," she prompted, "you came to see me . . ."

"And the gallery," he added, making her grin ruefully at her presumption. "After all, if you're going to represent me, I need to see how you work."

"Am I going to represent you?"

"I don't know," Joseph told her candidly. "The possibility interests me, but I haven't made up my mind yet."

He was honest, Sara thought wryly. Her proposal tempted Joseph, but not enough for him to accept it without careful thought. She could hardly fault his caution, since he was acting just as she would in the same circumstances.

"I'll answer your questions as best I can," Sara assured him, "and I'll tell you anything you want to know. But first, how about some coffee?"

Joseph agreed. For the next hour, they talked about the gallery. Sara explained how she got started, who she represented, and what successes she had achieved to date. She touched briefly on the contract to provide art for the People's Center, but didn't dwell on it.

As she talked, Joseph wandered around the gallery. His keen gaze took in the small but excellent selection. Occasionally, he glanced at the discrete placards beneath each piece to identify a new artist whose work was not known to him. But in almost every case, he had no difficulty putting a name to the work. About half the artists represented were from the nearby Hopi and Navaho reservations. The rest were of Anglo and Hispanic descent. They were all exceptionally talented, more than worthy of a gallery showing.

"You have a good eye," he said at last, "and you must have a knack for winning people's trust. Bright Star is not the only artist here who has been reluctant to exhibit."

Some of the tension eased from Sara as she went to stand

beside him. Together they studied a watercolor landscape which perfectly caught the transient flow of light across the desert. Joseph was still looking at it when he said suddenly, "I want to paint you."

Sara wrenched her eyes from the watercolor to stare at him in astonishment. "W-what?"

"I want to paint you," he repeated patiently. "I thought so the first time I saw you, and now I'm sure. Besides," he went on hurriedly before she could interrupt, "it's the best way for me to get to know you. By the time I finish the portrait I'll have decided whether or not I want you to represent me."

He'd know a great deal more than just that. One look from Joseph was enough to make Sara feel she had no secrets left. She couldn't even imagine how she would feel after posing for him.

"I can't leave the gallery," she hedged, hoping he would let the matter drop.

But Joseph wasn't easily discouraged. "I have a studio in Phoenix. We can work there. And I prefer the morning light, so there won't be any conflict with your other commitments. Unless," he taunted gently, "you can't bear the idea of getting up early?"

"It's not that," Sara began, wondering how she was going to make him understand how embarrassed she felt at the mere suggestion that she pose for him. The unexpected self-consciousness he made her feel was bad enough. But added to it was the conviction that his work would be studied and admired for centuries to come. He fully deserved such immortality; she did not.

"I'll pay you, of course," he was saying, shocking her back to reality.

"You will not! How could you even suggest such a thing? You know perfectly well what an honor it is to be painted by you. Wealthy people stand in line for the privilege, with no success, and here you are handing it to me." Her eyes widened as she looked up at him. "Why, Joseph? There's nothing special about me."

Sara bit her lip as soon as the words were out, hoping that he wouldn't think she was fishing for compliments. She knew she had none of the beauty associated with ac-

tresses and cover girls. But Joseph never painted women who might be regarded as classically lovely. There was always something difficult about his models, as though he needed the excitement of a challenge as much as of any particular woman.

"I can't explain why I want to paint you, Sara. Not in words. You'll have to wait until you see the finished portrait. Then perhaps you'll understand."

She had to be content with that. Joseph would not explain further, or make any more effort to persuade her. His terms were clear. Before he could decide if her gallery should represent him, he had to get to know her better. And to do that, he had to paint her. Hesitantly, not quite sure what she was getting into, she agreed.

By the following morning, she already regretted her decision.

Getting out of bed reluctantly, she grimaced at the bright sunlight streaming through the bedroom windows. She was suddenly sure that being associated with Joseph in a strictly business sense would be difficult enough. Spending hours with him while he worked might lead to complications she did not care to think about. The day had no right to look so marvelous when she was feeling anything but.

A brisk shower revived her somewhat, but the face that looked back at her from the mirror was still unnaturally pale. Makeup helped a little, as did a cheerful yellow dress she had bought the month before and not yet worn. By the time she went out to the kitchen to make coffee and to toast an English muffin, she was feeling almost human.

Just beyond the red checked curtains over her sink, wildflowers bloomed. Where only days before there had been no more than a scraggly lawn, now a riot of apricot, indigo, vermilion, and the softest emerald stretched clear to the street.

It never failed to amaze Sara that even the briefest period of warm breezes and rainfall could create such beauty. She stood entranced as a wren pecked the ground barely yards from her apartment. A flurry of movement off to one

side caught her attention as a black-tailed jackrabbit scurried for cover.

She swallowed hard, caught up in memories of growing up on her family's ranch. Surrounded by all the love and security a child could need, she had never guessed how much the harshly beautiful land was entwined with her own spirit.

Only when she left did she realize that some vital part of herself remained behind in the cliffs and mesas, the deep canyons and white water rivers. New places and experiences, as exciting as they might be, never quite managed to equal her beginnings. Love of the land remained deeply rooted within her, and was at the heart of her response to Joseph Highrock's work.

He, too, felt the pull of the endless, eternal horizon. Even as it humbled, it bred a soaring exaltation and the willingness to dare anything. A true son of the earth, Joseph didn't hesitate to confront a challenge. Sara reminded herself of that as she reached for the telephone. Pride demanded that she not show herself weaker than he was.

He seemed pleased, though not unduly surprised, when she said she had decided to pose for him. "How soon do you want to start?" Sara asked, determinedly hiding her apprehension. Joseph Highrock was not going to get the better of her. There was too much at stake.

"This morning," he announced. "Since you're awake and presumably ready to work, why not come over here now?"

"A-all right . . . what should I wear?"

There was a moment's silence before, in a distinctly amused tone, he said, "Anything you want. It doesn't matter."

Before Sara could pursue that, he hung up. She was left staring at the phone in dismay, wondering if she was going to have to tell one of the world's greatest artists—a man routinely ranked with the likes of Picasso, Degas, and Turner—that she wouldn't pose nude.

The short drive to Joseph's studio gave her no chance to work out the problem. Getting out of the car, she hesitated, trying to compose a short but dignified speech that would

explain her feelings. She failed. Her words and emotions were still in a hopeless jumble when she rang the doorbell.

Dressed in low-slung jeans and a natural cotton shirt molded to his powerful torso, Joseph looked even more virile and compelling. His thick, straight hair glinted damply, as though he had just stepped from the shower. The spicy scent of after-shave rose from him, mingling with the clean male aroma he exuded. His impenetrable black eyes scanned her.

"Come in."

Sara obeyed silently. A few steps past the door, she stopped to look around. Joseph's studio was not what she had expected. As an immensely successful artist whose work was in great demand, he might have been allowed some confusion and disorder. But there was none.

Instead, she saw only subtle but unmistakable signs of wealth and taste. Sparse modular furniture in shades of burnt sienna and sand was scattered comfortably about the large, high-ceilinged room. Polished wood floors glowed darkly against handwoven rugs. Against one wall, an oak and smoked glass case held choice pieces of pottery. On another hung a re-creation of a sand painting, one of the ancient, ethereal messages the Navaho sent into the spirit world.

A few large plants flourished in the sun-filled apartment, sharing space with an easel set to catch the southern light. Sara approached the easel nervously.

"I've never posed before. You'll have to tell me what to do . . ."

"Well, for a start," Joseph murmured, coming up behind her so silently that she jumped, "you can try to relax."

"I guess I am a little nervous," Sara admitted tremulously.

Smiling at her understatement, he pulled open a louvered door to reveal a small, compact kitchen. "How about some coffee?"

Sara agreed quickly. Anything to postpone the moment of reckoning. She watched as Joseph ladled freshly ground beans into an espresso machine. "I hope you don't mind it strong?" he asked.

"That's fine," Sara murmured. She was trying not to no-

tice the grace of his movements. His hands were large, with long, tapered fingers. They handled the delicate machinery with ease. She caught herself wondering what they would feel like on her body and blushed.

"Are you all right?" Joseph asked as the blush faded to leave her far paler than usual. "Did you have breakfast?"

"Y-yes . . . of course. I had a muffin."

"Typical! Posing is hard work. You need more than that."

"What's hard about it?"

"Have you ever tried to sit still—really still—for a couple of hours?"

Sara shook her head mutely.

"I didn't think so. By the time we're done you'll feel as though you've put in a full day's work. And this is only the beginning. Once we really get going, I may ask you to pose on weekends so we can stay with it six, maybe seven hours at a stretch."

"You expect me to hold still that long?" Sara exclaimed in horror. It didn't take too much imagination to figure out what she would feel like then. She'd be lucky to be able to move, much less meet her rigorous schedule at the gallery.

"With a few breaks," Joseph allowed. His eyes were teasing as he handed her the coffee cup. Relieved that he, at least, seemed relaxed, Sara sipped the espresso too quickly. The boiling hot liquid burned her tongue, making her gasp.

Thankful that Joseph was too busy rummaging in the refrigerator to notice what she had done, Sara put the cup down shakily. By the time he straightened up, the worst was over. Only annoyance remained. She really had to get control of herself.

The sight of what Joseph held made Sara forget the last of her discomfort.

"Lox! Where on earth did you get that? Out in the middle of the desert, no less!"

Joseph beamed appreciatively. "From New York. It's flown in. I know it's extravagant, but I'm really hooked."

"So am I. I'd never had it before I went to New York. Once I got started, I couldn't get enough. It's been months now . . . Mmmm, lox!"

Sara's mouth watered unashamedly. The delicate smoked salmon was a treat she had sorely missed. If only they had the proper accoutrements for such a feast . . .

Joseph didn't disappoint her. Before her astonished eyes, he pulled out cream cheese, thin slices of lemon, and—wonder of wonders—fresh bagels.

"They're baked by a lady down the street," he explained. "She used to live in Brooklyn and she takes pity on those of us who can't quite forget what a good bagel tastes like."

"If you had told me about this," Sara teased moments later between bites, "I wouldn't have hesitated about posing."

"Don't expect to get fed like this every time," Joseph cautioned. "Once I really start working, I forget to eat."

Sara could believe that. His body was too hard and lean to allow for much gustatory indulgence. Whatever appetites Joseph might have lay elsewhere.

Stop thinking about his body, her sensible side demanded. He's just another good-looking man. There are lots of them. Like Don. The thought of the architect made her expression soften. He was far more than just physically appealing. The rare combination of strength and gentleness that she sensed in him attracted her deeply. She couldn't remember ever before being so intensely drawn to a man as both a friend and potential lover.

As though he could see directly into her thoughts, Joseph scowled. Dropping the empty plates in the sink, he strode toward the main part of the studio. "Let's get started."

Sara came back to herself with a thump. All thoughts of Don vanished as she followed Joseph. He pulled the curtains of the huge picture window open wider and repositioned a stool. Sara stood unmoving in the center of the room. She knew this was her chance to speak up, but she still had not the slightest idea what to say. Anything she might come out with would make her sound like a fool, the very last thing she wanted to appear to Joseph Highrock.

By the time his attention returned to her, Sara's nails were digging into the soft inner flesh of her palms. Her back was rigid and a dark flush highlighted her cheek-

bones. The coffee she had just finished churned in her stomach as she fought a silent battle between dedication to art and sheer embarrassment.

"Well, come on," Joseph ordered impatiently.

"W-where . . . ?"

"Over here, of course. On the stool." When she still didn't move, he covered the short distance between them in a couple of strides and took her arm firmly. "You sit on the stool. I sketch. You can talk if you want to, but I'd prefer you didn't. Got it?"

"Sketch?" Sara repeated faintly. Relief made her voice unnaturally high, but Joseph didn't seem to notice. With cool impersonality, he sat her on the stool, adjusted her shoulders, and tilted her head to the right. His touch lingered briefly as he brushed a stray lock of hair from her forehead, but he caught himself quickly.

Taking a chair some ten feet from her, he said, "I'm doing facial studies today. It's not going to be easy to get your features right. They change, depending on what you're thinking."

The moment he stopped speaking he seemed to vanish into himself, concentrating completely on what he wanted to achieve. Sara felt strangely abandoned. Holding the pose, she muttered, "Then maybe I should stop thinking. How would that be?"

"Fine," Joseph assured her tersely. "Now be quiet."

Over the next two hours, Sara's endurance was severely tested. Except for occasional mutters and the rustle of rejected sketches as they were tossed crumpled to the floor, Joseph worked in absolute silence. Even when he rose to change her pose, lean fingers cool against her skin, he said nothing.

During the two breaks he allowed, as Sara struggled to get some feeling back into her cramped neck muscles, he answered her questions grudgingly.

No, she couldn't see the sketches. No, he had no idea how long the portrait would take. No, he hadn't made up his mind whether to use oils or watercolors.

At least she managed to determine that he had no intention of doing a nude. "I'll have enough trouble with your

face," he informed her flatly, "without making it all worse by trying to paint your body."

Far from being reassured by this news, Sara was perversely angered. "What's wrong with my body?" she demanded.

"Not a damn thing that I can see," Joseph shot back. The full intensity of his gaze abruptly fastened on her, sparing her nothing. Sara's mouth went dry. He walked toward her unhesitatingly, yet still giving her plenty of time to retreat or to make some light remark that would ease the sexual tension vibrating between them. But her mind refused to cooperate. Frozen in place, she could only watch helplessly as Joseph reached for her.

His hands on her shoulders were gentle. The impersonal touch of the artist was gone. This was a man holding her, a man who seemed as much in the grip of forces beyond his control as Sara was herself.

Gingerly, as though trying to stop the motion, Joseph's powerful head came down toward her. She could feel the heat emanating from him, knew that as intense as it was, her own need matched it. Her breath filled with the musky, spicy scent of him. There was no sound, except her own heartbeat mingling with his.

In the instant before he would have kissed her, Joseph pulled back. His hands dropped from her, leaving her swaying slightly before the shock of frustrated desire.

"Damn! I swore I wouldn't do that!"

"Why not?" Sara whispered, hardly daring to speak. Her breath came in gasps and she felt shaken all over. The strength had gone out of her legs, making it almost impossible to stand. Hastily, she reached for the stool.

"Because I want to paint you," Joseph said tightly, "not take you to bed. I found out a long time ago that I can't do both. At least, not at the same time." He ran a hand through his hair impatiently. "We'll just have to avoid touching each other as much as possible. Otherwise, I won't be responsible for what happens."

"You won't be responsible?" Sara repeated sharply, angered by the implicit suggestion that he could make love to her whenever he chose. "I happen to have something to say about what goes on between us. And you can bet noth-

ing will! You're a great artist, but you flatter yourself if you think I can't wait to jump into bed with you."

She was counting on a good fight to drive out passion. But Joseph outsmarted her. The more she ranted, the calmer he got. By the time she ran out of breath, he was grinning broadly.

"Whew! What a temper! You should have bright red hair, not dark."

"Don't change the subject!"

"The subject," he reminded her in an abrupt return to seriousness, "is whether or not you and I are going to make love. If you want to pretend that isn't an issue, go right ahead. But we both know you're kidding yourself."

His expression softened slightly as he went on. "There's something very strong between us, Sara. It's been there from the first moment we met. We're both adult enough to recognize it." He raised a hand, forestalling her denial. "But I don't intend to give in to it until the portrait is done. We'll both just have to wait."

She stared at him open-mouthed. She was about to inform him flatly that while she certainly found him attractive, it was Don she really wanted. But the startling realization that her desires were no longer that clear-cut stopped her.

Chapter Four

IT WAS just as well that the rest of the day turned out to be quieter than usual. Between posing for Joseph in the morning and looking forward to seeing Don at dinner, Sara had a hard time keeping her mind on business. Two sweet-faced little old ladies who came in to browse had to ask twice about the price of an oil painting that took their fancy.

Sara quoted it absently, knowing the figure was high for what some still regarded as second-class art and presuming the ladies would lose interest quickly. But on the contrary, they merely glanced at each other, nodded in agreement, and peeled off a roll of bills that left Sara gasping.

Ruefully, she admitted to herself that she had forgotten there were some extraordinarily wealthy people in Phoenix and they didn't all wear hand-tooled boots or lynx coats.

Several of her regular customers whom she had informed about Bright Star's rug made a point of stopping by. They were all greatly impressed by it. One in particular spent a good half hour futilely searching for the tiny flaw woven into the pattern in the belief that anyone who created perfection would die. Sara finally had to point it out to him, after admitting that Bright Star herself had had to reveal its location before she could see it.

From the enthusiastic comments of everyone who looked at the rug, she suspected it would not be on display long and that Bright Star would soon have yet another large money order to marvel over.

Taking advantage of the relatively slow day, Sara

caught up on her accounts and correspondence. The gallery was definitely in the best financial shape since its opening. She took pride in the fact that for once there was no need to go into her savings to pay the regular monthly bills.

Instead, there was actually enough left over to award herself a small salary. It wasn't much compared to what she used to make, but it gave her far more satisfaction. With a little more luck, she would squeak through this difficult period. And if she should score a major coup such as convincing Joseph to let her represent him . . .

Determinedly, Sara dragged her thoughts away from the artist and all he might or might not represent. After their encounter that morning, when he had once again so effortlessly made her aware of herself as a woman, she had decided that a healthy dose of self-discipline was called for, if only for her own protection.

To distract herself, she drew out the plan of the gallery's wall and floor space with an eye to determining if there was room for a display she wanted to create. Bright Star had suggested it when Sara pointed out that even among those who appreciated Navaho weaving there was little understanding of the process or what it represented.

Sara was quickly able to determine that it would require only moderate rearranging to set up a display explaining everything from how the wool was gathered and dyed to preparation of the loom and the meaning of various patterns. Her budget could certainly stretch to cover the cost and even some judicious advertising that might bring new people to the gallery.

For just a moment, she considered asking Bright Star to give a demonstration of her techniques. But she banished the thought almost as soon as it occurred. For the old Navaho woman, weaving was a mystical experience that united her with the essential life forces of air and land and water. It was unthinkable that she should be asked to perform such an intimate encounter in public.

Satisfied that the display could be effective without Bright Star, Sara spent the afternoon making a rough sketch of the different components and figuring out whom she should ask to help her prepare each part. She was so

engrossed that the hours slipped by without her being aware of them. Only the slanting light of dusk recalled her to her surroundings, and reminded her that she had to get home to get ready for her date with Don.

Locking up carefully, she headed for her car. The air pollution that too often plagued the city was mercifully absent that evening. Only the scent of the citrus trees along the main avenues blew on the gentle breeze. Soon enough, the air conditioners would have to be turned on against the fierce summer heat. But for now Sara could open all the windows when she got home and savor the sweetly perfumed air.

Running a bath, she laid out her clothes for the evening and gave her nails a quick check to be sure her manicure was holding up. The oil she sprinkled liberally over the hot water smelled of jasmine. Stripping off the skirt and blouse she had worn to work, she tossed them along with her lingerie into the laundry basket. A delicious sigh escaped her as she sank into the tub.

For almost half an hour, she was content to just lie there, her thoughts drifting back over the day. No matter how hard she tried, she couldn't keep from recalling her session with Joseph. Every gesture and word seemed engraved on her brain.

Shaking her head ruefully, Sara reminded herself that it was not very nice to be thinking of one man while getting ready to go out with another. Yet she couldn't deny a certain lingering satisfaction at the thought that the formerly gangly, graceless Sara Gavin, who had not had a date all through high school, should be in such a predicament.

People who remembered her from her tomboy stage, which had lasted into college, were still more than slightly amazed at the changes that had turned a too-tall, reed-thin girl into an undeniably lovely woman. They had no suspicion of the sheer work that had gone into the transformation. Or of the deep shyness she had overcome in the process.

Yet despite the evidence of her mirror, not to mention the number of men who had made no secret of finding her attractive, Sara still carried the image of her former self

uppermost in her mind. She was frowning as she climbed out of the tub and wrapped a thick towel around herself.

At least her figure was well proportioned enough to wear clothes elegantly, she thought as she patted her firm, youthful body dry. Absently she rubbed moisturizer into her skin before vigorously brushing her thick hair. It fell in its usual soft waves around her gamine face. Looking at herself in the mirror she had wiped free of mist, Sara decided to leave it down.

In keeping with the casually elegant look she was striving for, she wore little makeup, but applied what she did use carefully. Liquid blusher highlighted her cheekbones. A dusting of blue-green powder brought out the luminous glow of her eyes. Mascara further thickened lush lashes. Using a soft rose lip pencil, she outlined her generous mouth before lightly filling in the color.

The results, even Sara had to admit, were quite pleasing. She grinned at herself in anticipation of Don's reaction. He was all too used to seeing her a bit too hastily put together. It was time he discovered just how good she could look.

The dress she had selected was a light shade of azure silk that matched her eyes. Simply cut, it drifted over her breasts and waist before falling in gently gathered pleats to her knees. The neckline bared most of her honey-warm shoulders and went so far as to hint at the shadowy hollow between her breasts.

Not bad, she thought as she twirled in front of the mirror. Picking up her shawl and bag, she moved toward the living room just as the doorbell rang. Don was right on time, as usual. He, too, seemed to have taken special care with his appearance. The navy blue blazer he wore with dark gray slacks and a white shirt perfectly accentuated the ruggedness of his tanned features and the breadth of his powerful torso. His sun-bleached curls were brushed more or less into order around his well-shaped head. The golden glint of his beard drew Sara's gaze to his sensual mouth, which was curved in a blatant smile of masculine appreciation.

"Wow!" he exclaimed huskily, "You look fantastic!"

Laughing, Sara stood aside to let him in. "You look pretty good yourself."

His hazel eyes never left her as he followed her into the living room. "I'm not sure I want to take you out tonight. I'll end up fighting off every other man in town."

"Oh, no!" Sara retorted. "You promised to feed me and I'm holding you to it. Besides, I made a big sale today and I want to celebrate."

Briefly, she told Don about the two little old ladies and soon had him laughing over her amazement at both their wealth and canny sense of investment. His own experiences with civic committees had long ago convinced him that it was Phoenix's elderly who were often the sharpest and wiliest of its citizens.

Very little got past the men and women who had come out to the desert in the days before irrigation and air conditioning and wrested a living from the remorseless land. They could still teach the young newcomers a thing or two.

As they headed out, Sara thought about the vast changes that had occurred since those early years, symbolized by the glass and steel skyline stretching proudly against the sky. A few lights still shone in the office towers as Don maneuvered his Porsche toward Scottsdale. The small, highly affluent city some persisted in regarding as a suburb of Phoenix was a showplace for the best of all the divergent cultures brought together within it.

Along its tree-lined streets, modern urban architecture coexisted graciously with traditional Indian and Hispanic forms. Tourism fueled the economy, but the city's proudest feature was its resident artist community. As a gallery owner, Sara spent a great deal of time there. But she would have chosen to do so whatever her occupation, and she was pleased that Don had selected a popular Scottsdale restaurant for dinner.

El Sombrero Negro was justly famous for both its authentic Mexican cuisine and convivial atmosphere. The interior of white plaster walls and rough-hewn ceiling beams was warmly decorated with fresh flowers and select items of pottery drawn from the owner's personal collection. Sara noted that a large, black enamel stoneware jug she had recently sold him was on display. She made a mental

note to mention it to the Hispanic artist who was just beginning to be successful in his field and who would certainly be glad to know his work might be seen by prospective collectors.

Over mugs of cold Carta Blanca beer, their conversation shifted as always to the People's Center and its lurching, stumbling progress toward completion.

"The main crane broke down today," Don said. "Took three hours to fix. I may have to start the men working on weekends."

Sara grimaced. She didn't have to be told what time-and-a-half pay would do to the budget. "Is there any chance of making up the time some other way?"

Don shrugged. "Maybe, but the guys are working flat out right now. I don't see how I can push them much harder."

"You still do more than anyone else," Sara pointed out, knowing it was true. Don was always the first one on the site in the morning and the last to leave at night. If he could have, he would have worked single-handedly round the clock to get the building completed. But the complexities of modern construction combined with union rules to hamstring him. As much as he might dislike it, he had to choose between staying on schedule or keeping within the budget. One or the other had to give.

She had little doubt which it would be. After the heated struggle to get the Center's plans approved, Don considered it a matter of personal honor to have it finished on time. He would find the money somewhere, even if it meant badgering every political and business leader in the city. He was, she realized thoughtfully, a very determined man when he chose to be.

Watching him across the table set with snowy white linen, pewter plates, and flickering candles, Sara had the unmistakable feeling that she was about to be on the receiving end of his tenacity. There was definitely a resolute gleam in his eye as they settled down to consult the menu.

Over spicy meat turnovers flavored with cinnamon, clove, and cumin, they talked about her plans for the weaving display.

"You may get a lot of school kids in," Don warned.

"I wouldn't mind that. The sooner they get interested in art, the better. Besides, there's always the chance that they'll go home and tell their parents about what they saw."

"That's true." Don thought it over for a moment before asking, "Are you really sure you shouldn't ask Bright Star to help? After all, it wouldn't do her any harm to see the big city."

Sara wasn't so sure. She privately thought the old Navaho artist would be horrified by crowded streets, foul air, and people who were often too wrapped up in their own concerns to be aware of anything or anyone around them. Having experienced that sensation often enough herself, she wasn't anxious to inflict it on an elderly woman even less acclimated to city life than Sara herself had first been when she left the ranch.

"I'll write to her about what I'm planning, but I'm not going to say anything to make her feel she should be here. I think that would be too much of an imposition. If I'm wrong and she wants to come, all she has to do is say so."

Don had to admit that made sense. He finished off the last *empanadas de picadillo* as the waiter arrived with steaming platters of sirloin in chile sauce accompanied by fluffy white rice and a fresh salad with hydroponic lettuce grown only a few miles away.

Telling herself she would make up for both the rich food and the second round of beers the rest of the week, Sara dug in eagerly. Living alone as she did, she ate all too many rushed, plain meals. Somebody else's cooking was always welcome, and when it was up to the standards of El Sombrero Negro, it was a treat she definitely couldn't miss.

Guitars were strumming softly in the background as they declined the offer of dessert and took their leave. Sara turned toward the car, only to be stopped by Don.

He grinned engagingly. "Could I interest you in a moonlit stroll?"

Sara glanced up at the silver crescent floating high in the cloudless sky. Taking Don's arm, she laughed softly. "You could indeed, kind sir. Lead on."

They strolled slowly toward the old town whose streets

were lined with buildings evoking the area's rowdier past.
The dry goods store, saloon, jail, and other frontier-era es-
tablishments were so carefully preserved that it was possi-
ble to forget that anything had changed since they first
opened for business. Tinny music drifted from the saloon's
piano accompanied by the boisterous laughter of patrons
escaping if only for a brief time from the rigors of the twen-
tieth century.

"Do you ever wish you'd been born back then?" Sara
asked as she and Don stopped to glance in one of the shop
windows.

He looked down at her quizzically. "Can't say I have.
Why do you ask?"

"Oh, I don't know . . . it's just that sometimes I wonder
what it must have been like when things were so much
simpler."

Don laughed gently, tightening his arm around her slen-
der waist. "Sounds like you've got a pretty romantic view
of the Wild West. Remember, those were the days when a
man could get shot down in the street because someone
didn't like his face, crops could be destroyed by storms or
drought, and people died of all sorts of things we don't
have to worry about anymore. It wasn't all clean-cut cow-
boys and pretty dance hall girls."

"No," Sara admitted, "but there was a sense of freedom
and opportunity we seem to have lost. If you didn't like it
where you were, you could just pick up and go somewhere
else. The country must have seemed absolutely endless
back then, and people responded to that. They were willing
to try anything, dare any challenge, to see how much they
could achieve."

"A few of them were," Don hedged. "But most had all
they could do just to stay alive. I'm not denying we have
problems nowadays, but I sure wouldn't want to trade
places with anyone from back then."

The thought of Joseph flitted unbidden through Sara's
mind. He would have been perfectly suited to the rigors of
the old West. His powerful, finely honed body would have
met the challenge of survival easily, and his keen mind
and resolute determination might have enabled him to
successfully meet the inroads of the whites. What prob-

lems he encountered would have been the result of his pride and courage.

However well-equipped he seemed for the past, he was also eminently successful in his own era. Moreover, it was easy enough to imagine him doing equally well no matter what the circumstances. Joseph was a man who carried his own fate within him, independent of time or place.

Don, on the other hand, was utterly a man of the present, and the near future. He had a superb grasp of the moment, and a remarkable understanding of the needs and aspirations of his age. His buildings were commonly described as "timely," "responsive," and "harmonious." But they did not in any way evoke the same feelings as the eternal desert from which Joseph had come and to which Sara longed to return.

Perhaps Don was right, she thought as they headed back toward the car. She did have a broad streak of romanticism in her character. It was partially responsible for her love of art and for her decision to open her own gallery. It made her long to find one special man to share her life with despite the spiraling divorce rates and the general disenchantment with marriage.

Glancing at Don as he skillfully maneuvered the Porsche through a series of steep curves, she wondered if he might just be that man. Granted, they hadn't known each other very long, but she felt more comfortable with him than with anyone else she had ever dated. They had enjoyed an easy rapport from the moment they met. Moreover, he excited her both mentally and physically. But not, she had to admit, as much as Joseph did.

That's enough, Sara told herself sharply. She felt guilty for having thought of the other man yet again, despite Don's presence. Though she knew he had no hint of what was passing through her mind, she set out to make up for it by being as charming as possible.

By the time they reached her apartment, she had Don deeply engrossed in describing the projects he hoped to take on after the Center was completed. As he explained the approach he wanted to use in order to provide passive solar energy to private residences, Sara unlocked her door and reached inside to switch on the light.

"So, you see, the whole idea is to keep the environment as self-contained as possible," he was saying as he followed her into the living room. "That way there's minimal energy loss."

"Makes sense to me," Sara assured him. "Is it very expensive?"

"That's the main problem. Developing these new systems has required heavy research commitment from the firms that sell them. Without much government help, that cost has to be passed on to the consumer. For the moment at least, solar energy really isn't price competitive with oil or gas."

"But there's more involved than just the dollar cost," Sara pointed out. "What about damage to the environment."

Don grimaced, slipping his jacket off and getting comfortable on the wide modular couch. He looked very much at home in the simple but gracious room with low seating units covered in unbleached cotton, white oak tables, and built-in bookcases. Sara had deliberately kept the furniture to a minimum so as not to detract from the artwork. Several fine examples of pottery occupied lighted shelves, while the "Turquoise Woman" oil dominated the room from just above the adobe fireplace.

Don's eyes were on the painting as he said, "Try telling that to the guy who has to put food on the table and shoes on his kids' feet. All he cares about is what takes the least out of his wallet."

Gesturing at the painting, he asked, "That's one of Highrock's, isn't it?"

Sara nodded. She hesitated a moment before adding, "He's doing a portrait of me. I started posing for him this morning."

Without waiting for any comment Don might make, she went into the kitchen to pour her usual white wine and the brandy he enjoyed. Carrying both, she came back to join him on the couch.

Don's gaze remained locked on her as he sipped the drink before demanding, "What kind of portrait?"

She didn't pretend to misunderstand his meaning. "Just a facial study." She saw no reason to add that the artist

found her body "difficult." That comment still rankled too much to be repeated.

"If you say so," Don murmured doubtfully. He put the brandy snifter down and turned to her. "I thought he'd have other things in mind."

"Just because you find me irresistible doesn't mean everyone else does too."

A slashing grin broke across his strong features. "Their loss," he murmured as he reached for her gently.

Sara went into his embrace without hesitation. She knew they had been heading toward this moment all evening, and she was frankly anxious to get past it. Don wasn't going to like what she had to tell him, so the sooner it was done, the better.

But before she could say anything, the power of his caress enveloped her. All her senses came vibrantly alive to the taste, smell, and touch of him. His mouth was pleasantly tart from the brandy he had just sipped. The sandalwood after-shave he wore was subtly but unmistakably masculine. His skin was pleasantly rough under her fingertips, in sharp contrast to the silken mass of his beard that tickled her chin.

Her lips parted instinctively at the probing of his tongue, allowing him to savor her sweetness. Inside the dark, moist cavern of her mouth, they fought a silent duel which ended only when a low moan broke from her.

Pressing his advantage, Don trailed hot, tender kisses down the sensitive column of her throat, lingering at the scented hollow at the base of her neck. Warmth shivered through her as he licked it tenderly.

Through the thin silk of her dress, her nipples thrust urgently. She felt the tremor that raced through him as his big hands cupped her breasts, the thumbs rubbing with rough gentleness across the hardened peaks.

"Lord, you're so beautiful!" he muttered into her mouth as he kissed her again, even more urgently.

Without her being fully aware of what was happening, he stretched out on the couch and brought her to him. Trapped between the rough cotton upholstery on one side and his taut body on the other, Sara stiffened instinctively. Part of her wanted desperately to allow his ardent love-

making to continue to its natural conclusion. But another, wiser part knew she couldn't afford to take the risk, especially while her feelings were in such confusion.

Tearing her mouth from his, she murmured thickly, "Don, why are you doing this?"

Enthralled by the sheer impact of her loveliness, he looked up dazedly. "W-what . . . ?"

"The other day you said you didn't want to rush into anything."

"Oh, that . . . I was nuts. Forget what I said."

His head bent toward the ripe curve of her breasts exposed by his wandering hands, but Sara stopped him. "I can't. I think you were right."

A long sigh escaped him as he reluctantly sat up. The hazel eyes that focused on her were dark with passion. His voice shook slightly as he said, "Two days ago, you were the one who wanted to go to bed. I didn't make any mistake about that, did I? So what changed your mind?"

It was a fair question, but one for which she unfortunately did not have a reasonable reply. Hesitantly, she said, "I haven't changed my mind, exactly. It just occurred to me that we don't really know each other all that well, and I think we should before we . . ."

"Make love," he finished helpfully.

"Well, yes . . . Before we make any sort of commitment to each other."

The hard line of his mouth softened slightly as he asked, "Does that mean you regard lovemaking as a commitment?"

"Of course I do! It can't be any secret to you that I haven't gone in for much of that sort of thing. I need to feel there's something special . . . something that at least has the potential to last."

"What makes you think this doesn't?"

"I don't think that. I just . . . don't know . . ."

Sitting up on the couch, she looked at him carefully, relieved to see that he appeared more perplexed than angry. Softly, she said, "I'm not trying to string you along or play any sort of game. But I don't think either of us wants to rush into something that may not be right. All I'm asking for is more time."

He studied her for a long moment. His expression was unreadable and his voice, when he spoke at last, was unnaturally quiet. "How much time?"

"I-I don't know . . . A few weeks . . . I'm not sure."

Standing up, Don pulled his jacket back on. In the dim light from the shaded lamps, he looked startlingly tall and broad. She swallowed hard when he abruptly asked, "How much has this got to do with Highrock?"

"J-Joseph? Why should it have anything to do with him?"

"It shouldn't. But I want to hear you tell me that."

Reaching down, he pulled her to her feet, his calloused hands gentle but firm on her slender arms. Huskily, he said, "I want to know he isn't getting to you."

"We have a business association," Sara protested, determinedly ignoring the fact that Joseph had made it clear he wanted far more. "And we may not even have that. If he decides not to be represented by me, I'll probably never see him again after the portrait is done."

She thought she believed what she said, but even as she spoke part of her mind denied the words. Joseph was not going to just walk out of her life. He couldn't.

"If you say so . . ." Don muttered, clearly unconvinced. He shrugged dismissively. "It doesn't really matter. I have no intention of ceding the field to Highrock. If he wants you, he's going to have to fight me for the privilege."

"I'm not some piece of booty to be fought over!" Sara protested vehemently. She couldn't quite believe that any man in this enlightened day and age would think of a woman in such terms. But Don's supremely male grin quickly disabused her.

"Honey, you've got no idea what goes on when two men decide they want the same woman. But I've got a feeling you're about to find out."

Letting her go, he turned toward the door. There was confident laughter in his voice as he said, "Better get some rest, sweetheart. You're in for one hell of a ride!"

Chapter Five

"COULD WE stop for a minute?" Sara asked softly. "My neck's cramping."

Joseph immediately dropped the pastel he had been using to sketch the high curve of her cheek. "I'm sorry. I didn't realize we'd been at it so long."

"Neither did I until my neck started hurting. It's fascinating to watch you work."

He grinned wryly. "Must be rather like watching paint dry."

The mood between them was surprisingly light, given what had happened the last time they were together. In the privacy of her own mind, Sara had decided the only way she could go on posing for him was to put any thought of an intimate relationship on hold. Joseph appeared to have reached the same conclusion. So far at least, it seemed to be working. They were getting along well, although that was no indication of how much was actually being accomplished.

Sliding off the stool, Sara followed him into the kitchen. "Is it going that slowly?"

Pouring fresh orange juice into two glasses, Joseph nodded. "I knew from the beginning that I was going to have trouble capturing your features, but I didn't realize how elusive they really are. The pastels I've been trying to use are just too soft."

His own dark, fathomless eyes scrutinized her. He was standing barely inches away, so close that Sara could feel the warmth emanating through the snug cotton shirt and jeans he wore. "I'll have to switch to something firmer, a

charcoal pencil maybe. Though I still can't figure out why . . ."

"Maybe I just have hard features," she suggested lightly.

"No, your face is well-formed and harmonious. There's nothing hard about it. It's very puzzling . . ."

Being scrutinized so impersonally made Sara tense. Unconsciously, she raised a hand to the back of her neck where muscles were once again protesting. Joseph caught the motion and set down his glass. He moved behind her, lean fingers brushing aside her auburn hair.

"Here, let me do that."

At the first touch of his large, warm hand rhythmically massaging the nape of her neck, Sara bit back a gasp. Shivers of pleasure darted along her spine. She had to fight the urge to lean back against him and feel the full length of his hardness against her. The quiver that ran through his fingers told her she was not alone in her response.

His warning that he could not paint her if they were lovers became blindingly understandable. The overpowering sensation she was feeling left no room for anything else. If only the slightest contact could wreak such havoc, what would happen if the passion they set off in each other was ever fully released?

"Feel better?" Joseph murmured huskily. Shakily, she nodded. Disappointment and relief warred within her as he dropped his hand. Beneath his coppery tan, his face was pale. Impatiently, he pushed aside the lock of thick black hair that had fallen across his forehead. His mouth was drawn in a grim line as he turned away from her. "Let's get back to work."

For another half hour, Sara held the pose. She kept her mind carefully blank, refusing to think of the man before her. Instead, she let her gaze wander over the room, focusing on the few pieces of art scattered around the large, open space.

His collection was small and highly selective. She had no difficulty recognizing the works of several American and European artists. The diversity of styles fascinated her as she strove to discover what common element held

the collection together. That it succeeded as a unified whole was beyond doubt. The eye moved irresistibly from one piece to the other, caught up in some force she could not yet identify.

Not until she allowed herself to study the few examples of his own work that Joseph had apparently thought worthy to be included did she begin to understand. There was an overriding sense of struggle in the dozen or so paintings and half as many pieces of sculpture drawn together from all over the world. Whether abstract or representational, each work captured the essential human yearning to both belong to something larger and still be an individual.

The perilous balance between individuality and isolation was vividly evoked, especially in the small landscape Joseph had done. Depicting a vast, empty plain bordered by stark mesas and framed by a relentless horizon, it pulled the viewer into it. The sensation was almost dizzying, since there was nothing of human scale to grasp on to. Only a man strong and courageous enough to accept his own vulnerability could have created so poignant a vision of humanity's dual insignificance and exaltation.

So caught up was she in the painting that Sara jumped when Joseph suddenly announced, "That's it for today. I know you're not used to this and I don't want to push too hard."

About to reassure him that she was fully prepared to continue, Sara changed her mind when she noted the time. She really did have to get to the gallery. Parting from him was oddly difficult; she was reluctant to put any distance between them. Joseph seemed to feel it, too. He followed her out to the car, holding the door open for her, and stood talking for several minutes before at last stepping back. Even then, he hesitated. "I'll see you tomorrow . . ."

"Yes, of course." Hoping she didn't sound too eager, she added, "If you like, I could get here earlier."

"You wouldn't mind?"

"No, not at all. That way we could work longer."

The smile he gave her made Sara's throat tighten. It just didn't seem fair that any man could so effortlessly move her. Yet she couldn't deny the glow of pleasure that darted through her as he said, "I'd appreciate that. Thanks."

Driving away, she glanced in the rearview mirror. Joseph remained standing in front of the house, his hands thrust deep into the pockets of his jeans and his expression unreadable. He was still there as Sara turned the corner and disappeared from sight.

She was ten minutes late opening the gallery, and was surprised to find one of her regular customers pacing the sidewalk out in front as she drove up. The man, a rancher who had made his fortune in uranium mining, was the same one who had searched so diligently for the tiny imperfection in Bright Star's rug. Presuming he was back for another look, Sara smiled apologetically.

"I'm sorry you had to wait. I lost track of the time."

The man nodded absently, following hard on her heels as she opened the door and heading straight for the rug. "That's okay," he said over his shoulder. "Haven't been here long. Just didn't want anyone to get the jump on me."

Gesturing at Bright Star's work, he asked, "Price still the same?"

Sara nodded, then discreetly absented herself so that he could study the work in private. Hanging up the russet suede jacket that matched her skirt, she smoothed a minute wrinkle from the turquoise silk blouse she had paired with it. She had put the coffee on, opened the window beside her desk to catch the spring breeze, and watered her plants when the man suddenly stuck his head around the partition that separated her small office from the rest of the gallery.

His weather-beaten face creased in a broad grin. "You've got yourself a deal, little lady. Might seem extravagant to some, but that rug just sort of . . . speaks to me. Can't say I understand it myself, but I sure know I got to have it."

He flushed slightly, as though embarrassed at having revealed himself capable of such feelings. Sara smiled understandingly. "That's as good a description of how people respond to art as any I've heard. I'm sure you won't be disappointed."

Reassured, the man settled into the chair beside her desk as she drew up the bill of sale and certificate of ownership. A familiar sense of regret filled her as she realized

her own time to enjoy the rug was over. Every piece in the gallery meant a great deal to her, but Bright Star's work was particularly difficult to part with.

Reminding herself firmly that she was a businesswoman, Sara completed the documents and saw the man out, after promising once more that he would have the rug by that afternoon. As soon as he was gone, she called the delivery firm she always used and arranged for the rug to be collected. Only when that was done did she allow herself to appreciate the fact that she had made two major sales in as many days.

Things were definitely looking up. Common sense warned that she couldn't count on such a pace continuing. But she did let herself fantasize briefly about what it would be like when her business was sufficiently established to begin thinking about expansion. The music store next door wasn't doing too well but still had a year to run on its lease. Perhaps by then . . .

"Penny for 'em," a cheerful voice interrupted, abruptly dragging Sara back to earth.

She looked up startled. "Oh, Carrie. I'm sorry . . . I guess I was daydreaming."

The woman who had come into the gallery while she was so pleasantly preoccupied was slightly older than Sara, with an open, cheerful face set off by large brown eyes and a generous smattering of freckles over the bridge of her upturned nose and determined chin. She wore bright yellow overalls and a checkered blouse that should have looked silly with her carrot red hair but instead suited her pert attractiveness perfectly.

As the owner of a highly successful boutique on the other side of the gallery, Carrie liked to think of herself as a walking advertisement for her clothes. Sara couldn't remember ever seeing her in the same outfit twice, but no matter what she wore she always managed to look vivacious and feminine. Her customers could only hope they came off as well.

Perching on the edge of Sara's desk, she grinned engagingly. "Were you thinking about anything in particular, or can't you tell me?"

"I hate to disappoint you, but it was strictly business."

A tiny moue of distaste pursed Carrie's soft mouth. "Ugh! Don't you get enough of that without wasting a good daydream on it?"

"Not this kind," Sara assured her good-naturedly. "I'm finally beginning to see some light at the end of the financial tunnel, so I was just indulging in a little fantasy about how fast I could spend the money."

"You deserve to be successful," Carrie said sincerely. "I've never known anyone who worked harder." Unable to resist her favorite subject, she added, "Maybe now you'll have more time for a social life. Speaking of which, how's the hunk?"

Sara laughed, wondering what Don would think if he ever got wind of his pet name. Ever since she had met him one evening when he came to pick up Sara for dinner, Carrie had made no secret of her approval. Solidly involved with a local lawyer who was beginning to make noises about marriage, she had no personal interest in Don. But that didn't stop her from appreciating a good-looking man when she saw one.

"He's fine," Sara said, pouring two cups of coffee. When she didn't elaborate, Carrie raised a smoothly plucked eyebrow.

"Just fine? I would have guessed a lot better than that."

"We've only been dating three weeks," Sara reminded her. "At that stage, fine is as good as it gets." Shrugging, she added, "At least for me."

Carrie shook her head, bewildered. "I thought you were ready to take the plunge?"

Sara sighed. She sipped her coffee before answering. "I was, but Don wasn't. Then he was, and I wasn't. If that makes any sense."

"It doesn't. Want to try again?"

"I'm not sure I can explain it," Sara admitted. "Don still isn't completely over his marriage. He's quite understandably concerned about making any commitment that might lead to more pain for him. And as it worked out, he just may have been right. I'm not sure anymore that we're suited to each other."

"How come?" Carrie asked gently. "Has something happened?"

Not *something*, Sara thought. *Someone.* Joseph was making her see herself in a new light. The effect he had on her forced her to reexamine beliefs she had always taken for granted. Convinced that she was essentially a monogamous person, she was forced to wonder how she could be so attracted to two men at the same time.

"Carrie . . . have you ever . . . ? That is, did you ever find yourself in a situation where you couldn't decide which man you really wanted to be involved with?"

"Which man? You mean there's more than one in the running?"

"Well, yes, sort of . . . You see, I . . ."

Carrie shook her head disbelievingly. "And you're upset! Lord, girl, you should be delighted. Most of us would give our eyeteeth to have to make that kind of choice."

"I suppose, but . . ."

"There's no suppose about it. How many times have you thought you were never going to meet the right man? That everybody out there was a jerk or a creep? And now all of a sudden you've got two winners! For heaven's sake, if I were in your spot, I'd be so smug there'd be no living with me." She sighed languorously, savoring the mere thought. "Two of them! Oh, Lord, why don't these things happen to me? At least I'd know what to do with them!"

"It's not that simple," Sara protested. "I'm not sure of my own feelings, let alone of theirs. What if I make a mistake?"

"Then you get hurt," Carrie said softly. "It goes with being human."

"And maybe I also hurt someone else. That's the part I can't live with."

"Okay, I see your point. But you can't just refuse to do *anything* because you're afraid to make a mistake. That's not fair to you or them."

"I know," Sara admitted, "but it isn't all up to me, you know. A few days ago, Don wanted to wait and get to know each other better before making any sort of commitment. Now suddenly he wants a relationship right away. I'm concerned that he changed his mind for the wrong reasons."

"Such as?"

"He knows about Joseph, and he's jealous. He feels

threatened by him. They went head to head a few months ago over the People's Center, and Don basically lost. I think he's afraid he will again unless he moves fast. But to me that's a terrible reason to go to bed with someone."

Carrie nodded sympathetically. "So far we agree. But who's this Joseph?"

"He's an artist I'm posing for."

"An artist . . . involved with the People's Center . . . Wait a minute! You don't mean . . ."

"The one, the only."

"Oh Lord! The other guy is Joseph Highrock? I saw him at one of his shows. He's in a league by himself. Those eyes . . . and that body . . . and just the way he carries himself. I don't know what it is exactly, but I get goosebumps just thinking about him." Carrie glanced at her friend shrewdly. "And I'm not the only one, am I? I'll bet he gets to you in a way Don can't touch."

"Don is a nice man," Sara insisted stoutly. "He's funny and tender and intelligent. We understand each other."

"And you and Joseph don't?"

"Not entirely. Our backgrounds are so different. Oh, there are points in common, like the way we feel about the land and art. But there are also huge gaps." She shook her head worriedly. "I'm not sure we could ever overcome everything that holds us apart."

A challenging gleam entered Carrie's limpid brown eyes. "But it sure would be fun to try, wouldn't it?"

Sara laughed ruefully. She should have known Carrie wouldn't let her feel sorry for herself. After all, she was caught in a situation most women would envy. And if the truth be told, she couldn't deny a certain satisfaction at her predicament. The image of herself as a skinny, awkward adolescent still lingered in the back of her mind. It seemed incredible that she was actually the object of interest for two such compelling men. Perhaps she should just sit back and enjoy it.

She said as much to Carrie, who approved wholeheartedly, but with one change. "Make that *lie* back and you'll have the right idea."

"You're incorrigible!" Sara laughed, blushing faintly. It was all too easy to imagine herself making love with either

Joseph or Don. But what could happen in her mind was far different from what she was capable of in reality. Without a solid commitment to one man, she would remain stuck in limbo, unable to achieve the full, loving relationship she wanted.

That thought remained with Sara as Carrie finished her coffee and went back to work, after extracting a promise that Sara would keep her up to date on all the latest developments. Immersing herself in plans for the weaving display, Sara was able to get through the rest of the morning productively. Only when Don called around lunchtime did her concentration break.

"How's it going?" he asked cheerfully over the rumble of construction equipment in the background. Sara could see him at his desk in the trailer, feet propped up and long, sinewy body stretched out. It was hot again, so he would be wearing as little as possible. His chest was already bronzed from the sun and would undoubtedly get even darker . . .

"Fine. I sold Bright Star's rug."

"Hey, that's great! Congratulations. We'll have to celebrate."

Warmed by his understanding of how much the sale meant to her, Sara smiled. "That would be nice."

"But not tonight, I'm afraid. I've got another meeting with the planning board. Have to squeeze a few more bucks out of them. We'll go out tomorrow evening, okay?"

"Sure, that's fine." It was childish to expect Don to drop an important business conference just because she had made a big sale. Were their positions reversed, she didn't doubt she would act the same way. But still, she couldn't deny feeling slightly let down as she hung up the phone.

The deliverymen arrived later that afternoon to remove the rug. Sara watched carefully as they detached it from the wall and neatly rolled it up before wrapping it in quilted padding. She purposefully avoided looking at the bare spot it left behind. As soon as the men were gone, she went through her small inventory and selected a vibrant abstract to put in its place. The painting was smaller than Bright Star's work but at least it would stop her from

being constantly reminded of how much she missed the rug.

Balanced on the stepladder, she had just succeeded in hanging the painting when the door chime announced a visitor. In the next instant, Sara gasped as strong hands seized her around the waist and lifted her almost but not quite to the ground.

"Haven't we played this scene before?" a deep voice growled in her ear.

"Joseph, put me down!" Flustered by his sudden appearance, Sara spoke more sharply than she intended. Her feet were still dangling a foot above the floor, which put her just about on eye level with him. He grinned unrepentantly as their gazes met and held.

"What's the hurry? I won't drop you."

"A customer might come in," Sara hedged, trying to deny the effect being pressed against his broad chest, her thighs brushing the flat tautness of his abdomen, was having on her. "This is a very undignified position."

"That's true," he agreed complacently, making no move to release her. "I don't suppose anyone would believe we were discussing your representing me."

The breath left her in a rush. "Is that what we're doing?"

"If you're still interested?"

"Of course I am! But you said . . . the painting . . . I thought . . ."

"I still want to do the painting," he assured her quickly. "But it occurred to me that it wasn't really fair to make one dependent on the other. Anyway, I've done all the thinking I have to." Lowering her to the ground, he kept a hand on her waist as he said gravely, "I'd like you to represent me, Sara. Besides having faith in your ability, I'm impressed by your attitudes. Unless I'm very much mistaken, we should do well together."

"Thank you, Joseph," she said with equal seriousness. "I appreciate your confidence and I'm honored to represent you. You won't be disappointed, I promise."

The laughing gleam was back in his eyes as he said, "I'll hold you to that. But in the meantime, how about getting

together this evening to discuss the works I have ready to show?"

Murmuring a silent prayer of thanks that Don hadn't been free, Sara agreed quickly. She closed up the gallery a bit early to accompany Joseph back to his studio. As they were leaving, he noted the absence of Bright Star's rug and asked her about it. Her news of its sale was greeted with quiet commendation.

"I'm not surprised. When the right artist comes together with the right representative, things happen quickly."

His confidence warmed Sara. She felt perfectly at ease when they arrived at his house, and once there, it seemed natural to accept his invitation to dinner. He got the grill going while she wandered around, looking at the two dozen pieces that would form her first Highrock show.

He had surpassed his own extraordinarily high levels of creativity, Sara realized in astonishment as she studied the sculpture, oils, and watercolors propped against the studio's walls. Whatever medium he worked in, Joseph powerfully evoked his own sense of the land and its relationship with humanity. She recalled her reaction to the collection in his studio. Here, too, each of the pieces was a masterpiece in itself, but together they formed a unified body of experience that transcended each separate vision.

The fact that he had chosen her gallery to reveal them to the world filled her with humility. No matter how much effort it took, she would make sure the showing was worthy of the man and his art.

The sheer impact of his achievement was still uppermost in her mind as she joined him on the flagstone patio. "What can I say? They're incredible."

"They're not bad," Joseph acknowledged. "I really feel I've made some breakthrough with my work."

"I can see why. You were always superb . . . but now . . ." Sara looked at him intently for a moment before she said, "It's because you've gone back to your fundamentals, isn't it? All these pieces have a quality you've only managed to achieve a few times before. To do that, you must have reached some turning point in your own mind."

In the act of dropping a steak onto the grill, Joseph's hand froze. He stared at her doubtfully. "I'm not sure I like

your being able to read me so easily. But I suppose I'll learn to live with it. As it happens, you're right. I've decided that whatever problems and conflicts this place holds for me, I'm never going to feel at home anywhere else. And I need that feeling to do my best work. So I'm not going to be traveling much." He gestured toward the elegant adobe residence. "I've bought this house. Between it and the place I keep out on the reservation, I won't be tempted to wander much anymore."

"I'm glad," Sara said simply.

They looked at each other in silence for a long moment before the sizzling of the steaks broke the contact between them. Joseph turned abruptly away to tend to the food. "Yes . . . well, we'll see how it works out. For the present, I just want to concentrate on the show and your portrait."

Taking charge of the salad ingredients laid out on the nearby butcher block trolley, Sara asked, "Should I plan to include it with the other pieces?"

Joseph shook his head. "I don't think so. It's not the sort of thing I can expect to have done by a specific date. It'll come in its own time, but not if I try to rush it."

Sara nodded, surprised by how relieved she was to know that her portrait would not be part of the show. For reasons she didn't care to explore, she wanted the painting to remain something private between her and Joseph. At least for the moment.

"We have plenty to go with," she assured him. "I'll need about a month to get everything in the works. Would an opening in about four weeks be agreeable?"

"That's fine." He grinned suddenly, the onyx eyes teasing. "I suppose you'll want me to show up."

"Only if you don't want to disappoint every art lover in Phoenix." Bluntly, she added, "You're something of a mystery, Joseph. That's part of your appeal. People will turn out to see you as much as your work. Is there any reason we shouldn't capitalize on that?"

"No," he admitted, forking the steaks onto heated platters. "I can't claim to enjoy the glad-handing very much, but I know it goes with the territory. As long as there are very few successful Indian artists, those of us who have

made it owe it to the others to do everything we can to publicize our work."

Sara searched his words for bitterness, but found none. If he resented the special problems inflicted by prejudice, he gave no sign of it. Success hadn't come easily to him, and she wondered if perhaps meeting the prejudice hadn't strengthened his determination and persistence.

Over a dinner that more than proved his culinary skills, they continued to plan the show. Sara was relieved to discover they were in complete accord about how the works should be grouped and what sort of catalogue should be prepared. As for prices, Joseph's astute understanding of the value of his work coupled with her up-to-the-minute awareness of the market prevented any disputes in that area. More quickly than she would have thought possible, all the major issues were dealt with and they were free to talk of other things.

"Tell me about your home on the reservation," she asked impulsively, before her innate reticence could get the better of her.

"There isn't much to tell. You've stayed in Bright Star's hogan. Mine isn't very different."

"Is it near hers?"

"In the same general area," Joseph hedged. "As you know, the Navaho are nomads. We tend to live far apart."

Aware that she might be trespassing on a part of his life he did not wish to reveal, Sara asked hesitantly, "Is your new home in the same place where you grew up?"

Joseph hesitated before he nodded. "When my parents died, I took over their land. Neither my brother or sister wanted it. After we all left the reservation as children to go the Indian School here in Phoenix, they put that part of their lives behind them. I guess they had to in order to adjust to this world. But it remained part of me, no matter how much I may have wished otherwise. I ended up running further away than either of them, only to discover that I was trying to escape from myself."

"So you keep going back."

"As you pointed out when we first met, I don't have any choice. I'm connected to the land in some deeply spiritual way. No matter how harsh and unforgiving it is, I have to

return periodically. Otherwise something inside me starts to die."

Hoping she didn't sound presumptuous, Sara said slowly, "I think I know how you feel. After a few weeks in the city, I have to get away, even if it's only for a short time."

"You said you grew up on a ranch outside the city. Is that where you go?"

Sara shook her head. Hesitantly, she said, "It had to be sold when my father died. I haven't been back there since."

Joseph looked at her quietly for a moment, his gaze suddenly gentler than she had ever before seen it. "I'm sorry. That must have been very hard for you."

Reluctant to reveal the full extent of her pain at the double loss of the father who had raised her alone after her mother's early death and of the ranch they had both loved so fiercely, she made a halfhearted effort at evasion. "I wasn't brought up with the reverence for the land that you have."

Joseph wasn't fooled, but he would not trespass further on her privacy until she made it clear he was welcome to do so. Instead, he said simply, "You seem to value it as much as I do. Otherwise, you wouldn't see my work so clearly."

"There are aspects of your work that puzzle me," Sara acknowledged. "But I think you mean it to be that way. You take people through levels of understanding until they come smack up against some essential mystery. It's never clear whether the puzzle lies in what you choose to depict or in the spirit of the person looking at it. Your "Turquoise Woman" series, for instance . . ." She broke off, startled by her own garrulity. Perhaps it was the excellent cabernet sauvignon they were sharing that was making her so talkative.

"Go on," Joseph urged. "You were saying . . ."

"N-nothing."

"About the turquoise women," he insisted, unwilling to let her stop. "How do you happen to be familiar with them?"

"I'm not. That is, not with the whole series. Only with the one I was . . . given several years ago."

"You own one of my paintings?"

Sara nodded. She smiled slightly. "My father bought it for me several years ago when your prices were lower."

Joseph leaned back in his chair, twirling the delicate stem of the wine glass between his bronzed fingers as he asked, "Who picked it out, you or your father?"

"I did."

He nodded, satisfied that his guess had been correct. "You chose wisely. There's a great deal of yourself in that painting."

Sara's eyes widened with astonishment. She could hardly believe she had just heard one of her own most private thoughts voiced by another. Struck by an uncomfortable sense of exposure, she temporized. "I don't look anything like the model."

"That's true," Joseph agreed. "You aren't Navaho, so you can hardly resemble my sister, who sat for the series. But I wasn't speaking about physical characteristics, as I think you know. There is far more under the surface which you do share." He paused for a moment, before adding, "In fact, you embody what I was striving for but didn't quite manage to capture. Perhaps with your portrait I will have more success."

What could there possibly be about her, Sara wondered silently, that Joseph wanted so badly to capture on canvas? Certainly, he could not be drawn strictly to her appearance or he would not be looking for the qualities he had failed to secure in the other portraits. The thought rose unbidden within her that despite his claims to the contrary, he might really only want her as a model. If she did somehow inspire him to achieve whatever he was striving for, would his interest end?

As the evening wore on and she felt more and more relaxed in his company, she reflected that it might be simpler for her if it did. She meant what she had said about the gaps between their backgrounds possibly being too great to surmount. Were she to become involved with him only to discover that they had no chance of a future together, she would be badly hurt.

Compared to Joseph, Don seemed like a sanctuary from the storm. But she wasn't sure she wanted such a haven. As Carrie had pointed out, pain was the price of being hu-

man. Without risk, there was no hope of true reward. The man sitting across from her might be as remorseless as the desert wind that wore down the high mesas and carried away all but the most tenacious life. Yet the wind also blew a siren's song through the deeply etched canyons and over the wide, flowering plains. Even as she sat on the lantern-lit terrace surrounded by all the accoutrements of civilization, Sara knew his was an ancient call she might well be destined to answer.

Chapter Six

"I REALLY don't have time for this," Sara murmured. "I should be back at the gallery working."

"It won't kill you to take half an hour off," Carrie insisted, bustling into the fitting room with an armful of dresses. "Besides, when's the last time you bought any new clothes?"

"A while ago," Sara admitted. Staring at herself in the full-length mirror, she took in the effect of an elegantly draped lavender silk and smiled. "I guess it wouldn't hurt to get something special."

"Of course not. The way you're going, it's an absolute necessity. You wouldn't send soldiers into battle without proper ammunition, would you?"

"That's not exactly how I see my situation," Sara insisted, her voice muffled as she pulled off the dress to try another.

"Well, however you want to put it, you owe it to yourself to look as good as possible." Carrie stepped back, surveying the knee-length burgundy knit she had just dropped over her friend's head. Her professional appraisal was immediate. "In your case, that's very good indeed. That dress was made for you."

Sara was tempted to agree. It wasn't a color she had worn before, but somehow the darkly glowing silk brought out the opalescent glow of her complexion and made her eyes look bigger than ever. The dress clung to the high curve of her breasts and her slender waist before flaring out slightly at her hips. All in all, it was as subtly sexy a dress as she could hope to find.

"I'll take it."

Carrie nodded her satisfaction. "Smart girl. You won't need much in the way of accessories. A few gold chains will be it."

"I've got those. What about shoes?"

"Something very simple. Black and strappy. And leave your hair down. I know it's always tempting to put it up for evening, but when it looks as fantastic as yours does, it's a shame not to show it off."

Sara's eyes were warm with appreciation as they met Carrie's in the dressing room mirror. "Thanks for dragging me over here today. I really needed this."

"Just tell people where you got the dress. I couldn't ask for a better advertisement."

Advertisement or not, Sara insisted on paying full price for her purchase instead of taking advantage of the wholesale discount Carrie offered. She did, however, agree to accept a roll of white wrapping paper that was large enough to hold a detailed plan of the gallery. All the shows she had done so far were worked out ahead of time on graph paper using a very small scale. But for Joseph's opening she wanted to make sure every element was precisely right.

Back in her office, she put the dress carefully away before getting started. Spreading the paper out on the floor, the only surface large enough to hold it, she drew a careful outline of the gallery, including the display walls, then began trying to figure out where each of Joseph's pieces should go.

It was hard work. Besides having to take into account the lighting, both artificial and natural, and the traffic patterns through the gallery, she wanted a smooth progression that would leave the viewer at the end with the sensation of having experienced a unified whole.

Fortunately, each of the two dozen artworks she had seen in the studio stood out so vividly in her mind that she had no difficulty envisioning how they should fit together. The main problem was deciding the best possible configuration of the movable gallery walls so that the crowds she was reasonably expecting would not become congested at any one point. Nothing was more guaranteed to spoil a showing than a herd of people getting stuck part way through.

As she worked, Sara's thoughts went inevitably to the man whose remarkable spirit she hoped to express, if only to a small degree.

Since the previous afternoon when he had dropped his surprising news about accepting her as his representative, she had fought hard against the idea that he was doing her a favor. Sara didn't doubt that she was fully qualified in her field. But so were a lot of other people. An artist of Joseph's caliber could pick and choose among the best. Yet he had decided to take a risk on a new, as yet unproven gallery. Part of her wanted to believe it was only because he had confidence in her professionalism. But another part cherished the secret hope that his decision was at least partly based on more personal feelings.

Between the effort needed to get a plan for the show into halfway decent shape and a gratifyingly large number of visitors, the afternoon passed swiftly. She was unaware of the time until the gathering dusk outside her windows warned her Don would be arriving soon to take her to dinner.

Jumping in and out of the shower with moments to spare to redo her makeup and pull on the burgundy knit, she just made it to the door as he rang the bell. Pulling it open, she smiled at the thought that she would have to settle down soon if only because she couldn't keep up the pace of such an active social life. But for the moment at least her effort seemed worthwhile.

Don whistled softly. "Are you sure you want to go out tonight? Couldn't we just stay home and . . . uh . . . put our feet up?"

"Great idea. You can make dinner while I get a headstart on next month's accounts."

"On second thought . . ." Don didn't even bother to come inside. He reached out for her bag and shawl sitting on a nearby table, gathered them and her into his arms, and headed straight for the car.

Not until she was safely settled in the seat next to him did he say, "You look terrific. New dress?"

"Sure is. Just bought it today. Carrie picked it out for me."

"The redhead?"

"Mmmm."

"She's got good taste."

They drove the rest of the way to the restaurant in companionable silence. Sara let her head fall back against the plush leather upholstery, content for the moment just to relax. Her mind was still on the hectic week she had just put in. She thought it only fair she should clear her thoughts a bit, for her own sake as well as Don's.

The smooth motion of the powerful car and Don's calm presence both had the desired effect. By the time they reached the restaurant, she felt considerably revived, which was just as well, since it turned out that they had little opportunity to linger over dinner.

"I hope you won't mind," he said after he asked the waiter to serve them immediately, "but I really don't want to miss the exhibit I mentioned at the Natural History Museum. I'm not sure I'll have another chance to catch it."

Sara had no objection to taking in the display of Amerindian artifacts, but she was a little surprised that Don was so eager to see it.

"Since when did you get interested in archaeology?" she asked over the scallop seviche.

"Since never, " he admitted cheerfully. "But there's supposed to be a lot of stuff about passive solar heating and cooling systems used in the pueblos. That's the part I want to look at."

Knowing as she did that Don was rarely curious about anything not directly related to his work, Sara asked, "Could something so ancient really be applicable to present day needs?"

"There's no reason why not. We're still faced with the same problems and the basic principles haven't changed."

"Like what?"

That was all the encouragement he needed to launch into an explanation of natural building materials and techniques used by native cultures that continued through the rest of dinner. Sara didn't really mind; he was interesting and articulate. But she was rather disappointed that by the time they agreed to skip dessert, he had yet to men-

tion the sale of Bright Star's rug, which was, after all, the ostensible reason for the dinner.

Her first glance at the exhibit, however, made her forget everything except her curiosity. Besides being fascinating in their own right, the artifacts and explanatory diagrams were presented far more effectively than most such displays she had seen. Without mentioning it to Don, who was still going on enthusiastically about his ideas for an evaporation-cycle water collector, she began making mental notes of the layout so that she could adapt it to her own needs.

They had wandered halfway through the exhibit when Sara's professional concentration abruptly shattered.

A vague sense of unease had grown in her for several minutes before she became more than faintly aware of it. Don was saying something about the pueblo reconstruction they were standing before, but she hardly heard him. Instead all her senses coalesced on the man staring at her from the other side of the room.

Joseph looked at once completely at ease and somehow removed from his surroundings. Because she was accustomed to seeing him in jeans and a shirt, the tailored jacket he wore over a white turtleneck and fitted gray slacks made him seem almost a stranger. But there was no mistaking the impact of onyx eyes turned on her full force, or the hard set of his mouth as he recognized her companion.

So complete was her absorption in him that it took a moment for Sara to notice the woman at his side. The tall, elegantly-dressed brunette broke off her scrutiny of a wall schematic to listen as Joseph said a few words and gestured toward them. She was smiling faintly as he led her across the room.

"Oh, great," Don muttered when he spotted who was coming toward them. "What's Flatrock doing here?"

"Behave yourself," Sara hissed. "You act like two little boys going at each other in the schoolyard."

Don ignored her. He was giving Joseph a cool nod and turning a high-powered smile on the woman as she was introduced. "Pleasure to meet you, ma'am. May I ask what brings you to Phoenix?"

Dr. Catherine Baker laughed softly. Her amber eyes were dancing as she glanced from one to the other of the unlikely trio. "An excess of New York winter. When it started to sleet again last week, I convinced my editor the time was right for an on-the-scene report of southwestern art." Her smiled deepened as she looked up at Joseph. "I'm imposing on an old friend to show me around."

Sara, who had immediately recognized one of the country's leading art critics, was hardly pleased by this news. The renowned C.N. Baker who wrote brilliant articles on everything from the latest experimental styles to the economics of the gallery business had hitherto been a shadowy figure domiciled in some East Coast office. Her abrupt emergence as an undeniably beautiful, appealing woman knocked Sara off stride. Nor was her composure helped by the easy air between the critic and Joseph. Sara could believe that they were "old friends." She had never seen him looking so relaxed with anyone, including herself.

A tiny spark of hurt darted through her, which she firmly resisted. She couldn't, wouldn't, be jealous of Joseph. There was no basis for the possessive chord reverberating deep within her. She had no more claim on him than he did on her. But some fundamental part of her refused to get the message. A slight frown furled her brow as Don and the critic continued to chat.

"If you want to learn about the state of art around here," he was saying, "you should talk to Sara. She owns a terrific little gallery."

"Not exactly little,"Joseph interposed smoothly, "or at least not for long." Turning to Catherine, he explained, "Sara has just agreed to become my representative. She'll be handling all my work from now on."

Surprise, and interest, registered plainly on the critic's flawless features. "Congratulations. That's quite a coup. You must be thrilled."

Not wishing to appear ungracious, Sara nodded politely. "Thank you, but it hasn't quite sunk in yet."

Joseph's gaze narrowed slightly. "I'm sure it will soon, since we're already planning my first show together."

Don, who had heard the news with unhidden displeasure, demanded stiffly, "When was all this decided?"

"Yesterday . . ." Sara began.

"Last night." Joseph said firmly.

Silence. Catherine, who gave every appearance of becoming more highly amused by the moment, again studied each in turn. Don scowled. His hazel eyes flashed dangerously as he shifted his piercing gaze from Joseph, who merely stared back complacently, to Sara, who reddened painfully even as she told herself that was the worst possible reaction. Her embarrassment looked very much like an admission of some sort.

"I see," Don muttered.

Getting a firm grip on herself, Sara shook her head determinedly. "I don't think you do. We discussed the show over dinner."

"How fortunate that I was busy."

"Wasn't it," Joseph drawled. He looked faintly embarrassed himself, as though not quite sure why he was behaving so boorishly. But that didn't stop him from going on. "I'm delighted you like my cooking," he said, gazing directly at Sara.

"I hope it's improved some," Catherine broke in before Don could respond to this new provocation. Her deliberate effort to ease the tension fell rather flat, at least as far as Sara was concerned, when she added, "I can remember the day you couldn't boil an egg."

"That was when I thought artists shouldn't be bothered with such mundane things," Joseph admitted, his good humor resurfacing at the memory. "It would not be inaccurate to call that my pompous period."

The two women laughed, if a bit warily, but the men only continued to eye each other, mute challenge evident in every inch of their bodies. Sara had a sudden mental picture of two irate stags locking horns. The image struck her as funny. A nervous giggle welled up in her. She tried hard to hold it back, but did not quite succeed. The other three looked at her, startled, as an irrepressible titter escaped.

Catherine rightly judged that the encounter had gone far enough. She took Joseph's arm firmly as she turned to Don and Sara. "I'm sure you're anxious to see the rest of the exhibit. Don't let us keep you."

Sara picked up her cue gratefully. "We had just gotten

started and it is getting late . . ." Her hand slipped into Don's. Still scowling, he glanced down at it blankly for a moment before abruptly nodding. A humorless grin curved his mouth as he tucked Sara's hand into his arm and covered it with his own. Inclining his head mockingly, he murmured, "Nice to meet you, ma'am. Highrock . . . don't count on any more dinner meetings with Sara. I'll be keeping her too busy."

Still smiling, he strolled off before the other man could respond. Only when they were safely out of earshot did he have the grace to murmur, "Sorry about that, honey. Something about that guy just gets my hackles up."

"No kidding? Thanks for telling me. I never would have guessed."

"Now don't get all hot and bothered. Wasn't nothing to that 'cept a little hardballing."

"Don't go all folksy on me," Sara snapped. "Every time you start sounding like a cowboy straight off the range, I know you're up to no good."

Don ignored the reprimand. He grinned down at her unrepentantly. "Honey, you've just got to accept what I told you: When two men want the same woman they go head to head. You might like to believe the decision's up to you, but Highrock and me do have something to say about it."

Sara was willing to grant that much, but not an inch more. "That may be less than you seem to think. I won't be tricked or cajoled into anything."

" 'Course you won't," Don murmured soothingly, steering her toward the exit. "If you were that kind of woman, I wouldn't want you."

"Do you . . . really . . . ?" The question slipped out before she could stop it.

In the dim light of the museum's entrance, Don's eyes were hooded. He stared down at her for a long moment before he said softly, "Don't you know?"

Mutely, she shook her head. The sense of vulnerability that swept over her left her shaken. She told herself she had been working too hard and was merely tired. But she couldn't escape the haunting spector of old inadequacies.

Don smiled gently, his face softening as he reached out a

hand to lightly touch her cheek. "You're beautiful," he said simply. "Inside and out. All the pieces of you fit together exactly right. How could I not want you?"

"You can't be sure," Sara insisted. "We haven't known each other long enough."

Don studied her gravely. Quietly, he said, "I'm sure."

"But you weren't just a few days ago."

His mouth tightened, the hand falling away from her cheek. "Are you going to throw that up to me forever?"

"That isn't what I'm doing at all. I just don't want to make a mistake."

He seemed about to speak, but hesitated, as though remembering where they were. Instead of whatever he'd intended to say, Don murmured, "Let's go home, honey. We'll talk there."

Sara agreed. She wasn't absolutely sure she wanted to pursue such a sensitive topic when she was still feeling the residual effects of seeing Joseph with a beautiful woman who was clearly very close to him. But neither did she want to put it off. The fantasy-come-true of being torn between two highly attractive men was proving more unpleasant than she would ever have guessed possible. One way or another, she wanted it resolved soon.

But Don, despite what he had said about talking, clearly had other things in mind. Parking the car in front of her house, he surprised her by walking round to the trunk and pulling out a compact cooler. Grinning at her puzzlement, he explained, "Did you really think I'd forgotten about your big sale? This is just a little something to celebrate it with."

"A little something" turned out to be a magnum of the very dry, very expensive champagne for which Sara had an acknowledged weakness. As Don got a fire going in the living room, she found two tulip-shaped crystal goblets and an ice bucket. They settled down in front of the adobe fireplace, he in shirt-sleeves and she barefoot after having kicked off her high-heeled shoes.

Expertly twisting out the cork so that only a minimum of bubbles escaped, Don filled both their glasses halfway before proposing a toast. The crystal goblets touched

lightly as he said, "To a very special lady. May she always have everything she wants."

Their eyes met, his carrying the unspoken challenge that all she had to do to assure that the toast came true was to make a choice.

Why was it so hard? Sara wondered a while later as she sat comfortably snuggled against Don, her head on his broad chest and his arm round her shoulders.

They had settled into relaxed silence, not needing words to express their contentment with each other. The champagne was going down very smoothly, Don was making no demands, and for the moment her thoughts, which might have been expected to get a bit fuzzy as he refilled her glass yet again, were instead assuming a startling clarity.

She was getting really hung up on Joseph. Her reaction to Catherine Baker proved that. She had actually hurt inside when she saw him with the other woman. It was the height of foolishness to let anyone affect her like that, especially someone she had to work with. Avoiding such entanglements was one of the most fundamental rules of professionalism. Yet she had only to look at Joseph to forget it.

She sipped some more champagne absently, reflecting that she might well be headed for disaster. He had given her no reason to believe he felt anything for her but what might very well turn out to be a passing physical attraction. And for that she was getting torn up inside?

Joseph, she decided silently, was a dangerous man. She had sensed it from the beginning, but now she was sure. Without even meaning to, he could do her irreparable harm. Whereas Don . . .

Hardly aware that she did so, she nestled closer into his embrace. Don was much more a known quantity. She might have doubts about the exact motivation for his decision to speed up the pace of their relationship, but at least his behavior was fairly predictable. They shared a common base of experience and upbringing, with a compatible set of expectations. She felt far safer with him.

The champagne glass was lifted out of her hand. Don set it carefully along with his own goblet on the tiles sur-

rounding the fireplace. His expression as he turned back to her was resolute, as though he had reached some decision.

"Relax, sweetheart," he murmured as his lips brushed hers gently. "This won't hurt a bit."

Of course not, Sara thought dimly. Don kissed very nicely. He set just the right rhythms, building gradually from the slightest touch to the full penetration of his tongue stroking hers. He tasted of champagne and the thin cigar he had smoked on the way to the museum.

Drawn closer into his arms, she could feel the warmth of his powerful chest through the light cotton shirt he wore. Her nipples hardened reflexively as her breasts brushed against him. The faint aroma of spicy after-shave teased her nostrils, mingling with the musky scent that was intrinsically his own.

As he met no resistance, Don deepened the caress. His hands slid gently down her back, playing over the sensitive line of her spine before coming to rest on the arching curve of her buttocks which he gently cupped. A husky groan broke from him as he eased her down onto the floor.

"Oh, honey, what you do to me . . . !"

Sara barely heard him. She was aware of little except the demands of her own body. The tension that had been building inexorably within her for days cried out for release. Instinctively, she moved against the man who held her so urgently, knowing he could blot out for at least some little time all the doubts that plagued her. She would be able to stop thinking about Joseph . . .

The pleasant haze induced by the champagne and his ardent caresses abruptly splintered. Reality intruded remorselessly. What on earth was she doing? Had she really gotten to the verge of making love with one man simply to forget another?

Self-disgust tore through her. Caught between the clamoring of her senses and the demands of her conscience, she teetered on the edge of panic. The hands that had been so pleasantly occupied in stroking the rippling muscles of his chest began instead to push against him frantically.

Chapter Seven

For a sickening moment, she thought he didn't intend to let her go. Don's weight pressed her remorselessly into the rug. His powerful arms locked her to him. The heat of his body engulfed her. She twisted desperately, only too conscious of the urgency of his desire.

Abruptly, she was free. Don stared down at her, his eyes still glazed with passion. His breath came in harsh pants. "For God's sake! What are you trying to do to me?"

Sara's throat was clenched so tightly that she could hardly speak. Sitting up shakily, she struggled to control the sense of self-revulsion that still threatened to overwhelm her.

"I-I'm not trying to do anything . . . I'd never let something like this happen on purpose. I just . . ."

She broke off, torn between the need to apologize and the urge to strike out at him for what he had deliberately done to her. Neither of them was guiltless in this encounter. She knew she had behaved badly, but she was also fully aware of what Don had hoped to accomplish. Between the champagne and her own vulnerability, he had come very close to preempting the choice only she had the right to make for herself.

He was too honest to pretend otherwise. Running a shaky hand through the thick blond hair her fingers had mussed minutes before, he sighed deeply. "I shouldn't have pushed. I'm sorry."

His apology made hers possible. Smiling hesitantly, she murmured, "So am I. I'd never deliberately hurt you, but I'm afraid I came pretty close to it tonight."

She didn't have to spell it out for him. He might not

want to admit how much seeing Joseph had distressed her, but he recognized the implications of her surrender under such circumstances.

His face was pale as he moved over to the couch, regarding her solemnly. Speaking slowly, choosing his words with care, he said, "Sara, I've already had a relationship with a woman who was uncertain about her feelings for me. That's not an experience I want to go through again. You don't have anything in common with my ex-wife, who was rather shallow and selfish. But this situation is similar in some ways to my marriage. For one reason or another, I think I've been trying to force you into a commitment you're not ready for yet. Maybe we'd both better take a few steps back and decide where we go from here."

Sara nodded, grateful for his understanding. Something was happening to her that was beyond all her previous experience. She was handling it badly. Perhaps Don was right and some time apart would clarify the situation for them both.

But by the next morning, when she stumbled groggily from her bed, Sara had to wonder if she was ever going to understand what she really wanted. She had slept badly, tormented by dreams of both Joseph and Don, and of herself, alone and bereft. It didn't take a genius to figure out that she was afraid both relationships would end up going nowhere, and she would be left to continue her solitary existence of the last few years.

The life-style that had served her well while she was building her career was no longer so attractive. She needed to share herself, and to be part of someone else. But not just anyone would do.

Don had said all the pieces of her fit together exactly right. With his architect's eye, he had discerned what she was only just beginning to appreciate. At twenty-eight, she was a whole, fully-formed person. The rough edges of adolescence were gone. She had grown into herself in a way that many people never managed. Having achieved that, she couldn't be satisfied with a relationship that fulfilled only the most obvious needs for sex and companion-

ship. There was far more to her that she had to share with someone who had just as much to offer.

Hard though it was to admit, solitude was better than forced intimacy with a man to whom she could not give her whole heart and mind.

She kept reminding herself of that as she showered and dressed. Through her bedroom window, she could see the riot of wildflowers erupting in the empty lot next door. The promise of spring only hinted at a few days before was being fulfilled. The usually stark landscape was softened by daisies and peonies sharing space with flowering cacti and yucca plants. Insects and small birds fluttered among them. Not even the nearby drone of traffic signaling the start of the morning rush hour could mar her enjoyment of the sight. Images of her childhood on the ranch when she had spent such days wandering free and unfettered over the countryside rose to haunt her. The memories were piercingly sweet, balancing her between pleasure and longing.

When the phone rang, she was glad of the interruption. But not, as it turned out, for long.

"I'm glad I caught you before you left," Joseph said. "There's no need to come over today. The portrait will have to wait for a while. I've got some other things to take care of."

The thought flashed through Sara's mind that he must be referring to Catherine. She had no idea how long the beautiful art critic would be in town, but it wasn't surprising that Joseph would want to spend every possible moment with her. Besides, he had said himself that the portrait was going badly. Perhaps he intended to drop it altogether.

Unwilling to ask if that was his plan because the answer might very well not be to her liking, Sara managed to keep her voice light. "Fine with me. I can use the time to work on your show."

Joseph was silent for a moment, as though surprised by her casual acceptance. Hesitantly, he said, "If you need to see me about anything . . ."

"No, that won't be necessary. I'll get in touch with you in a few days and we can go over the plans. Okay?"

"I guess . . ."

"Good. So long." She hung up before either of them could say anything more.

Deliberately keeping her mind blank, she finished dressing and went out to the car. The spring day no longer seemed so lovely, but she resolutely refused to feel disappointed at having both men remove themselves from her life as abruptly as they had entered it. Stubbornly, she held on to the idea that she had gotten along fine on her own for quite awhile and could certainly do so again. The time alone could be put to good use. There were dozens of solitary pastimes she had not had the chance to enjoy recently. A long, peaceful evening spent curled up with a book or soaking in a hot bath would help restore her sense of self-sufficiency.

Even as she reminded herself of the full, pleasant life she had built for herself without the help of either man, she knew it no longer held the same appeal. There was a sense of emptiness inside her that had not existed before. Instinctively she understood that any activities she pursued would only be a means to mask that void.

Work, at least, provided some refuge. Opening the gallery, she busied herself with refining the plan for Joseph's show. By concentrating strictly on the particular size and shape of each work of art, she managed to block out thoughts of the man for at least awhile. But by midmorning, the effort was taking a toll. The peal of the door chime gave her a welcome excuse to stop.

Standing up, she took a step forward, only to stop abruptly as she recognized her visitor. Catherine Baker smiled. "I hope I haven't come at a bad time, but I really thought we should chat."

Sara couldn't completely hide her lack of enthusiasm, but she did manage to respond politely. "Please come in. I wasn't doing anything that can't wait."

Catherine accepted that at face value and stepped into the office. Her expression brightened as she took in the diagram lying on the floor. "Is that for Joseph's show?"

Reluctantly, Sara nodded. "I was just trying to get some idea of where each piece should go."

"You're very thorough. Most gallery owners would be

satisfied with a more approximate outline." An astute glimmer touched the critic's light blue eyes. "But then this show must be very important to you. Would you mind telling me how Joseph decided to make you his representative?"

Sara froze. Stiffly, she said, "I'm not sure that's any of your business."

Catherine's eyes flew open, astonishment giving way almost instantly to blatant amusement. Her generous mouth curved in a smile as she said gently, "But that's just the point, it *is* my business." When Sara still looked at her uncomprehendingly, she continued, "I write about art, all aspects of it. And I'd like to interview you for the article I'll be doing on the Southwest."

A dark flush stained Sara's cheeks. Acutely embarrassed, she murmured, "Oh, I see . . . I'm sorry . . . I thought . . ."

"You thought my interest was personal?" Catherine concluded gently. "I can see how you might have been left with that impression yesterday evening. And in a way, it's correct. Joseph is a very old and dear friend." Casting her a perceptive look, she added, "My husband and I both think the world of him."

The relief that surged through Sara was so profound as to leave her shaken. She took a deep, steadying breath before she said, "Perhaps we could start over? I'd be delighted to be interviewed by you."

Catherine grinned, pulling a notebook out of her bag. "I was hoping you'd say that. My readers are sure to be interested in how a young woman not only opened her own gallery but also acquired the acumen to become Joseph Highrock's agent. Do you come from an artistic family?"

Sara laughed softly, feeling infinitely more comfortable with the woman now that her status in Joseph's life was made clear. Sitting down across from her, she shook her head. "My father's creative efforts were limited to breeding cattle and raising me. I never set foot inside an art museum, much less a gallery, until I went away to college. But I had seen a great deal of Native American art done by the Navahos and Hopis who lived near us. So once I realized what I wanted to do, there was no doubt in my mind about the kind of works I should represent."

"I take it you've had experience with other galleries?"

Sara nodded. Briefly she outlined her movements since completing college seven years before. "I liked all my jobs, but I always knew I wanted to work for myself. So when I got the chance, I jumped at it."

"It can't have been easy. There must have been considerable financial risk."

"There was, but that didn't matter. I've seen too many people who spend their lives wishing they could do something else, but never take the chance. They end up embittered and bewildered, disastisfied with everything and everyone. I was determined that wouldn't happen to me. Even if the gallery fails, I'll at least have the satisfaction of knowing I tried."

"I don't think there's much risk of that," Catherine told her frankly. "I know Joseph well enough to understand that he doesn't let personal feelings interfere with his business decisions under any circumstances. If he's convinced you can do well as his representative, then you must have what it takes to succeed."

Sara wanted to believe her, not because she really had any doubts about her professional ability, but because she needed to feel that Joseph saw her as more than simply a woman he found physically attractive. Hesitantly, she said, "You and your husband have known him for a long time . . . ?"

"About fifteen years," Catherine confirmed. "We first met when Joseph came to New York to study there. Charlie was still in medical school and I was roughing it out with a tiny newspaper down in Soho." She smiled nostalgically. "They were tough times in the sense that we were living in one of the most expensive places in the world and there was never enough money. But they were great times, too. None of us lacked for confidence. We all had very clear ideas about what we were going to achieve, and oddly enough we were all quite right. Although I have to admit none of us accepted the same degree of challenge as Joseph. He's in a class by himself."

Sensing a willing source of information about the man who so fascinated her, Sara admitted softly, "I wish I had

known him then. Maybe I'd be able to understand him better."

Catherine looked at her sympathetically. "He hasn't changed much except on the outside. He dresses better, lives more comfortably. But the man himself is the same. He's always had his priorities straight and understood what he wanted." Candidly, she added, "If there had been any doubts in his mind, he would never have made it this far. We can't really begin to understand the brutal poverty and prejudice he had to overcome to get where he is."

Sadly, Sara acknowledged that what Catherine said was true. No one who had not lived through a similar experience could really understand what Joseph had endured and triumphed over. Try though she might, that part of him would remain locked away from her forever. And without it, could she really hope for a lasting relationship between them?

That thought stayed with her long after the interview was finished and Catherine had gone. It remained to dampen what would normally have been her elation at being noticed by such an important critic. Just when her career was taking off, her personal life was too confused to be able to enjoy it.

Sighing, she made a halfhearted effort to distract herself with the mail. Amid the bills, catalogues, and professional notices, the letter from Bright Star stood out like an unexpected gift. Sara opened it swiftly, scanning the small, neat handwriting that was so much like the woman herself.

Bright Star spoke to her from the pages. She was delighted by the sale of her two rugs and amazed by the sum each had brought, particularly the large work purchased by the rancher. Since seeing Sara, she had completed several more pieces and was eager to have Sara's opinion of them. She would also like to discuss plans for the weaving display, although she regretted she would not be able to take part in it directly. Bright Star hoped that she understood her reluctance to leave home, and that she would be willing to come out again to visit with her so that they might talk about both the new pieces and the exhibit.

Reading the last part over, Sara glimpsed a way out of

her present emotional dilemma. There was really no reason why she couldn't close the gallery for a few days, as she had on other occasions when she needed to visit artists living outside the city. The time she had spent with Bright Star several months before stood out in her mind as a particularly happy interlude. Even if she had not been at loose ends, she would have found the thought of a return visit very tempting.

It took little more to make her decide. By lunchtime she had made up her mind. Without giving herself a chance to reconsider, she put a call through to the trading post closest to Bright Star's home, asking that a message be taken to the artist to warn of her arrival. Several other calls to her most regular customers assured Sara that they would not be inconvenienced by her absence. A sign tacked to the inside of the door took care of anyone who might happen to wander by. Notes to the artists who currently had artwork on display at the gallery explained her absence and said she would be back shortly. Finally, she gathered up the information she needed to take to Bright Star, made certain the security systems were switched on, and went over to see Carrie.

"Sure I'll hold on to the keys," her friend said when Sara explained where she was going. "Don't worry about a thing."

"Thanks, I appreciate it. I should be back by the end of the week."

Carrie nodded, looking at her more closely. "Fine . . . uh, there isn't anything wrong, is there?"

"Of course not," Sara assured her, a bit too quickly. "Why would you think that?"

"You just seem sort of . . . anxious . . . Did something happen last night?"

A wry grin softened the steadfast line of Sara's mouth. "Let's just say I think it's a good idea to get out of town for a while, and Bright Star is providing me with the perfect excuse."

Carrie forced herself to be satisfied with that. Good manners wouldn't let her pry any further, but she was still frowning as Sara said good-bye and hurried out to her car.

A quick stop at home was time enough to fill a small

suitcase with jeans and tops. Mindful that the desert nights were still cold, she remembered to pack a warm sweater and several thick pairs of socks. Changing into slacks and a pullover, she dug in the back of her closet for the pair of boots that had served her well for several years. They were a bit scuffy, but too comfortable to disown.

With her hair quickly plaited in two thick braids and the modest amount of makeup she had put on that morning washed away, she looked country fresh and ready for anything. Grinning at herself in the mirror, Sara tossed a sheepskin jacket over her shoulders and gave the apartment a final check before she was on her way.

Traveling straight north out of the city, she reached Flagstaff by late afternoon. From there it was only a few more miles to the border of the vast Navaho reservation that spread over some twenty-five thousand square miles of the Shonto plateau.

Though she had visited the area many times before, Sara was still struck by the immense contrast between the nearby urban centers and the stark, relentless expanse of seemingly unoccupied land. Occasionally she passed scattered trading posts perched beside the main road to attract the tourists who were just beginning to arrive with the warmer weather. The stores offering blankets, pottery, jewelry, and baskets were, with the sprinkling of sheep watched over by solitary shepherds, the only signs of human habitation.

It was getting on toward evening when Sara began to doubt the wisdom of trying to make the trip without stopping. She had forgotten how arduous the journey could be. Her shoulders ached and her head throbbed dully. She was tired and hungry, and despite the heater in the car she was getting cold. Dismally, she noted the clouds gathering over the nearby mesas. Spring weather was notoriously treacherous. The day that had begun so brightly began to turn ominous.

She was still miles from the turnoff to Bright Star's hogan when the wind picked up in earnest. It battered the car relentlessly, hurling waves of dust that obscured her vision. She slowed to a crawl, struggling just to stay on the road, but found herself making less and less progress with

each passing moment. Finally, in desperation, she pulled off to the side and settled down to wait out what she hoped would be only a brief storm.

It wasn't. An hour passed, then another. To conserve the gas, Sara was forced to turn off the engine and with it the heat. She got her suitcase out of the back seat, grateful that she hadn't put it in the trunk, and pulled an extra sweater on. With her jacket, it was enough to keep the top part of her comfortable. But her legs were clad only in thin wool slacks and her head and hands were bare. Shivering, she wrapped her arms around herself and lay down, hoping to conserve body heat by lying still.

For a time, her strategy worked. But as dusk gave way to night and the storm continued to rage, she began losing the battle to keep warm. Howling winds slammed against the car, rattling it fiercely. The air was too dry for snow, but between the subfreezing temperatures and the relentless churning of dust clouds that made it impossible to see even a foot ahead, she might as well have been trapped in a blizzard. She could not leave the car without being cut and slashed by the whirling bits of sand and gravel. But neither could she just remain as she was, with her body losing precious heat with each passing moment.

Refusing to give into the fear that gripped her, Sara sat up. Determinedly, she moved her arms and legs over and over to keep the circulation going. The exertion, slight though it was, left her panting. Her body, locked in a mortal struggle to keep warm, was nearing exhaustion. Slowly, inexorably, weariness crept over her.

She fought it tenaciously. Keeping up a steady stream of conversation with herself, she forced her stiffening limbs to move. Repeatedly, she remembered that the worse thing she could possibly do in such a situation was to fall asleep. But even as she said that over and over, her eyelids were drooping and her words were becoming slurred.

Twice Sara's head fell back against the seat. Twice she jerked upright. The third time she tried but failed to stave off sleep's deadly blanket. A black mist of unconsciousness drew her down, far from everything but the implacable cold that reached into her very bones and the remorseless wail of the wind.

Chapter Eight

SHE WOKE to warmth and the sensation of something tickling her nose. Reaching a hand out gingerly, Sara attempted to brush whatever it was away, only to stop abruptly when she felt soft, thick wool beneath her fingers. Opening her eyes hesitantly, she stared down at the blanket covering her body. It was Navaho and so beautifully woven that it could be one of Bright Star's own.

Joyful at the thought that she must have been rescued and brought to her intended destination, she tried to sit up. The effort proved too much for her. Every muscle she possessed protested vehemently. With a low groan, she fell back against the pillows, but not before she caught a glimpse of the man standing at the other side of the hogan.

The sound she made brought an instant reaction from him. He crossed the small, compact space in quick strides and knelt down beside her bed. A strong hand grasped hers, feeling for the pulse that was still weak.

"Sara . . . can you hear me?"

Her eyes flew open again, fastening on the source of that voice. Disbelief surged through her as she stared up at her grim-faced rescuer, who at that moment looked for all the world as though he wasn't sure he shouldn't have left her to the storm.

"J-Joseph . . . ?"

He dropped her hand instantly and stood up, moving away from the bed. In the shadows cast by the kerosene lamp, his features looked even more harshly carved than usual. His taut skin, stretched over strong bones, glowed with a coppery sheen. A pulse beat in the square line of his jaw, above the flannel shirt tucked into buckskin pants.

The cold glint of his onyx eyes made her throat tighten painfully.

"Do you have any idea," he demanded harshly, "how close you came to dying out there?"

In her vast relief at being alive, the thought that he was berating her for getting caught in the storm struck her as funny. Smiling faintly, she murmured, "I gather I'm not as tough as I thought I was."

The hard line of his mouth tightened further. He took a step closer to the bed, his fists clenched at his sides. *"Tough?* You didn't stand a chance. If I hadn't come along when I did . . ."

"Thank you," she interrupted softly. "It's not much to say, but I don't really know how to express my appreciation for your saving me. I know if you hadn't . . ."

"I don't want your thanks!" Joseph growled, glaring down at her. "How do you think I felt when I found you there unconscious and . . ."

"How did you find me?" Sara broke in, anxious to stem what gave every evidence of developing into a full-fledged tirade about her reckless disregard for her own safety. She was fully aware of the foolishness of her actions and didn't need to be reminded of it by anyone, much less the indomitable man before her.

Grudgingly, he relented enough to answer her. "Your friend Carrie told me. When I found the gallery shut, I went round to the closest stores asking if anyone knew where you'd gone. She told me about the letter from Bright Star and your intention to visit her. We both thought you'd be smart enough to stay overnight in Flagstaff, but I had a suspicion we were giving you too much credit for common sense. So I thought I'd better check for myself."

Wearily, Sara shook her head. She was having trouble concentrating on anything but the fact that she was still alive and that Joseph was with her. "I don't understand. Why did you go to the gallery?"

He hesitated, some of the anger leaving him. "I . . . was worried about you. When we talked this morning. . . you sounded distressed. I wanted to make sure you were all right."

His sensitivity to her feelings and his concern for her

stunned Sara. She hardly dared to credit what she was hearing. Had Joseph really gone looking for her, followed her all this way and somehow found her despite the vast spaces all around them and the rampaging storm?

"The wind . . ." she whispered faintly, "how did you get through it . . . ?"

He lowered himself beside the bed, perhaps to answer her, but she was asleep again before he could do more than brush a gentle finger across her cheek.

Deep in the night, Sara stirred restlessly. She came awake slowly, uncertain of where she was or what had happened to her. Only gradually did she become aware of the unaccustomed sense of security and comfort engulfing her. She was wrapped in warmth and strength, cocooned in velvet hardness. A soft gasp escaped her as she realized it was Joseph's arms that held her and his long firm body that was pressed against her own.

Moving cautiously, she managed to shift just enough to be able to look at him. His broad chest rose and fell rhythmically. In sleep, the hard lines of his face were softened. Thick, dark lashes lay against his cheeks. His lips were slightly parted, giving him a defenseless look. Sara had to resist the temptation to touch them with her own. She was profoundly shaken by the effect of his nearness. Yet she made no effort to put any distance between them.

The residual impact of her brush with death had dulled all but her most basic instincts. Without allowing herself to question the wisdom of her actions, she nestled closer to him. His arms instinctively tightened. Sara glanced up anxiously, afraid that he might have wakened. But Joseph's eyes were still closed and his breathing was still slow and even. Relieved, she gave up the effort to stay awake and allowed the comfort of his presence to follow her into her dreams.

She was in her bed at the ranch, reluctant to get up but tempted by the smell of fresh coffee and corn cakes heated over a wood fire. Turning over, she reached out a hand, only to find the other side of the bed empty and cool.

Memory surged through her, bringing her fully awake even as it stained her cheeks bright red. Sitting up, she

glanced around cautiously. There was no sign of Joseph, but if the aromas she smelled coming from just outside the hogan were anything to go by, he couldn't be far away.

The domed structure, made of forked branches and logs covered with brush, was small and might, to some eyes, look bare. But Sara appreciated the utilitarian beauty of each object within it. Several exquisite rugs lay over the dirt floor. More of them covered the low bed on which she lay. A hand-carved table stood against one wall. Choice pieces of pottery were set out on it. A leather and wood chest must have held extra clothes, for there was no sign of them elsewhere. Pegs were secured to the interior poles to hold various implements, including a bow and a sheaf of arrows. There was nothing picturesque about the weapons. They looked very much in keeping with the natural order of the hogan and its environment.

Pushing back the covers, she stood up carefully. Joseph had removed her boots and the sheepskin jacket, but nothing else. Her clothes were a bit wrinkled but still presentable. She felt stiff and sore, but refused to let that bother her. The mere fact that she was alive made everything else irrelevant.

The door of the hogan faced east, toward the rising sun. Sara had to duck slightly under the crossbeam. Straightening, she stared out over the endless sweep of prairie fading imperceptibly into sky.

The storm of the night before might never have occurred. Spring had returned in full glory. The tiny glimpse of nature's rebirth she had seen in Phoenix was now infinitely repeated and expanded. She breathed in deeply, savoring the scents of the earth stirring after its long sleep. The perfume of golden paloverde trees just coming into bloom touched her gently.

Far off across the plain she caught a glimpse of sheep moving leisurely among the rocks and crevasses, their newborn lambs gamboling among them. Closer in, she heard the soft, contented song of the white-winged dove nesting among the scattering of saguaros that bordered the piñon grove where Joseph's hogan stood.

Pure, vital joy rippled through her. The mundane cares of everyday existence that seemed so important in the city

fell away. She felt at once serene and exuberant. Only sharing it with someone could make the experience richer.

She got the chance quickly. Something distracted her; a sound perhaps, or simply the sensation of being watched. She looked across the nearby paddock to find Joseph staring at her. The breath caught in her throat as she returned his gaze. He was wearing only the buckskins she remembered dimly from the night before. The broad expanse of his chest was left bare to the sun. Powerful muscles rippled in his arms and along the taut line of his waist, tapering down to narrow hips. The dark pelt of his hair was brushed back from his strong-boned face and secured by a headband. Framed by the cobalt sky, he was the epitome of male grace and beauty.

As agile as a supremely fit animal, he moved toward her. His voice was low and husky. "Feeling better?"

Sara nodded. She had to remember to breathe before trying to speak. "Yes, thank you. I'm fine now."

Joseph looked skeptical. He saw the shadows beneath her blue-green eyes and felt a faint air of fragility clinging to her. "Let's wait awhile before deciding that. There may be some aftereffects you aren't expecting. In the meantime, how about breakfast?"

Sara's stomach growled obligingly. "Is there somewhere I can wash up?"

The teasing gleam that lightened his eyes made her heart hammer painfully. "There is, though I'll bet it's not quite what you're used to."

A moment later Sara saw what he meant. Following his directions, she found the outhouse a short distance behind the hogan. After washing her hands and face in a wooden trough, she undid the plaits holding her auburn hair and combed the tangles from it as best she could with her fingers before letting it fall unhindered to her shoulders. Her body felt grimy and she wondered if there might be a spring nearby where she could have a full bath, or if she would have to wait until she got to Bright Star's.

The thought of the old woman who must by this time be very worried about her sent Sara hurrying back to the hogan. Joseph was out in front, pouring coffee into mugs.

He took in her flushed face and frowned. "Is something wrong?"

"Bright Star was expecting me to arrive yesterday. I have to get word to her."

The frown changed to a slight smile. Handing her one of the cups, he said gently, "I rode over to see her this morning and explained where you were. She was relieved that you are safe, and won't expect to see you until you've had time to rest up from what happened."

"Oh . . ." Sara sat down slowly on a low, flat rock set before the wood fire. She had mixed feelings about this revelation. Bright Star clearly presumed she would be staying with Joseph, at least for a while. How exactly she got that impression wasn't clear, nor was Sara at all convinced that she shared the older woman's presumption about her being safe. Joseph made her feel many things, but safe wasn't one of them.

She knew she should immediately correct any idea he had about her remaining in his hogan, but somehow the words wouldn't come. To distract herself, she searched for some innocuous topic. "Those horses in the paddock, are they yours?"

Joseph nodded. He studied her quietly as he ladled corn cakes, scrambled eggs, and slabs of pan-fried ham onto two of the pottery plates she had seen inside the hogan. "I keep them stabled at a trading post near here. I left my car there yesterday when I realized how bad the storm was getting and took the palomino stallion out to look for you. The mare was brought over this morning." He hesitated a moment before explaining, "I thought you might want to ride when you're feeling better and Bright Star doesn't have any horses."

"That's the one thing I missed the last time I visited her," Sara agreed eagerly. "The only way to really see this country is on horseback."

Joseph was clearly pleased by her response, but that didn't prevent him from cautioning her firmly, "Don't get any ideas about riding today. You're going to take it very slowly until I'm convinced you've really recovered."

"You make me sound as though I'm made of glass," Sara protested. "I told you I feel fine."

He didn't bother to answer. They finished breakfast in silence. Food had rarely tasted so good to Sara. Joseph chuckled softly as she polished off a third corn cake, but she merely wrinkled her nose at him and went on eating. Not until every scrap of food was gone did she at last lean back, full and content.

"Mmm, that was good. Where did you learn to cook like that?"

"I picked up a bit when I lived here as a kid, but I didn't really have to fend for myself until I went to New York. With so little money, it was learn or starve."

His culinary ability reminded her inadvertently of Catherine. Slowly, she said, "Dr. Baker came to see me yesterday."

Joseph stopped in the middle of racking over the fire. "To interview you?"

"Yes . . . we had rather a long chat."

That didn't seem to surprise him. "I'm glad she's including you in the article. It should be good for business."

Sara wasn't thinking about that. Instead, she said, "To be honest about it, I was surprised to find out she's married. I'd gotten a completely wrong idea about your relationship."

Joseph looked genuinely surprised. He dropped what he was doing and gave her his full attention. "You thought Catherine and I were lovers?"

"The possibility occurred to me," Sara admitted wryly.

"Because she was staying at my place?"

"That, and because you said the portrait had to wait because you had other things to take care of."

Joseph was silent for a moment, mulling over what she had just told him. Finally, he said, "I'm sorry if it sounded as though I'd lost interest. It wasn't meant that way at all. It's just that . . . I was having a hard time with the painting and I thought if I left it alone for a while it might start to work out. That happens sometimes. But I never intended to give you the impression I was just letting it drop."

It was impossible not to believe him, or to deny the relief that surged through her. Softly, she said, "Whenever you want to take it up again, just tell me."

Joseph nodded, grateful for her understanding. They lingered a few minutes beside the glowing embers of the fire, both reluctant to break the sense of communion growing between them. Not until the stallion nickered impatiently were they recalled to their surroundings.

Joseph rose, holding out a hand to her. His skin was warm against hers; his touch, undemanding, but with an undercurrent of strength that nourished her own. Standing so close beside him, she was vividly aware of his size and power, but also of the intrinsic gentleness that was a vital part of his masculinity.

Always before she had thought of the man and the artist as two beings who happened to occupy the same body. But now, seeing him in this place where he cast off the burdens of so-called civilization and became truly himself, she realized that everything he strove to achieve stemmed from the same source. Remembering the pure, unaffected beauty of the hogan and looking around at the harmonious blending of his home and nature, she realized that he approached his life just as he did his work. Everything bore the same stamp of respect for his own high standards and concern for others.

A lambent flame sparked deep within the turquoise pools of her eyes. Perhaps Bright Star was right . . .

When Joseph drew her a fraction closer, she did not resist. He hesitated, giving her ample opportunity to withdraw. Only when he was certain that she did not wish to did his head slowly bend toward her.

"Sara . . ."

A low sigh escaped her. She rose slightly to close the last distance between them.

Chapter Nine

THE SUN beat down on her, into her, through her, dissolving the barriers of skin and bone, filling her in spaces she had never realized were empty. Shafts of golden light pierced her, linking her to both heaven and earth. Time fell away down the shadowed canyons. The pulse surging to life within her echoed the song of rushing rivers and pounding hooves; the blood racing through her followed the course of the endless wind. She was at once losing herself and being affirmed in a way she had never known was possible.

There was no sense of strangeness in the touch of the man who held her, even though they had never touched like this before. What had been for either of them no longer had any meaning. All that mattered was what they were finding in each other as the disparate pieces of their separate minds and spirits flowed smoothly, inevitably together.

She was Joseph and he was Sara, and that was as fundamental a facet of the natural order as the stone and sky and soil surrounding them. When they at last moved reluctantly apart, there was no sense of loss. What was born in an instant out of time remained imperishable. There was only the knowledge that what flowed between them was stronger than mere human frailty, and that they must go carefully.

Joseph ran a trembling hand through his hair, looking as stunned as Sara felt. "I . . . I'd better see to the horses," he murmured shakily.

She let him move away without protest, feeling no impulse to stop him. The same need to be alone filled her,

even as she recognized that to a large degree it was impossible. Part of her went with him just as she carried the resonance of his touch within her.

Inside the hogan, she found the suitcase she had packed so swiftly the day before in another life. The air was turning warm. The morning already promised more of summer than of spring. Selecting a pair of white shorts and a violet T-shirt, she changed hurriedly.

Joseph was still busy in the paddock as she slipped out of the hogan. She hesitated a moment, wondering if she should tell him where she was going, then decided against it. She had no intention of wandering very far. If he called out to her, she would hear him.

The piñon grove which sheltered the hogan was nestled against the sheer wall of a cliff. Skirting it, Sara found herself in gently rising ground. She followed a path blazed by foraging sheep for some little distance, until the sound of water drew her toward a small, secluded pool hidden in a rock crevice.

Surrounded by high boulders, the sun-dappled oasis proved an irresistible temptation. Glancing swiftly over her shoulder to make sure she was alone, Sara slid down the slope. She tossed off her shoes and eased a toe into the tantalizing coolness. A sigh of pure pleasure escaped her. Any lingering doubt vanished as her skin prickled uncomfortably in the heat.

Stripping off her shorts and top, she hesitated for a moment before also removing her bra and bikini panties. Without a towel, it was going to be bad enough getting dressed again. She didn't want to add to the discomfort by putting her clothes back on over wet lingerie.

The pool received her gently. Pushing off from the rock edge, Sara floated leisurely. Her hands and feet barely moved as she paddled slowly from one end to the other, staring up at the azure canopy of sky. Her body glowed like alabaster beneath the clear water. Her hair fanned out around her, floating tendrils brushing her shoulder. An osprey flitted past before settling in a nearby saguaro, from which it peered at her benignly.

Rediscovering an almost forgotten game from her childhood, she amused herself by seeing how many colors she

could count in the striated cliff face. Vermilion alternated with terra-cotta and sienna, highlighted by an occasional strip of cornmeal gold. In tiny cracks where moisture gathered, sturdy shrubs and cacti added a muted touch of green. Nature had painted the high desert with a lavish hand. It was no wonder that generations of artists had found inspiration there. In the mesas and buttes, the canyons and ravines, she saw Joseph's palette.

The thought of him shattered her reverie. She straightened in the water, her feet just brushing the rocky bottom. An almost imperceptible sound from the nearby boulders made her instantly alert.

He stood tall and strong as the royal oaks that grew high on the mountain range, the long length of his burnished form held tautly. The buckskins he had worn earlier were gone, replaced by a loincloth that left almost all of him free to feel the sun and air. Even from the distance of several yards, Sara could see the ripple of his powerful muscles and the glitter of his onyx eyes as he watched her quietly.

She made no move to hide herself, nor did she protest his intrusion. Instead she waited, until her very silence signaled her acceptance.

The loincloth dropped to the ground. She had a glimpse of untrammeled maleness as resplendent as nature had intended it before he stepped gracefully into the water. A few quick strokes were enough to bring him to her side.

His hands brushed her shoulders gently, drawing her to him. Their legs entwined, velvet steel touching pliant softness. A gasp escaped her as her breasts made contact with his chest. The sensation was electrifying. Her nipples hardened instantly. Diamond droplets of water gleamed off his massive shoulders. Her fingers dug into them helplessly as Joseph took her mouth with his.

His lips were warmly firm. They moved slowly, savoring her lingeringly. His restraint was all the provocation Sara needed to tip her over the edge. Any hesitation she might have felt was banished. Refusing to wait for him to deepen the kiss, she parted his lips with her own. The low groan that rippled deep within him was her reward. Their tongues met in a rapturous duel that could have but a single end.

Only the buoyancy of the water enabled her to stand upright as his big hands cupped her breasts, the thumbs rubbing over her straining nipples. His touch was gentle, as an artist's would be. But the hands that worked regularly with stone were calloused. Their tender roughness overwhelmed Sara. She was inflamed with the need to learn his body as he was learning hers.

Soft, slender fingers slipped down his back, luxuriating in the discovery of each bulging muscle and corded sinew. There was nothing the least bit flaccid about him. Every inch of his body was magnificently conditioned. From the wide sweep of his shoulders down his sculpted back to the flat planes of his buttocks and beyond as far as her touch could reach, the masculine feel of his body drew her irresistibly closer to him. Never had Sara felt more certain of herself as a woman, or more driven to reaffirm her femininity in the most elemental way possible.

The sight of his dark head bent against her breast wrung another moan from her. Joseph's warm, wet tongue licked all the way around the arching fullness before at last flicking across the swollen nipple that burned for his touch. When he drew her into his mouth, suckling her gently, she moved against him desperately. Beneath the water, her thighs parted as the flat softness of her belly brushed his hardness.

Joseph raised his head, his eyes clouded by passion but still unmistakably tender. "Sara . . ." he groaned huskily, "tell me your spirit wants this as much as your body."

His plea touched her deeply. Instinctively she understood that if Joseph sensed any doubt in her he would not continue no matter how intense his own arousal. Their joining had to be complete and without the slightest uncertainty.

A smile as timeless as the very rhythms of life curved her mouth. "Come to me," she murmured, her lips brushing the square line of his jaw before slipping down his throat. "Please, Joseph, don't wait any longer . . ."

It was all the reassurance he needed. Powerful arms curved around her upper thighs, lifting her to him. His mouth closed again over her breasts as he carried her from the water.

The sand beneath her back was smooth and warm. The air against her skin felt like cool silk. The man who towered above her, huge and dark against the sun, was all she wanted in the world. Raising her arms, she reached out to him.

Joseph dropped to his knees beside her. His hands skimmed over her shoulders, down the ripe curve of her breasts and across the delicate line of her ribs. Grasping her waist, he lowered himself until they were touching all along the length of their bodies.

"So beautiful . . ." he murmured before his mouth and hands subjected her to a tender assault so skillfully passionate as to shatter her last thin grip on reason.

Before the fast-gathering mist of pleasure reached the furthest corners of her mind, Sara somehow understood that Joseph brought to lovemaking the same extraordinary creativity that was exemplified by his art. Only now her body was the medium through which his unleashed power flowed. Beneath his hands and mouth she became a wild thing, lost to even the remnants of self-control. He seemed determined to drive them both to the very brink of sanity and beyond into a level of ecstasy she had never before so much as glimpsed, let alone experienced.

Her body unfolded to receive him like the petals of a flower reaching for the sun. The hard thrust of his manhood drove the spiraling pressure higher and higher within her. Her eyes, glowing with aqua fires, opened wide. Their gazes locked and held through the endless moments of shattering pleasure that undulated through them both. Joseph's arms tightened convulsively around her as she moaned her pleasure into his mouth. Her cry was answered an instant later by his own as his huge body throbbed in rapturous release.

They returned to earth reluctantly. After long, tender moments, Joseph rolled over on his back, nestling Sara against him to protect her from the ground that in the aftermath of explosive passion was suddenly less than comfortable. His big hands brushed her hair back from her face as he smiled at her tenderly.

"You are exquisite. Beyond anything I could have imagined."

Astounded to discover she could still blush, Sara murmured huskily, "You aren't so bad yourself. I'd get up, but I don't trust my legs to hold me."

Joseph chuckled. He glanced around at their secluded refuge. "I wouldn't mind staying here all day, but I think we should get back." His eyes darkened with concern as they settled on her languorous features. "You still need to rest. The effects of that storm can't be underestimated."

About to point out that the previous night's storm was nothing compared to what they had just shared, Sara was forestalled when he rose lithely and gathered her into his arms. He carried her over the rocky slope toward the hogan, easily, as though she were a child.

"Our clothes," she protested breathlessly.

"We can get them later. Right now, I want to get you inside."

Sara abandoned any thought of arguing. The fluid strength of his body against hers eclipsed everything else. With a soft sigh, she snuggled into his chest, feeling infinitely cared for and secure.

That sensation continued as Joseph laid her on the bed and pulled a light blanket over her. Her throat tightened as she took in his tender gaze and the gentle smile playing across his bronzed features. Lean, hard fingers smoothed her hair as he murmured, "Go to sleep, little one. I want your strength to return quickly."

Reluctant to be parted from him even by dreams, she tried vainly to deny her own weariness. But the strain of the last few days followed by the utter release he had given her made sleep irresistible. The thick lashes shielding her turquoise eyes fluttered once . . . twice . . . and were still.

She woke long, restorative hours later to find the hogan empty and the slanting rays of the sun filtering through the doorway. Rising, she wrapped the blanket around her nakedness and went to the entrance to peer out. A pot of some delicious-smelling stew bubbled over the cooking fire. Joseph sat nearby, turning a skewer heavy with succulent bits of wild rabbit. He glanced up, catching sight of her, and rose immediately.

His voice was low and husky as he murmured, "Did you sleep well?"

Sara nodded, unable to tear her eyes from his. He was wearing the buckskin trousers again, with a soft, fawn colored shirt. In her mind, she could see the magnificent body beneath them and yearned to touch him. Instead, she looked away.

"I'd better get dressed . . ."

He nodded, as though understanding and accepting her unease. Matter-of-factly, he said, "I brought your shorts and top back, but they really aren't warm enough for evening. You should put something else on."

He lingered a moment longer, his eyes drifting over the flushed delicacy of her face down her throat to the swell of her breasts just visible above the blanket. Then he turned abruptly and went back outside.

Sara breathed a low sigh of relief. His presence so mesmerized her that she could barely move or think. Not until he was gone did she scramble into warm slacks and a sweater. There was no mirror in the hogan, but she did find a small one in her purse. It showed only a sliver of her face, enough to reveal luminescent eyes and a slightly pouting mouth, ripe with remembered pleasure. Smiling faintly, she brushed her hair to a glistening sheen before pushing her suitcase under the bed and hurrying out to join Joseph.

He was ladling stew into bowls as she came over to the fire. Though he seemed to barely glance at her, she knew he took in every aspect of her appearance. They were seated close to each other before he said, "That's better. You should be warm enough until the sun's been down awhile."

"Do you think it will storm again tonight?" Sara asked, concentrating on her food. His nearness was sending little tendrils of excitement ricocheting through her. Her appetite was nonexistent, but she forced herself to eat to keep her strength up. With any luck, she would be glad of it later when they were back in the hogan.

That thought helped her to relax. Joseph sensed the easing of tension within her and responded in kind. They

shared a quiet, congenial meal as the sun sank behind the mesa and the sky turned purple with the coming night.

As the first stars flickered against the darkness, Sara stirred restlessly. There was something she needed to say to Joseph but she was unsure how it would be received. After long moments of hesitation, she murmured, "I want you to know I wasn't involved with Don the way you may have thought. If I had been, nothing would have happened this afternoon."

Joseph met her anxious gaze calmly. "I know."

"H-how . . . ?"

He touched her hand lightly, a tender smile quirking his mouth. "Because it was obvious you hadn't been with a man in some time."

Sara blushed, presuming he was referring to her unbridled response. His smile deepened as he read her thoughts. "Don't misunderstand me. I take full credit for your passion, which, incidentally, I thoroughly enjoyed. But I have learned to know you well enough to understand that you couldn't have given yourself so freely if there had been even the remotest thought of another man in your mind."

Uncertain of how she felt about being so intimately understood by anyone, even the man with whom she had experienced such joy, Sara looked away. She stared out over the shadowed plain, trying to come to terms with her contrary emotions. After so many years of being alone and independent, she yearned for true communion with a man she could reveal herself to unrestrainedly, and who would unabashedly reveal as much to her. But the immensity of such a commitment frightened her. She and Joseph were so far apart in life experience, how could they hope to share any but the most fleeting encounter? And yet . . . if they were really so different, how could their very souls have joined in such shattering union only a few short hours before?

His hand on her arm recalled her abruptly to her surroundings. Joseph was watching her quietly. As she met his eyes, he murmured, "It's getting cold. Let's go in."

They cleaned up the dishes and put out the fire in silence. By the time they were done, the air was definitely

chilly. Sara shivered slightly. She was glad of the hogan's warmth, but surprised that Joseph did not join her there right away. She paced restlessly, wondering what was keeping him. Surely, he didn't mean for her to sleep alone?

That intolerable thought at last drove her outside. She glanced around in bewilderment. He was nowhere to be seen. Not until she spied a faint light coming from a smaller shelter near the hogan did she realize where he was and what he was doing.

Joseph's clothes were laid neatly over the branches of the piñon tree closest to the sweat lodge. Sara barely hesitated before adding her own to the pile. The night air was biting against her bare skin, but she hardly noticed it. Pulling aside the flap covering the entrance, she ducked inside.

Waves of moist heat engulfed her. The lodge was small and bare except for the fire pit covered by glowing stones and a single wooden bench. Joseph sat there, his long, hard body stretched out toward the source of the almost suffocating warmth. A sheen of perspiration shone against his coppery skin. He looked up as she entered, but said nothing. Instead, he merely held out a hand to draw her down beside him on the bench.

Dazed by the heat and the sheer impact of his nudity, Sara obeyed. She leaned back, resting her head against the lodge wall. The ceiling was barely inches above it, but she felt no sense of confinement. Instead there was only the growing languor of her body as it opened to the sultry vapor rising from the pit.

Glancing down, her eyes fell on the bare expanse of her thigh glowing palely against Joseph's far darker skin. A shiver of disquiet darted through her as she thought again of all that lay between them. Determined to let nothing spoil the pleasure of being with him, Sara shifted slightly, just enough to bring their legs together.

She saw as well as felt the tremor that ran through Joseph. They both watched as his penis grew hard and urgent. Despite the intense heat, his need was unmistakable, as was her own. Her nipples were taut peaks beckoning his touch. The secret recesses of her womanhood

were warmly moist. A low moan gathered in her throat, emerging as a small, yearning sigh.

Without words, they slid down onto the floor. The smothering heat of the lodge made it impossible to draw out their passion. Joseph hesitated only an instant, his long, lean fingers reaching inside her to make sure she could receive him, before he plunged into the haven she so ardently offered.

The fulfillment they found together this time was at least as complete as what they had experienced by the rock pool. Sara cried out helplessly, swamped by waves of ecstasy so intense she thought she could not possibly endure them. Yet despite the absoluteness of her release, she was vividly aware that Joseph was with her through every moment. They blended together in perfect harmony, responding as one to the spiraling crescendo of pleasure that exploded with a force that shattered their very senses.

Sara was barely conscious when he at last carried her from the lodge. She hardly felt the cold night air on her skin, or knew that he tenderly wrapped his shirt around her to shield her until they were once more inside the hogan. Only when he laid her on the bed and joined her there did she recover sufficiently to try to make some sense of her tumultuous emotions.

"I don't understand . . ." she murmured. "Has this always been inside me without my knowing . . . ?"

Joseph settled down beside her, gathering her close against him before covering them both with a soft wool blanket that smelled of sage brush and pine. His breath was warm against her ear as he murmured, "Perhaps, for I, too, have discovered something in myself I never suspected. You touch a place in me I didn't even know existed."

His admission warmed Sara more than any fire could begin to do. She nestled against him as naturally as though she had done so every night of her life. Only in the last moment before sleep claimed her did she wonder at the wisdom of giving herself so totally to a man with whom she was not yet convinced she could share anything lasting.

Chapter Ten

"THE ROOT of the sorrel plant," Bright Star explained, "can be used all year round to make yellow dye in various shades. If fresh, it is simply pounded and boiled. But when it is dry, like this one, it must be ground first."

She held up a tuber that looked very much like a withered sweet potato. A slight smile touched her weathered face. Her skin, stretched tautly over thin bones, was more bronze than copper. Age had darkened it even as it wore away the broad planes and angles of youth until there was nothing left but finely honed strength. The only lingering evidence of what she had once been lay in sparkling black eyes peering out at the world from beneath white brows that matched the tendrils of hair peering out from beneath her calico head scarf.

Her voice was slightly reedy but still firm. "You wouldn't think anything so ugly would help to create beauty, would you?" she said, turning the root in her hand.

Sara glanced up from her notes. They were seated in the shadow of the ramada where Bright Star preferred to work. Joseph was somewhere out of sight around the other side of the hogan, chopping wood.

Since riding over with her to visit the elderly woman, he had been busy with a myriad of chores Bright Star had difficulty doing for herself. She protested when he first set to work, saying they were not proper occupations for a great artist. But Joseph brushed her objections aside, knowing full well that she was only teasing him.

Neither saw anything undignified in performing the tasks needed for the sustenance of life. Such things were to be done matter-of-factly, though with the reverence that

should mark all interactions with nature. Nothing would be taken that was not absolutely necessary. Every plant and animal, every piece of wood and drop of water should be used to the fullest. To do otherwise was to reveal a degree of wanton sloth all but unthinkable to those raised with true respect for the land.

Sara studied the root with eyes that were rapidly acquiring an even greater appreciation for the most minute aspects of the greatness surrounding her. "No, I wouldn't have guessed its use, but that's hardly surprising considering that even after the lessons you gave me a few months ago, there's still so much I don't know."

But she was making progess. The complex preparations needed to transform raw wool into beautiful blankets and rugs were beginning to make some sort of sense, and the loom that produced the finished creation no longer looked like a disorganized jumble of sticks and strings.

Bright Star confirmed her thoughts. "You are coming along. Already you know more than many of my own people." She sighed softly. "The young ones these days are not so eager to learn. They say they want to preserve the old ways, but that doesn't mean they are willing to do all the work necessary to keep our traditions alive."

Sara felt her sadness. At seventy-eight, Bright Star had lived through more upheaval and struggle than most people could even imagine. As a child, she had heard stories of the Navaho's four-year captivity at Fort Sumner followed by the tragic "Long Walk" that had killed so many, from the mouths of those who had lived through them.

She knew firsthand the unrelenting poverty of the reservations and the grinding cycle of disease, malnutrition, and neglect that destroyed bodies and minds before they had any chance to bloom. Beyond even the suffering of countless individuals, she knew what it meant for an entire way of life to be so severely threatened that it was almost lost. She understood the burden of race hatred that made people turn their backs on their own culture and try desperately to conform to standards set by others.

But the legacy of sadness she carried was balanced by the gifts of nature and her own constantly reaffirmed belief in the power of creation. Though her small, frail body,

clad in the traditional velvet blouse and full skirt, was bent by age and her fingers were gnarled by arthritis that made it impossible for her to weave more than a few minutes at a time, she persevered.

Quietly, without fanfare, Bright Star had set out not just to survive but to flourish. In her, the inherent strength and wisdom of her people shone in their purest forms. Through the warp and shuttle of her loom, they were poured into works of art that Sara believed would survive for centuries.

Gently, she said, "But some of the young people are learning, aren't they? Your students, for instance."

Bright Star nodded, her regret giving way to generous pride. "I have a new one, a young girl who is spending the spring and summer with her parents on the reservation before she goes off to college. That makes six all together, and every one of them is doing well."

Sara grinned, well aware of Bright Star's extraordinary patience and tenacity in teaching her skills. "How could they do otherwise? Remember how fumbling I was the first time I tried to string the warp? You had to take me through it over and over before I got it right."

Coal black eyes gleamed merrily at the memory. "That's true, but I notice you didn't forget. This time, you did it without any help or mistakes."

Glancing at the loom set under the lean-to, Sara wondered again at its deceptive appearance. Made from the most rudimentary materials and essentially consumed in the act of weaving a single rug or blanket, it still performed all the functions of far more elaborate mechanized looms with remarkable efficiency. Yet its design had remained unchanged through uncounted decades. Its uncluttered effectiveness reminded Sara of the Navaho belief that all things necessary for life should be done well but simply, and that anything unnecessary was by its very definition not worth the trouble of doing at all.

That credo explained, at least in part, why Joseph could move so effortlessly through seemingly contradictory patterns of existence. He possessed a fundamental set of skills that served him well wherever he went. In the city, he could enjoy all the benefits of a highly complex society

while coping smoothly with all its problems. On the reservation, he slipped naturally into buckskins and went off to hunt as easily as if he were going for a stroll. She had stopped asking herself which was the real man. Instead, she was learning to simply accept all of him and go on from there.

"Sara . . . ?"

Looking up quickly she found Bright Star gazing at her, an amused smile highlighting the web of fine wrinkles crisscrossing her gentle face. "You were very far away."

"I'm sorry . . . I was just thinking . . ."

The wise black eyes glowed humorously. "About weaving?"

"Uh, no . . . not exactly . . ."

When she had arrived that morning with Joseph, Sara had known a few moments of unease as she wondered how Bright Star would receive her. Since she came without luggage, and therefore with clearly no intention of moving in for the remainder of her visit, the conclusions were inescapable.

The Navahos were traditionally conservative. They tended to view informal couplings far more sternly than many whites. But if Bright Star thought there was anything wrong in her staying with Joseph, she did not show it. Instead she welcomed them both so graciously that Sara's self-consciousness almost disappeared.

But it revived somewhat as the elderly woman said, "Believe it or not, I still remember what it's like to be a young woman. There was a time when no loom could have held my interest either."

"I am interested," Sara assured her quickly. "After all, I have to learn everything I can if I'm going to be able to do that display we talked about."

Bright Star nodded complacently. "You'll do it, I'm sure of that. But tell me, is it planned for before or after Joseph's show?"

Sara's eyes widened slightly. She'd had no idea the old artist knew she now represented Joseph. "How did you hear about that?"

"He told me when he rode over a few mornings ago to ex-

plain where you were." More sternly, she added, "We were worried about you. What you did was very foolish."

"I know," Sara admitted. "The whole time I was growing up on the ranch, my father and all the men who worked for him drilled into my head that you can never take anything for granted in the desert. I just don't understand how I could have forgotten that even for an instant."

"Perhaps," Bright Star ventured impishly, "you were distracted."

Her flagrant grin made Sara laugh. "You're incorrigible. Now I know what you think about all the time you're weaving."

"So what if I do," Bright Star shot back. "At my age, all you can do is think. Whereas, at yours . . ." She sighed fondly, her eyes misting over with memories. "My husband was a marvelous man. Not as handsome as Joseph, but close. I was fifteen when we married. That first winter, I don't think we stirred out of the hogan more than a few hours. Of course, I had a baby by spring, but that was all right. We both wanted a large family."

Her smile faded as she explained, "Both my sisters had died of tuberculosis they caught at the Indian School in Phoenix. I might have been sent there, too, except that I was so determined to marry White Thunder no one could reason with me. Of course, things have changed a lot since then." She shook her head, wondering at the swift, remorseless passage of time. "It's hard to believe I have three great-grandchildren going there now."

Sara, who had seen photos of the three along with most of the other offspring of Bright Star's numerous children and even more numerous grandchildren, asked softly, "Do you ever regret living apart from them?"

The old woman shook her powder-white head firmly. "No, I don't. I always enjoy seeing my family, but this is my time to live alone. Without solitude, I wouldn't be able to work."

And that would be a terrible loss. Bright Star had come into her art late in life. There was little time left to her. Every moment was precious.

Even as the thought passed through Sara, Bright Star was resuming the lesson. She held up a handful of indigo.

"Most of our blue dyes come from this. Traditionally, the powder is dissolved in the urine of a child, which doesn't sound very nice but is the surest way of making the color fast. The wool is soaked for several weeks, depending on how dark the shade is to be."

"Where does the indigo itself come from?"

"There is no local source, so we trade for it. It's one of the few items adopted from the whites that has really become a part of our culture. To my way of thinking, its success far outweighs the many failures. Without it, many of our most beautiful rugs and blankets would not be possible."

Sara's pen stopped in mid-sentence. She could not escape the suspicion that Bright Star was suddenly talking about a great deal more than weaving. Her next words seemed to confirm it.

"Only a few things in this world can be uprooted from one culture to become part of another. They are invariably all the more precious for being so rare."

"Sometimes . . ." Sara said carefully, "It isn't a question of uprooting so much as blending. Sometimes, two things have to come together from different directions to create a greater whole. That's very hard."

"Very," Bright Star agreed softly. "But what of great value is not difficult to attain? Isn't there a saying in English to that effect?"

"Yes . . ."

"And don't you believe it? Haven't you found that everything you really value has required a struggle?"

Sara's pen lay forgotten in her lap. All her attention focused on the old woman whose glittering eyes had seen so much and whose spirit remained so strong despite the growing frailty of the shell that contained it.

"A few days ago," Sara said slowly, "a friend reminded me that the risk of pain is the price we pay for being human. I don't resist that, but as I told her, I don't want to hurt someone else."

"So that is what you fear," Bright Star murmured thoughtfully. She smiled, her worn hand brushing Sara's. "You have yet to learn the full measure of another's strength. But you will, of that I have no doubt."

She said nothing more, turning instead to the loom

where she began to lay down the first rows of weaving that would form the border for a new blanket. Sara watched her carefully, letting the smooth motion of the batten slipping through the warps carry away her uneasy thoughts. She was still watching when Joseph joined them.

His gaze was very tender as it settled on Sara. Lowering his big body onto the ground beside the two woman, he said teasingly, "I see you've managed not to get tangled up in the loom."

Sara laughed. The pleasure she felt at simply being near him sang in her voice. "Only just. If Bright Star hadn't been watching my every move, I'm sure I would have made a mess of it."

"Nonsense," the old woman snorted, "she's a natural at this. I've never seen anyone learn so quickly." As she spoke, she glanced from one to the other, amusement crinkling her eyes. "However, I think we've done enough for today. An old woman like me needs her rest."

Joseph raised an eyebrow, making it clear he understood exactly what Bright Star was up to. "Old? You could wear both of us out and then some. But if you really want us to go . . ."

"I do. You've got better things to do than listen to me prattle." She raised a hand to stop Sara's instinctive protest. "Come back tomorrow and we'll talk more. In the meantime, I'm sure you can find some way to keep yourselves amused."

Joseph's appreciative laugh only deepened Sara's blush. She refused to look at him as she packed her notebook away and said good-bye to Bright Star. Not until they were once again mounted and riding over the low ridge did she glance at the tall, compelling man at her side.

"Are we going straight back?"

"No, I have to stop at the trading post for supplies. I hope you don't mind?"

Sara shook her head. "I want to call Carrie, otherwise she's liable to keep worrying."

Joseph grinned at her. "You'd better prepare yourself for a bawling out. Something tells me my temper's nothing compared to hers."

Silently, Sara agreed. As their horses continued toward

the tiny cluster of buildings perched on the edge of the road, she thought of how far the gallery and Carrie seemed to be from the world around her and began rehearsing just what she would say to her friend.

Chapter Eleven

THE TRADING post that straddled one of the main roads heading north through the reservation was a collection of squat wooden buildings that had grown up over the years from much simpler beginnings. What had been a single, ramshackle structure was now a mini-town crowded with trucks, cars, horses, and the slowly increasing stream of tourists in their motor homes who would continue to grow in number until they reached a peak toward late summer.

The tourists came searching for bargains in blankets and jewelry. The Navahos came to trade for staples they did not produce themselves. They bought frugally, considering each purchase with great care. As a result, the trading post was almost always crowded.

Sara and Joseph had to maneuver their horses slowly along the road until they found a place where they could be left safely. As they dismounted, he tossed a saddlebag over his shoulder. Hand in hand, they strolled over to the small restaurant where they had agreed to stop for lunch.

Over burgers and beer, Sara drew him out about his work. She had noticed that he kept no art supplies in the hogan and asked why.

At first, he tried to shrug the question off. "Laziness. I come out here to relax. As long as there are no supplies around, I don't feel compelled to work."

The stern look she shot him made it clear she wasn't going to accept the excuse he had obviously given to others. He had the grace to look a bit abashed as he acknowledged, "Oh, all right, there's more to it than I generally like to admit. If I'm at the studio, I find myself

working whether I'm really ready to or not. Sooner or later, I end up drained. So I come back here to recharge."

"But when you're so close to the source of everything that inspires you, don't you ever feel tempted to try to capture some of it right on the spot?"

Joseph shook his head. "Remember, I don't work in the traditional art forms of my people. If I did, I'd just stay here and forget about the rest of the world. As it is, everything I do is an effort to convey something about this way of life to others. In order to do that, I have to be in close contact with the people I'm trying to reach."

"So that's why you live in the city?"

"Not entirely," he admitted with an engaging grin. "The fact is, I enjoy both places. Moving back and forth the way I do, I get the best of both worlds." More seriously, he added, "And in a small way, I set an example for other people who would like to do the same. Some Navaho believe that they cannot exist among the whites without losing their identity as Indians. My experience proves otherwise."

Sara couldn't dispute that. She had seen for herself how effective he was in both settings. Whether in the city or the high desert, Joseph dealt confidently with everything he encountered. Even the sudden twist in their own relationship didn't seem to cause him the slightest concern. Though she now knew his body intimately, she still had only a glimmer of what went on in his mind. It was becoming vitally important to understand how he thought of her and what, if anything, he envisioned for them when he looked ahead.

"When you come here," she began hesitantly, "do you ever feel lonely being so far from everyone else?"

"No, I can't say that I do. Whatever loneliness I've experienced has been in cities." Looking at her thoughtfully, he asked, "Am I wrong to think you're content here? You seem to be able to slough off all the distractions of civilization as though they were inconsequential to you."

"I suppose they are," Sara admitted. "On the ranch, we had relatively little contact with the outside world. My father discouraged me from watching television, preferring that I read instead, and we didn't go into town more than

once a month. So I learned to rely on myself, instead of on something external."

His dark, impenetrable eyes met hers over the table. So softly that she could hardly hear him, he murmured, "Then perhaps our backgrounds are not as different as we both seem to think."

And perhaps, Sara thought, wishing she had the courage to say it out loud, the gaps between us can be bridged.

For the moment, the words remained unsaid. But the sense of hopefulness remained strong between them when they left the restaurant a short time later, her hand nestled in his, and went over to the trading post's main store.

The interior smelled pleasantly of sawdust, flour and leather. While Joseph arranged for his supplies, Sara found a telephone. It was hidden away in a corner and looked oddly out of place in surroundings that might have been lifted almost intact from an earlier time. Yet she was put through to Carrie in minutes.

"Are you all right?" her friend demanded. "Has Joseph found you yet?"

"Yes to both questions, I'm sorry about the worry I caused. But everything's fine now. Any problems at the gallery?"

"No, it's been very quiet. How's Bright Star?"

Sara hesitated. Since first seeing the elderly artist that morning, she had been struck by certain changes in her. Nothing stood out in sharp relief, but she couldn't shake the feeling that the old woman had weakened significantly in the few months between her visits.

"Her work is every bit as good, but she seems slower . . . frailer. I can't pinpoint it exactly, but I'm worried about her."

"She's probably just feeling her age," Carrie said reassuringly. "That's inevitable, you know."

"I suppose, but it's hard to accept. Her work has such a timeless quality, I can't get used to the fact that she won't be with us forever."

"She's still able to teach, isn't she? If she can take you on as a student, how weak can she be?"

Sara laughed, acknowledging the truth of that. "I'll

have you know I did very well today. Another decade or so and I may even know what I'm doing."

"What about Joseph?" Carrie asked suddenly. Before Sara could respond, she went on eagerly, "You could have knocked me over with a feather when he showed up here. Lord, there's even more to him than I thought! Let me tell you something, if that man were interested in me I sure wouldn't have gone running off. You can bet I'd be sticking real close!" Her enthusiasm wound down finally into an awkward silence that Sara was reluctant to fill.

"Uh . . . he's fine," she murmured at last, grappling with what she did and did not want to say. Her new relationship with Joseph was still too uncertain to be talked about.

"He sure is," Carrie giggled, "about as fine as a man can get. Did he have any trouble finding you?"

"No . . . we met up on the road."

"Was he still so angry? He sure was when he left here."

"He made it clear that he thought what I did was very foolish," Sara admitted ruefully.

"Do you think you'll be seeing him while you're at Bright Star's?"

Sara shifted from one foot to the other. She didn't want to lie, but neither was she willing to admit where she was staying. In an effort at compromise, she said, "Joseph was over there this morning doing chores for her."

"And you still managed to pay attention to the weaving?" Carrie exclaimed. "You've got more self-control than I would."

Actually Sara thought she had very little where Joseph was concerned. All the common sense and maturity acquired in her twenty-eight years seemed to dissolve whenever she got anywhere near him. He unleashed forces in her no one else had ever even suspected. The experience was at once exhilarating and frightening.

If they had remained in the city, she suspected she might have been able to keep a tight enough rein on herself to avoid jumping into the kind of relationship they now had. But away from the restrictive patterns of "civilization" it had been all too easy to give in to her most fundamental urges. She had no regrets, but she was honest

enough to admit that a great deal remained unsettled between them.

And there was still Don.

She had purposefully avoided thinking about him since leaving Phoenix, but suddenly thoughts of Don and Phoenix came rushing into her mind. He belonged to another life removed from everything she was presently experiencing. She wished that her relationship with Joseph was firm enough to preclude any possibility of a commitment to another man. But she knew that wasn't the case, at least not yet.

Sooner or later, she was going to have to come to terms with her feelings for Don, even if that meant finding out he had decided in her absence that there was no future for them.

"Sara? Are you still coming back Monday?" Carrie asked, breaking into her thoughts.

Sara didn't hesitate. She had no idea how long Joseph planned to remain on the reservation, but she fought against the impulse to stay with him. She had a business and a life back in Phoenix that demanded her attention. If her time with him was going to be nothing more than a brief, glorious interlude, it would do her no good to postpone facing up to reality.

"I'll be there. In the meantime, thanks for looking after things for me."

When she hung up a few minutes later, Joseph was still busy at the supplies counter, so she wandered over to look at the displays of weaving and jewelry. The chances of finding anything that crossed the difficult line between craft and art were slim, but it was worth a try.

Bright Star had come to her attention only because of a small blanket purchased by a friend at the same trading post. It had taken a personal visit and long conversation with the store owner to convince him to tell her who the weaver was, and still longer to arrange a meeting. But she would make the same effort again to find someone even a fraction as gifted as Bright Star.

All the items on display were competently made, and many were genuinely beautiful. But none carried the radiance of true art. Sara had to be content with finding an

engraved silver pendant she knew Carrie would like. She purchased it as a token of her appreciation for being able to leave the gallery in such good hands.

Turning away from the counter, Sara's attention was caught by a group of boisterous, laughing women who had just entered the store. At their center was a flushed young girl of about eighteen carrying a bundle which she carefully unwrapped for the store owner to examine.

The rug inside was large and colorful. Even from a distance, Sara could see that it was well made. Though she had no interest in acquiring it for herself, she was curious to learn how the shopkeeper would value it.

Far from engaging in the usual tough haggling, the man smiled, complimented the girl on her work, and offered her a generous exchange of household supplies. As Sara listened, it quickly became apparent that the young weaver was setting up her first home. On the eve of her marriage, her happiness touched everyone in the shop and mundane cares were briefly forgotten.

With the trade done, the women were free to greet their friends and exchange the latest gossip. Joseph, who was apparently well known to them all, was the primary focus of their curiosity. He good-naturedly answered a slew of questions about what he'd been doing since they last saw him. But when he spotted Sara, he broke off abruptly. Holding out a hand, he called her to him.

She went reluctantly, very conscious of the sharp looks the women were giving her.

Joseph also caught them. Quietly, he said, "Sara is here to visit Bright Star. She represents her in Phoenix and has already sold two of her rugs in her gallery there."

The suspicious stares were replaced by smiles as the women realized this was the young woman they had heard about. Bright Star had spoken of her in glowing terms which had quickly gotten round the neighborhood.

With her credentials established as respectable, Sara was graciously included in Joseph's invitation to attend the wedding the following day.

The ceremony began with the blessing of the new couple's home, which was a successful blend of the traditional

hogan style with more modern additions. A revered chanter of the spirit songs, Henry Graybeard, had been chosen to perform the rite. He was an old man, almost as old as Bright Star herself, but still strong and active.

Sara and Joseph arrived in time to watch him lay new oak sprigs at the cardinal compass points around the hogan and sprinkle each with corn dust as he sang the blessings for long life, happiness, and fertility. With this done, everyone adjourned to the bride's home, where the marriage itself would be performed.

"Notice anyone missing?" Joseph murmured as they joined the large assortment of guests surrounding the young couple.

Sara nodded, sensing there had been a proud face in the crowd at the store which she didn't see now.

"The bride's mother is staying away, in the cook shed," he explained softly. "They're a very conservative family. Tradition dictates that if a bridegroom catches sight of his mother-in-law, he will be instantly blinded. That always sounded to me like a great excuse to avoid family squabbles, but some people at least pretend to take it seriously."

Looking at the strong, sturdy young man sitting beside the bride, Sara wondered how much credence he gave to the superstition. Though he wore the traditional slacks and shirt of Navaho men held by a wide belt studded with silver and several white-shell necklaces, he looked thoroughly modern in every respect. Certainly the wide smile he gave his bride suggested that no thought of ancient taboos diminished his happiness on this day.

Sara was struck by the beauty of the girl who smiled back at him. In the store the previous day she had looked merely pretty. But dressed in the customary velvet blouse and wide sateen skirt decorated by numerous silver buttons, necklaces, and bracelets that represented a good portion of her family's wealth, she glowed with a radiance reserved for brides.

Though the young couple did not touch each other, there was a sense of togetherness about them that gave added depth to the ritual formalizing their marriage.

In the center of the assembly, Henry Graybeard rose to

fulfill his second vital role of the day. In a clear, strong voice, he began to stridently lecture the bride and groom. Joseph translated enough for Sara to understand that he was spelling out to them in unmistakable terms their responsibilities to each other as husband and wife. The instructions went on for some time without the old man showing any sign of slowing down. But he apparently reached some conclusion satisfactory to all concerned for when he suddenly broke off and resumed his seat there were pleased nods around the circle.

"Why is he doing that?" Sara whispered a few moments later as she watched the bride's father sprinkle lines of white and yellow pollen before mixing the two and enclosing them both in a circle.

"The white represents the groom, and the yellow is the bride. Mixing them together in a circle conveys the hope that they will live together for a long time in harmony."

If the beatific smiles on the faces of the bridal couple were anything to go by, that hope stood a good chance of being realized. The ceremony and feasting continued into the evening, with the high point being the presentation of gifts. The bride and groom's friends had outdone themselves in providing everything they possibly could for the couple's new home. There were traditional presents as well as a tape deck and stereo which drew oohs and aahs from the appreciative guests.

But the greatest praise was reserved for those gifts which represented deeply held values and customs. The blanket Bright Star had sent by way of Sara was exclaimed over, and the small, perfectly made sculpture of a warrior on horseback which Joseph gave drew tears of appreciation from the awestruck bride.

As dusk settled over the plain, the guests slowly dispersed. Henry Graybeard escorted the new couple to their hogan, walking before them with the whirling stick from which he would light the first fire in their new home. There he left them to find their pleasure in each other and the life they were beginning together.

Joseph and Sara rode home slowly. She was happily tired after the events of the day, but had no desire to sleep.

Neither, it seemed, did Joseph. In the snug warmth of the hogan lit by a single kerosene lamp, he loomed larger and broader than ever. Despite her laughing protests, he insisted on undressing her, not stopping until the last fragments of lace lay on the ground at his feet and she was completely bare to his gaze.

She stood quietly before him, her arms at her sides and her head high. Any embarrassment she might have felt was impossible in light of Joseph's unmistakable admiration. Even in the dimness of the hogan, she could see the rapid rise and fall of his chest and the flare of passion in his eyes.

When they made love before, she was content to let him take the lead. But this time she would not relinquish the initiative. Moving a step closer to him, she slowly, deliberately began to unfasten his shirt. Her fingers lingered on each button, just brushing the velvety steel beneath. Glancing up at him through her thick lashes, she saw the sudden tightening of his jaw and the tremor that ran down his powerful throat. An alluring smile curved her mouth as she slipped the shirt from him, baring the smooth expanse of his chest.

"Sara . . ."

"Hush."

With her hands moving to his belt buckle, he had no choice but to obey. She unfastened both it and the snap at the top of his jeans before easing the zipper down. The warmth radiating from him engulfed her. Her own body was on fire with need, but still she moved leisurely to rouse his passion to a fever pitch.

A slender hand slipped inside his pants, cupping the burgeoning fullness that overflowed her palm. He groaned as she squeezed his pouch gently before stroking all along the hard shaft of his penis. Delicately, her fingers brushed the straining tip in a repeated circular motion that made him gasp.

"Sara!"

"Yesss . . ."

"You're driving me crazy!"

A soft giggle escaped her. "That's the idea."

Taking a deep breath, she eased the jeans down over his

hard buttocks and sinewy legs. He stepped out of them quickly, kicking them away. His last garment vanished just as swiftly, so that their naked forms pressed together without the slightest impediment.

"Two can play that game," he growled huskily in her ear, his hands sliding down her back to slip unerringly between her thighs.

Before he could do more than touch the moist delta there, Sara pushed him away. Her eyes glowed as she insisted, "It's still my turn."

Far in the back of her mind, it occurred to her that much of the fascination with this particular game lay in the fact that Joseph might end it any time he chose. He was vastly stronger and could easily compel her to accept anything he wished to do. But she had a different sort of power all her own. The pleasure she could give him made him pliant in her hands.

Gently but determinedly, she pushed him back on the bed. Kneeling above him, she let the long fall of her silken hair trail over his powerful chest and flat abdomen before teasing lightly at his groin. Slowly, tantalizingly, her lips followed the same path.

His response was highly satisfying. The tremor that ran through him emerged as an urgent groan. Sara looked up, smiling, only to realize the game was over.

Joseph's hands locked on her hips, lifting her easily. The groan turned to a growl as he forced her upward until he was able to tease and torment her exactly as she had him. Waves of pleasure crashed through her. Her head fell back, her eyes closed as blinding slivers of light exploded behind them.

But even in the midst of overwhelming rapture, Sara was not content to simply yield. The instant Joseph's grip on her eased, she moved. A gasp tore from him as he was drawn inside her. Only a few rapid thrusts were needed to send them both spiraling over the edge to fulfillment greater than any they had found before.

Afterward, he fell asleep almost instantly, though not before gently holding and stroking her until the aftershocks of their pleasure faded. Sara lay awake long after his breathing became slow and even. She stared up at the

ceiling, thinking about the ceremony she had witnessed and wondering if she would ever know the absolute happiness and certainty of the young couple she had seen wed that day.

Chapter Twelve

"Now sit down and tell me all about it," Bright Star insisted. "How many people were there? Was the bride shy or bold? Did old Graybeard manage to hold up his end?"

"Wait," Sara said, laughing. "Let me answer before you ask more questions." Sitting cross-legged under the ramada, she began to recite all the details of the wedding, omitting nothing of tone or texture or color that the elderly woman might find interesting.

As she listened, Bright Star worked her loom. When completed, the blanket would be a series of large hexagons with terraced edges bordered by stripes some six feet long and four feet wide. To execute the complex design, she had to hold the entire pattern in her mind at each moment while also concentrating on the single line formed by each strand of thread. Only the greatest weavers could achieve this. Bright Star did it without difficulty.

Sara watched as she suddenly switched colors, threading a strand of contrasting color through the deep blue border. Softly, so as not to disturb her concentration, she asked, "I've noticed you do that before. But I don't see anything like it in most other rugs. Does it serve some purpose?"

Bright Star laughed softly. "Only an old woman like myself would think so." A gnarled finger gestured toward the red strand now imbedded among the blue. "That is the path the spirit of the rug will follow to be released from it. You will find such a thread in every rug I weave, and in many of those done years ago by others. Now it is not so

common. The younger weavers don't really believe the rug has a spirit, so they see no need to release it."

"But you really think so?"

"I only know that by the time a rug is finished there is so much of myself in it that I can believe it has some form of being." She glanced at Sara out of the corner of her eyes, judging her reaction. "Why should I take the chance that something I cannot quite understand but which may still be very real might be trapped inside a form it does not want? If the spirit wishes to stay in the rug, it can. If it prefers to escape, the path is clear."

"That thread you put in is almost the only common element I've noticed in all your work I've seen so far. No two designs are even remotely similar. Where do all the different elements come from?"

Shaking her head, Bright Star admitted, "I have no idea. Certainly some of the patterns I use are very old, handed down from weaver to weaver. But everyone who gets near a loom seems inspired to create her own designs. I've woven in shapes that have come to me in my sleep or that I've noticed in the sky, sometimes even from photographs in magazines and newspapers."

As she pounded down the weft to secure a newly placed strand, Bright Star went on, "So you see, Navaho weaving is a very fluid art. It is always changing, growing. There is no prejudice against new ideas; on the contrary, they are eagerly received. And anyone who is properly trained can aspire to be a good weaver, whether born Navaho or not. No distinction is made as long as the spirit is willing."

Sara's hand dropped to a pile of soft gray wool. Her fingers touched it lightly as she said, "Such tolerance is rare, isn't it? I thought there were many restrictions against accepting non-Navahos into your society."

Bright Star stopped weaving for a moment to rest her aching fingers. Her bright, fathomless eyes settled on Sara's. "Are you thinking of any restrictions in particular?"

Hesitantly, she nodded. "Isn't there a rule against marrying outside the tribe?"

"Yes, just as there is a rule that forbids marriage within one's own clan where people are liable to be closely re-

lated. Like many such prohibitions, it is intended to protect our way of life. However, that doesn't mean it is never overlooked."

"Do you think it's really possible then for an outsider to truly be accepted?"

"Acceptance," Bright Star said slowly, "has to be earned, and even when it is completely deserved, some will always withhold it. I respect the tenets of my tribe, but I realize that sometimes individuals have to decide what is best for themselves, even when that means taking great risks."

Sara listened to her carefully. She understood that Bright Star was trying to offer her comfort and advice without trespassing on the Navaho sensitivity to privacy. She couldn't come right out and ask about her relationship with Joseph, but she could sense where Sara hoped it might lead and offer what encouragement was possible.

Aware of the elderly woman's diminished strength, she ended the visit a short time later. Riding back with Joseph, Sara was quietly thoughtful until they were almost within sight of his hogan. Only then did she ask softly, "Am I imagining it, or is Bright Star ill? She seems much weaker than she did even a few days ago."

Joseph didn't answer at once. He slowed his magnificent palomino stallion to keep pace with the smaller mare. His eyes were full of compassion as he said gently, "She is dying."

All the color drained from Sara's face. Her hands tightened on the reins, nails digging into her palms. Disbelief spiraled through her. "No! She can't be . . . she's still working and teaching . . ." Hard on the heels of denial came anger. "If she's ill, why is she still living by herself? Why isn't she in a hospital?"

"Would you really condemn Bright Star to that? This is where she belongs, where she was born and where she wishes to die. She doesn't want to be among strangers, or even her family. She wants only her art, and the few people like you she will continue to teach as long as possible. Surely she has the right to decide how her life should end?"

Sara shook her head dazedly, struggling to come to

terms with what she had just learned. "But she has so much to share . . . she can't just give up . . ."

Reaching out across the short distance separating them, Joseph took her clenched hands in his. Tenderly but firmly he straightened each taut finger. "Her body is old and weary. She wants to leave it. Can you imagine her hooked up to machines and tubes, her spirit forced to remain in this world when it longs for the next? Bright Star deserves better. Her life has been long and hard; her death at least should be easy."

Sara didn't argue further. Her thoughts were too jumbled and painful to be articulated. They finished the trip home in silence. The surefooted mare had to find her own way along the trail. The tears that blurred her rider's eyes made it impossible for Sara to lead.

By the time they reached the hogan, much of her instinctive anger had dissolved, to be replaced by a level of resignation that surprised her. Joseph was right. She couldn't bear the thought of Bright Star being denied the comfort and serenity of her home for the cold reality of a hospital room and an ignominious, futile struggle against death. But neither could she yet manage the selflessness required to let one so precious go without regret. She would have to work hard to achieve that.

Joseph considerately left her alone when she offered to prepare dinner. He busied himself brushing down the horses and readying them for the night as she started a fire and put together a fragrant beef stew.

Sara did the tasks automatically, drawing on remembered skills from her childhood when she had often camped out on the range with her father and his men. Though the implements she used were different, she was pleased with the results. It had been a long time since she prepared food in such unspoiled surroundings. She found the experience soothing.

This time they did not go inside as soon as they finished eating. Instead, Joseph brought a blanket from the hogan and wrapped it around them both as they gazed up at the night sky. He knew the stars well, having learned in childhood to identify the constellations which signaled the seasons for hunting, planting, and harvesting.

Sara leaned back in his arms, listening to his quiet voice as he pointed out the various figures and explained their meanings. His nearness and the slow, gentle words flowed over her like balm. The time of her grieving for Bright Star was only beginning, but already she knew that she feared it in part because of the memory of how she had suffered after her father's death. That she had lived through alone, whereas now she could at least hope to take comfort from the strength and assurance of the man who held her so gently.

The tears came as she lay in his arms. They trickled down her cheeks, slowly at first and then in a torrent he made no effort to staunch. Instead he only drew her closer, rocking gently back and forth, comforting her as though she were a child in pain.

Sara clung to him, knowing that she wept as much for her father whom she had never had the courage to properly mourn alone as for Bright Star herself. The fire had fallen into embers before her sobs at last faded away. She was only dimly aware when Joseph carried her inside, slipping the clothes from her with tender solicitude that stood out in vivid contrast to his demanding passion of the night before. Drained of all emotion, she burrowed into his arms and sought sleep as her own path of escape from the tightly meshed strands of pain and pleasure that made up the fabric of life.

The blanket was done. Sara saw that even before she dismounted in front of Bright Star's hogan. The glowing length of blue, yellow, and red she had watched grow day by day was now complete. It lay neatly folded up beside the empty loom.

Her throat was tight as she slid quickly from the mare and tied the reins to a post. There was no sign of Bright Star, nor any response to her call. The door of the hogan stood open. Ducking inside, Sara needed a moment for her eyes to adjust to the dimness before she could make out the frail shape on the bed. The old artist lay covered by a blanket of her own making. Her thin, gray hair was spread out over the pillow and her gnarled hands were folded neatly on her chest. Not until Sara knelt trembling beside her

129

was she able to determine that Bright Star was still alive. Her breathing was so slight that the covers barely moved and her pulse was almost indiscernible. But enough life still moved within her to allow her to open her eyes and speak faintly.

"Child . . . don't stay here alone. Go and get Joseph."

Sara shook her head instantly. "I won't leave you."

"You must," Bright Star insisted. "Something needs to be done that requires his help."

Reluctantly, Sara rose. She hated the idea of leaving the old woman alone even for a moment, but she realized that Bright Star would not be able to rest until whatever it was she wanted Joseph to do was accomplished.

"All right . . . I'll be back quickly . . . We both will."

Bright Star nodded wearily, her eyes closing again even as Sara raced from the hogan. Digging her heels into the mare, she urged the horse to a gallop. The ground flew past beneath them, but the trip still seemed interminable. She was gasping for breath when she finally reached the paddock where Joseph was working.

"It's Bright Star! She's . . . she wants you to come."

No further explanation was needed. Throwing a blanket over his stallion, Joseph slid onto his back easily. The mare tried valiantly to keep up, but could not. Joseph was already inside the hogan with Bright Star when Sara reached them.

Standing uncertainly at the door, she could not hear what the old woman whispered, but she did see Joseph's quick nod and hear his low, gentle murmur as he promised to carry out her wishes. Carefully, he lifted the frail bundle into his arms and took her outside.

Sara watched, bewildered, as Joseph laid Bright Star beneath the shade of the ramada. He settled the blanket more securely around her and slipped a pillow beneath her head. Only then did he look up and note Sara's silent question. Softly, he explained, "The Navaho believe that when someone dies, the structure they are in must be destroyed. It cannot be occupied again. Bright Star wants her hogan to be used by others, so she knows she cannot die in there."

"But . . . she can't stay outside . . . when it gets dark, the cold . . ."

Joseph's voice was gentle as he said, "Sara, by tonight it will not matter."

A glance at Bright Star's weary, strained face was enough to show that he was right. She was living out her last few hours. Sara found some slight degree of comfort in the knowledge that her old friend was where she most wanted to be. But she was still hard pressed to deny her tears as she knelt and took a withered hand in hers.

From above her, Joseph asked quietly, "Can you stay with her alone for a little while? I want to get Graybeard."

Mutely, Sara nodded. She knew the traditional healer could offer Bright Star nothing but comfort. But he would come because they were old friends and contemporaries. The time she spent waiting for Joseph to return with him passed very slowly. Bright Star seemed to lapse into unconsciousness. She showed no sign of hearing as Sara continued to hold her hand and speak to her softly. But when she fell briefly silent, the old woman's hand tightened on hers as though in encouragement.

Graybeard greeted Sara kindly. Seeing the extent of her grief, he tried to ease it. So softly that his voice might have been no more than a breath on the wind, he said, "Bright Star has long hoped that she would end this life peacefully on her own lands. I know she must feel great gratitude to you and Joseph for making this possible."

His tone soothed Sara as much as the words themselves. She moved aside slightly, making room for him to kneel beside Bright Star.

If Graybeard had truly been called there to heal, he would have come prepared to stay for the several days needed for a full restoration chant. Many songs would have been sung to the spirits as various rites were performed and sand paintings made. But as it was, all this had to be compressed into the few hours Bright Star had left. The medicine man would perform only those portions of the Shooting Chant used in the hope of restoring the seriously injured.

From the feathered prayer sticks in his medicine bundle, Graybeard took one set with turquoise and fastened with a long cord. After chanting over Bright Star, he took

the stick outside the ramada and whirled it toward each horizon.

When this was done, he drew out pouches of finely colored sand to construct the symbolic message requesting intercession from the spirit world. Sara and Joseph watched silently as Graybeard worked. If he made a single error, the entire ceremony would have to begin again. But the old medicine man had been practicing his skills for many decades. The painting took shape slowly but steadily, without interruption.

The sun was slanting toward the west before the painting was completed. Sara worried that Graybeard must be tiring, but he showed no sign of weakness. Instead, his voice rose strongly as he first pressed the prayer bundle along the length of Bright Star's body and then rubbed pinches of sand taken from the painting into her limbs and head.

Joseph left them briefly to bring a bucket of glowing coals into the ramada. When they were set on the ground before him, Graybeard sprinkled herbs that gave off a fragrant smoke.

For a long while after the incense faded into the air, the old man continued to kneel beside his patient. He had done all he could and was resigned to the inevitability of her death. His face was calm as he silently made his farewells.

Joseph went with him back to his horse. The two men spoke briefly for a few moments before Graybeard left. The sun was setting as he rode away, his thin back erect in the saddle and his eyes turned resolutely forward.

Always before when she was outside the city, Sara savored the moments when the setting sun turned the sky to a riot of colors. But that night she was oblivious to one of nature's greatest glories. All her senses were focused on Bright Star as she struggled for some measure of acceptance.

Joseph touched her arm gently. "You should lie down for a while. I will call you if anything happens."

Silently, Sara shook her head. She would not leave, but she did agree to share the frugal meal he prepared for them. The food seemed tasteless and she was barely con-

scious of eating. As soon as the bowl was empty, she returned to Bright Star's side.

Joseph did not try again to convince her to rest. He seemed to understand and share her need to keep the vigil through the few brief hours. As the last rays of the sun faded behind the mesa, it occured to Sara that Bright Star was getting her wish. Her going could not have been more peaceful. There was no sign of pain or fear, only a slow ebbing of her breath until at last it stopped altogether.

They wrapped the body in a plain, store-bought blanket that Graybeard had left for that purpose. Bright Star had made it known she wanted none of her own work to go with her into the grave. That was the part of herself she was leaving behind and she was determined others would see and enjoy it. When the empty shell was covered, they left it under the ramada near the loom.

Sara did not think it was possible for her to sleep, but she and Joseph had barely lain down side by side on the old artist's narrow bed when her eyes closed irresistably. Any dreams she had must have been oddly comforting for she woke the next morning feeling easier in her heart and mind than she had since first learning that Bright Star was dying.

It was even possible for her to look at the small bundle under the ramada without any feeling of horror or denial. The blanket and what was wrapped in it seemed to fade into the ground. Already Bright Star was returning to the elements that had created her. Her form and spirit were blending with the universal whole as they had always been intended to do from the first moment of time.

In sharp counterpoint to the elaborate wedding ceremony of a few days before, the funeral was simple to the extreme. Shortly after dawn, a truck arrived from the trading post. Graybeard had notified the storekeeper of Bright Star's death, and the man had made all the necessary preparations. Those of Bright Star's children who were near enough to attend were already on their way. By afternoon they were gathered in the cemetery set far enough back from the main road so that only someone seeking it would guess its purpose.

Sara had heard of the Navahos' seemingly unemotional response to death, but she still wasn't fully prepared for it. To some, the quiet, matter-of-fact behavior of the dead woman's offspring might have seemed callous. No one shed a tear, no one exclaimed in any way about his or her loss. Instead, there was only resigned silence as the body was lowered into a wooden coffin and placed in its grave.

Not until they were back at the trading post, where Joseph had quietly arranged a meal for the family, did anyone speak. Then slowly, tentatively, Bright Star's children began to talk. Without formality, they stood up one after the other to say that she had been a good woman, a cherished wife, and a strong, loving mother. She had given generously of herself all the days of her life, and the spirits had rewarded her by the gift of her art which would live forever.

When the children were done, the grandchildren took up the sharing of cherished memories.

"She taught me a great deal," said one. "She was always patient and kind."

"She was very wise," another offered. "She understood our hopes and fears, and she tried to help us wherever she could."

"If you ever needed anything she had, you didn't even have to ask."

"She believed everyone could do good, if they were only given the chance. She convinced me that I should study harder and try to make more of myself."

Finally, it was the turn of the smallest great-grandchild. He had to be urged forward gently by one of the adults, who held his hand as he pondered over what to say. Looking up shyly, the little boy burst out, "She made me laugh. She told funny stories 'bout animals and things that were so real you could see them in front of you. I 'member the stories. Someday, I'm going to tell them to my children too."

Sara thought the testimony was over then. She was startled when Joseph gently pushed her forward. Surprised to find all eyes suddenly on her, she stumbled slightly as she said, "I-I didn't know Bright Star very long . . . only a few months . . . but I learned to love her as a friend and as an

artist. She captured great power and beauty in her weaving. In the years to come . . . when we seek to remember her . . . we will only have to look at what she did to know this was a woman blessed by nature and unafraid of sharing her gifts."

The halting speech that had come straight from Sara's heart pleased the family. They smiled at her kindly as the food was served and gradually, without strain, the conversation turned to ordinary, everyday things. Halfway through the meal Sara realized with something akin to wonder that the habitual rhythm of life had once again resumed.

Chapter Thirteen

THE LAST blanket was folded and laid on top of the stack outside the hogan. The last skeins of wool were piled nearby. Bright Star's large, cast iron pot that she had used for dyeing was in the wagon along with the supply of leaves, powders, and ground minerals from which she concocted her remarkable colors. The pieces of her loom were carefully wrapped in burlap and placed alongside each other.

Later, all except the blankets would be returned, but first they would be used in the exhibit that was now to be a memorial to the woman who had done so much to preserve and refine one of her people's greatest arts.

While the hogan was empty, it was blessed again by a chanter of spirit songs so that when the time came it could be reoccupied. No decision had yet been made as to who would live there, but Sara was certain that among Bright Star's students there was at least one who could take up the task of teaching.

Her children, who by tribal law retained all her property for themselves, had generously offered the land for use as an arts school. Given what Bright Star's remaining works would bring on the market, there would be no trouble financing such an endeavor.

But one blanket would not be sold. Bright Star had willed her last work to Sara. Her eldest son had brought that news at the same time as he revealed the plans for the school. Her protests that she didn't deserve such a gift went unheeded. The blanket would stay with her, to be treasured forever.

"Are you ready?" Joseph asked as he finished loading the truck.

Sara nodded. She was reluctant to leave the place where some remnant of Bright Star's spirit still seemed to linger. But she knew there were decisions ahead of her that could no longer be postponed.

It was Sunday afternoon. So far neither of them had said anything about her leaving, but they also hadn't talked of her staying.

Was it cowardly not to want to be presented with the choice? If Joseph asked her to remain with him, he would in effect be asking her to choose between her life back in Phoenix and the relationship they had forged in this secluded interlude snatched from the rest of the world. Such a request would flatter her vanity, but leave too many other needs unanswered.

Sighing, Sara kept her eyes averted as she got into the truck beside him. She was deeply drawn to the man she had learned to know in the last few days and she was content with the parts of herself she had seen emerge in his company. But it wasn't enough.

The high desert was, as Joseph had said, an endless source of strength and inspiration. It wasn't, and could never be, the sum total of her life. She needed the world she was building for herself in Phoenix. The fragile bonds she and Joseph had struck still showed no evidence of stretching that far.

Sara's car was parked outside his hogan. It had been towed to the trading post after the storm. With the battery recharged and everything else in working order, there was no reason she couldn't leave whenever she chose—no reason, except that when she went she might be leaving a large chunk of herself behind.

Joseph seemed to have caught her introspective mood. They spoke little as Bright Star's belongings were transferred to the car. When the truck was empty, he gestured toward it. "I'd better return that to the trading post. Is there anything you want me to pick up?"

Sara shook her head. "I can't think of anything." On impulse, she added, "Will you be gone long?"

"No, not more than an hour."

Silently she refected that an hour apart could seem like

far more. The grim set of Joseph's face as he restarted the truck gave her some hope that he might feel the same way.

Left alone, she picked up a towel and soap and headed for the rock spring. With the sun resplendent in a cloudless sky and the air already beginning to shimmer with a heat haze, she had no hesitation about bathing outside. The water was as warm and calm as any bathtub.

Stripping off her clothes, she waded into the pool. She left her shampoo and soap at the water's edge. By dunking herself under several times and rubbing vigorously, she was able to work up a good enough lather to clean the heavy mass of her auburn hair. Rinsing it thoroughly, she soaped every inch of her body before finally turning on her back to float for a few minutes.

She found some unexpected comfort in the knowledge that what she had just done might be construed as a further sign of her adaptation to Navaho customs. After contact with the dead, it was traditional to perform an act of purification. Joseph had risen early and gone down to the spring alone for that purpose. Paddling slowly round the pool, she could appreciate why he sought its healing effects. Though she knew he regularly bathed twice a day when it was hot and he was working around the hogan, she understood something more had driven him that morning.

When her fingers and toes began to wrinkle, she reluctantly climbed out and toweled herself dry. Putting on clean shorts and a top, she sat cross-legged on the ground. Tipping her head forward, she let the silken mass of her hair fall before her as she brushed it vigorously.

In the tranquility of her solitude, distant memories surfaced. Her mother had brushed her hair like that when she was a little girl. After her mother's death, her father had taken up the chore. She remembered he was clumsy at first, pulling too hard. But she had never told him. United by grief and bewilderment, they had quickly become as close as a parent and child could be.

For a while after he died, she had wondered if she wasn't seeking some sort of replacement for him in another man. Her reluctance to involve herself might have stemmed from that fear. But now she understood that the danger was past. When she thought back to the love and security

she had known as a child, it was only with the hope that someday she would be able to offer the same to a son or daughter of her own.

Joseph, too, had a great deal to offer. The challenges he had confronted and the battles he had won had imbued him with tremendous strength and gentleness. Far from being the arrogant, presumptuous man she had for a while wanted to believe he was, she knew now that he possessed extraordinary sensitivity and a willingness to give of himself that she had not encountered in anyone else.

But there was a fine line the generosity of his spirit would not cross. He would always, no matter what the circumstances, be true to himself. In that, his character mirrored the steadfast, remorseless desert from which he came.

The bleating of a curious baby goat interrupted her pensiveness. She laughed out loud as the gray ball of down with ridiculously long, stick-like legs slid awkwardly down the hillside until it was standing close enough for her to almost touch. They regarded each other solemnly for several minutes before the goat felt brave enough to let her rub his nose.

"You're so soft," Sara murmured to him gently. Her low, reassuring voice made the kid bolder. He nuzzled his snout into the palm of her hand, pushing with such unexpected strength that she toppled over backward. The laugh that burst from her startled the goat. He took off agilely up the incline where his disapproving mother waited.

She was still smiling several moments later when she knew, without having to turn around, that she was no longer alone. No sound marred the stillness, but when a hand fell warm and strong on her shoulder she felt no surprise. The arms that enfolded her were familiar and welcome. The broad chest where her head rested felt like home.

Joseph buried his head in her glistening hair, inhaling its clean, sun-dried scent. Beneath the thin cambric shirt he wore, she could feel the steady beat of his heart. The sleeves were rolled up to expose his powerful forearms. Her fingers stroked them lightly, feeling the smooth expanse of muscle and sinew. Disappointment surged through her when he pushed her a little bit away.

"Sara . . . we have to talk . . ."

"No." The word was out before she could stop it. Her fear of what he might say shone in her eyes. Moving closer to him again, she murmured, "Later . . . we'll talk later."

For just an instant she thought she saw a surge of anger in him. Then it was gone as he laughed huskily. He couldn't pretend to resist. They had not made love since before Bright Star's death and the need they set off in each other was simply too strong to ignore. His hands were on the hem of her T-shirt when he glanced up, noting the slow massing of clouds that were beginning to drift across the sun.

"Let's go inside," he murmured against her ear, "where we won't be interrupted."

They walked back to the hogan with their arms wrapped around each other's waists. With the door closed behind them, Joseph lit one of the kerosene lamps as Sara turned down the bed. Quietly, purposefully, they stripped off their clothes.

Her eyes never left him as the hard, lean body was revealed in the lamp light. All her senses were acutely tuned to him. A rush of heat darted through her as she felt his gaze moving slowly over the fullness of her breasts, her slender waist, rounded hips, and long, slim legs. His look was potent enough to be a caress in itself. By the time he crossed the small distance separating them, her nipples were already hard and she trembled with desire.

"Talking," Sara whispered against his mouth, "is only one way of communicating."

His arms closed around her, drawing her closer. "You've gotten very wise out here in the desert."

"I'm a fast learner."

"I've noticed that." Big hands entangled themselves in her hair to draw her lips to his.

The words were a further goad to her desire. She knew he was acknowledging the swiftness with which she had learned what most pleased him. Through a combination of instinct and the rare empathy she had felt with him from the beginning, she was able to gauge the deepest responses

141

of his body and mind, and play on them from moment to moment until he was driven to the heights of rapture.

But her skill was well matched by Joseph's own. Sometimes, in the aftermath of the overwhelming pleasure he gave her, she had wondered if he always brought a woman to such heights. Only gradually did she realize that he was as astounded by her responses as she was by his own. Though she didn't doubt he had always been a good lover, she cherished the knowledge that with her there was something more.

That something, whatever it might be, was clearly at work again as their bodies met and fused in extended caresses that challenged their self-control to the utmost.

Sara cried out once, then again. Coils of pressure wound tighter and tighter within her, bursting one upon the other in a series of dazzling explosions. With each cataclysm she thought she could not possibly bear any more, but Joseph persisted. Ignoring her breathless pleas that were blatantly contradicted by the radiant response of her body, he drove her again and again over the edge of fulfillment and beyond.

The convulsive trembling of his body signaled his own release, but did not end his ardent siege of her passion-fired senses. A gasp of disbelief broke from her as he remained inside her, growing swiftly hard again.

The explosion of ecstasy they found together was so intense that in its shattering aftermath Sara instinctively nestled against him, needing to be held and soothed, as he had always done before when they made love.

But the languid peace of her body was abruptly shattered when Joseph turned away, denying her the comfort of his nearness and leaving her to slip into sleep alone and bereft.

When she woke hours later it was raining outside. The heavy splatter of drops against the walls of the hogan was matched by the slow trickle of tears down her cheeks. She had been crying in her sleep and awoke to find the pillow beneath her head damp with moisture.

Why had Joseph behaved so coldly? The effect of his ab-

rupt withdrawal after being so intimately united with her was devastating. She felt shattered into a thousand pieces.

Though she could feel the length of his body pressing lightly against her, she was afraid to move. The tenuous bonds still holding her together seemed incapable of enduring the slightest strain.

Long moments passed before she realized he was awake. Joseph shifted just enough so that he could see her. His eyes swept over her ashen face, taking in the marks of tears on her pale cheeks and the trembling of her swollen mouth.

An anguished moan broke from him. "S-Sara . . ." As his hand moved toward her, she almost flinched. But at the last instant some instinct held her still. The fingers that brushed her cheeks were infinitely gentle. When his mouth followed, she offered no resistance. Docilely, she lay under him as he kissed away every tear. Only when he was done and his head was buried in her shoulder did she find the courage to murmur, "W-why . . . ? Oh . . . Joseph, why did you let it end like that?"

She felt him swallow tightly before he answered. Propping himself up on his elbows he stared down at her intently. "Sara, I am truly sorry I hurt you. But out there by the pool, when you said you didn't want to talk, something just snapped inside me."

That much was now obvious. What she still didn't understand was the root of his anger.

When her turquoise eyes darkened with bewilderment, he rolled onto his back, carrying her with him. She was nestled close against him before he said, "It made you seem like too many other women I've known. In the past, it hasn't really mattered to me if a relationship was based solely on sex. But now I find it does matter, a lot."

He stared down at her intently, forcing her to meet his gaze. "I want far more from you, Sara. To be honest, I want everything that's in you."

A shiver ran through her. This was the moment she had dreaded, even as she knew it was inevitable. So softly that he could hardly hear her, she murmured, "I'm not sure I can give that, Joseph. But even if I could, it would have to

be reciprocated. If you're truthful, I think you'll admit you aren't certain you could give as much either."

He sighed deeply. "I know. What we've shared has been . . . extraordinary. And in a sense, it's unreal. We've snatched something out of the rest of our lives. It seems we're both aware that what we have together won't necessarily survive if we try to transplant it beyond this single place and time."

Her eyes were dry as she slowly nodded. Before she had a chance to reconsider, she asked, "How much of this do you think has to do with the fact that you're Navaho and I'm white?"

Her frankness must have surprised him, for he hesitated a moment. Something that looked very much like admiration darted through his eyes. "I should have known you'd come right to the point. Well, how about it? How much do you think that matters?"

"More than I wish. We share a great deal, but we also come from very different starting points. Our experiences and expectations are miles apart. And that's just as far as the two of us are concerned. You've become a symbol to many of your people of what they can achieve. I think deep inside you're afraid that by being involved with a white, you're betraying them."

"I had hoped," he admitted huskily, "that had not occurred to you."

Her soft, wistful laugh was muffled by his chest. "I wish it hadn't. But there's no getting around the fact that a legacy of enormous hatred and mistrust separates our people. For a single man and woman to attempt to overcome that would require an absolute commitment to each other."

"Are you so sure we don't have that?"

"No," she acknowledged. "Right now, I'm not sure of anything. That's the problem."

His arms tightened around her. "That's why you want to go home?"

Sara blinked back the tears that were threatening once again. " 'Want' isn't the right word. I have to."

A hand tenderly stroked her hair. "And 'home'; is that the right word?"

"I don't know. I've felt very much . . . at home here with

you. Maybe if we could experience that beyond this place
. . ." Rising up suddenly, she entreated, "Oh, Joseph,
come back with me. Let's find out together if we have what
it takes to surmount everything between us."

His eyes were full of regret as he shook his head. "No,
Sara. You have to find the answer in your world, and I
have to find it in mine. To do otherwise would be to betray
ourselves and each other."

She had known what he would say even before he spoke,
but the words were still hard to bear. It didn't occur to her
to try to persuade him. She was too certain that he was
right. The conviction that these might be the last hours
they would ever share as lovers made Sara's decision for
her. Rather than waste them in futile recriminations or
pleadings, she would put them to the best possible use.

Her arms reached round him, melding them together.
The ripe peaks of her breasts teased his chest. "Make love
with me, Joseph. And this time let it be everything we
share, whatever that may be."

He studied her silently for a long, tender moment. The
light in his onyx eyes made her tremble as his mouth came
down to meet hers.

The union that followed suggested there was still hope
that the answer they would find in their separate places
would be an affirmation of love rather than an admission
of impediments they could not surmount. Joseph was infi-
nitely gentle and considerate, but he was also yielding. He
allowed her free rein to explore his body fully.

Inspired by his trust, Sara let her body fully express
what her mind and heart could not yet accept. Every touch
of her hands and lips spoke of love unhindered by the
slightest doubt. Every stroke of her skin against his was a
promise of eternal devotion. Every unrestrained response
was an appeal he did not ignore.

His body spoke as clearly as her own. The covers were
kicked aside as they lay entwined across the bed. His
mouth adored her as his hands brought her to dazzling life.

Without hindrance, they soared on a crystal clear note of
the purest rapture. Lifting higher and higher, they passed
borders both had thought must be the final limits of sensa-
tion, only to find them giving way to a shimmering region

of sustained ecstasy through which they drifted endlessly. Physical barriers dissolved, as did individual awareness. In an instant snatched from everything that had gone before or was to come, they joined in a shatteringly complete union made all the more precious by its fleetingness.

Even as they drifted back to sleep, the first tentative rays of light were showing over the eastern horizon. Their time together was ending. Whether it would ever come again remained to be decided.

Chapter Fourteen

"YOU'LL DRIVE carefully?" Joseph asked, leaning against the car into which they had just loaded the last piece of her luggage.

Sara nodded without looking at him. There had been too many partings lately; from Don, from Bright Star, from ideas about herself that weren't yet replaced. Since she had to get through still another, she was going to make it as short as possible.

"I'll be fine. The weather's clear and you said yourself it will stay that way." Turning the key, she managed to glance up at him brightly. "When you get back, give me a call. I should have the show pretty well planned by then."

Neither one mentioned that they might, or might not, have a great deal more to talk about besides the show. Sara understood Joseph's conviction that they needed time apart to discover what they might have together; she even agreed with him. But that didn't make it any easier to leave. A vital part of herself was remaining behind.

Although she had let Joseph believe she would stay overnight in Flagstaff, she ended up driving straight through to Phoenix. The thought of a night alone in a motel room forced her to keep moving. It wasn't until she was back in the comfort of her own apartment that some of the tension eased from her.

As she unlocked the door and pushed it open, she felt a faint sense of surprise that the world she had left behind a short week before still existed. So much had happened to her since then that it was startling to find everything just as she had last seen it. Her plants were a bit dry, there was

a small amount of dust on the furniture, but other than that it was all exactly the same.

Relief flowed through her as she realized that whatever else might lie ahead, at least there was still a familiar place where she could relax and regain some sense of herself apart from Joseph.

But that proved even more difficult than she expected. As she went about the routine tasks of unpacking and getting ready for bed, he was in her thoughts constantly. She caught herself wondering what he was doing, whether he was thinking of her, whether he felt the same gnawing emptiness. Not until she had completely exhausted the small store of energy left over from the long drive did she at last slip into sleep. Even then, Joseph followed her in dreams that alternately aroused her and left her weeping.

By the following morning when she opened the gallery, she understood that the shattering interlude they had shared in the desert was going to affect her for some time, perhaps forever. But she also knew that she had to go on. There was no question of simply sitting around hoping that Joseph would decide he couldn't do without her. She had her own needs and priorities to consider. The doubts that plagued their relationship were not his alone. She, too, had to discover if he meant enough to her to overcome all that stood between them.

Friends like Carrie helped. "I'm sorry about Bright Star," she said as they shared a pot of coffee at Sara's desk. "I know you'll miss her."

"A lot of people will. She was an incredible woman. I just hope the show I'm going to build around her work will do her justice."

"I'm sure it will." Carrie hesitated a moment, before she asked, "What about Joseph's show? Is that going well?"

Sara shrugged, suddenly busy adding sugar to her cup. "I guess."

"You don't sound very excited about it."

"Oh, I am, really. It's just that . . ."

She broke off, without realizing that her bleak expression told Carrie all she needed to know.

Gently, her friend said, "Look, I don't want to intrude,

but sometimes it helps to talk. Did you two . . . get involved out there?''

Sara managed a faint smile. That was such an innocuous way to describe what had happened between her and Joseph. A low sigh escaped her. "Yes . . . I guess we did. Or at least, I did. I'm not sure how he feels.''

Carrie frowned. "Didn't he tell you?''

"Oh, we talked, all right. In the end, we didn't have much choice. What it came down to is that neither of us is sure our feelings are enough to make up for all the differences between us, and for the problems we'll face if we try to make a life together. So we agreed we need some time apart.''

Sara laughed ruefully. "That's exactly what Don and I decided, too. I seem to have a real knack for getting all the way to the brink and then not knowing what to do about it.''

"The two cases aren't really the same, are they?" Carrie asked gently. "There's rather more at stake with Joseph.''

"Yes," Sara admitted, flushing slightly at the reminder of how much further that relationship had gone. "But you have to take into account where we were. In the desert, we seemed cut off from everything. There was no past or future, no world beyond what we made for ourselves. For a while, it seemed perfect. Even when Bright Star died, we were able to comfort each other in a way I've never known before. But eventually, we had to come to terms with the fact that there was a larger world; two, really, Joseph's and mine, with a lot of conflicts between them.''

"Lots of people from different worlds manage to make it together," Carrie pointed out. "What makes you think you can't?''

"I don't think that, not for certain. But it's impossible not to ignore the fact that there's been an enormous amount of hatred and pain between the Indians and the whites. Any couple who tries to bring the two together inside a marriage is going to need enormous love and commitment, or they won't stand a chance.''

"So you think that by being away from Joseph, you'll find out whether you care enough for him to stand up to all the problems?''

"That's the idea."

Carrie thought that over for a moment before nodding decisively. "Well, you sure won't come to any conclusions sitting here. Care for a piece of advice?" When Sara nodded, she went on, "Call Don Campbell. Find out how much the two of you still have going. If it's more than just friendship, you'll know you're not as hung up on Joseph as you thought."

The idea tempted Sara. Whatever else she might feel for Don, she liked him enormously and had missed him. But that didn't give her the right to use him to try to discover the full extent of her need for Joseph. Of course, it didn't have to be that way. They could just get together to talk, catch up on news, enjoy each other without necessarily becoming any more entangled than they already were. Or could they?

Between one thought and the other, Sara managed to dither around for several days. She kept busy at the gallery, where business was better than ever. At the rate she was selling the works on display, few would have to be removed to make room for Joseph's show.

The rancher who had bought Bright Star's rug came around to say how much he was enjoying it. When told of the old woman's death, he was deeply saddened. Sara managed to cheer him up a bit by describing the weaving exhibition she was putting together. His interest and the sincerity of his regret over the loss of the artist brought home to her once again how many people from different backgrounds were touched by Bright Star's work. She had seen that happen over and over again with artists of extraordinary caliber who managed to touch people in fundamental ways no matter what their origins. Certain things, it seemed *were* truly universal.

Joseph was another of those who communicated across the chasms of disparate cultures and perceptions, at least in his work. It remained to be seen if he could do the same in his personal life.

By the end of the week, Sara found herself wondering if he was back in town. Though he hadn't said how long he planned to stay in the desert, she sensed he would not be able to remain away from his studio for any extended pe-

riod. Sooner or later, the lure of paint and canvas, stone and metal, would compel him to return. He might be there already, at the other end of the phone. All she had to do was reach out for it.

Sara stared at the phone, struggling against the impulse that flared inside her. She lost the battle, but in a sense won the war, for the number she punched out wasn't Joseph's. It was Don's.

As she hoped, he was still at the office. The voice that snapped at her over the line sounded tired and curt.

"Campbell."

"Don . . . it's Sara . . . I just wondered how you were."

"Sara . . . I wasn't expecting . . . that is, I'm glad you called."

So was she. Now that he was less impatient, his voice was reassuringly familiar. She was smiling as she said teasingly, "You didn't sound it when you picked up the phone. I thought you were going to bite my head off right over the wire."

Don laughed. "Sorry about that. I guess I haven't been in the greatest mood lately."

Perhaps not, but his mood seemed to suddenly improve— enough so that Sara felt she could safely ask, "How's the Center doing? Are you still on schedule?"

"Yes, but only because I held the city council's collective feet to the fire. They came through with the money for overtime, so we're still slated to open next month. But that's enough about work. How are you?"

The question held a wealth of meaning, which Sara wasn't particularly eager to deal with just then. "Oh, I'm fine," she hedged. "Busy with the gallery, of course."

There was a pause before he said gently, "I read in the paper about Bright Star's death. She meant a great deal to you, didn't she?"

So he had noticed. Sara had never been sure how much of her involvement at the gallery got across to Don. He was always so caught up in his own projects. But to be fair, she knew he could say the same of her. They both tended to concentrate on their work so intensely as to sometimes seem oblivious to everything else.

Maybe it was still possible to change that. Sara was

getting her nerve together to invite him over for dinner when Don preempted her. He had clearly been thinking along similar lines.

"Look, I'd really like to see you again. Are you free tomorrow?"

"Yes."

"Good. I'll pick you up early. We'll make a day of it. Okay?"

It was better than good, as Sara told him before hanging up. She felt immeasurably happier after talking to Don. None of her problems with Joseph were solved, but at least she was doing something about them. As Carrie had said, she wasn't going to come to any decisions sitting around by herself.

That evening she washed her hair, did her nails, and rooted through her closet until she found an outfit she hadn't worn very often but which looked terrific on. Laying it out, she debated whether or not to go to bed early. A good night's sleep would be a welcome change, but the chances of not lying awake were slim.

Rather than risk it, she got out the vacuum cleaner and went on a tidying binge. It had been longer than she cared to remember since she had really given her apartment a thorough going over. Scrubbing the bathroom floor at midnight, she was surprised to discover the tiles were blue rather than the dingy gray she remembered. The kitchen also came in for a long-overdo evacuation, though she drew the line at stripping the waxed floor. Enough was enough, she thought dimly as she at last stumbled into bed. She was asleep almost before her head hit the pillow, and remained in blissful oblivion until the alarm clock went off the next morning.

For as long as she had lived on her own, Saturdays were laundry day. Sara was barely awake as she stuffed the contents of the hamper into her small machine while the coffee perked. By the time it had spun through its last cycle and was ready for the dryer, she had showered, started on her second cup, and was feeling rather more human.

A glance in the mirror revived her further. Her stay in the desert had deepened the apricot tones of her skin and made her turquoise eyes look even larger and brighter.

She made up her face more out of habit than need, and was satisfied with the results before she had gotten past a minimum of mascara and lip gloss.

The outfit she had chosen looked deceptively simple. The jeans were soft and well made, with discreet embroidery at the waist and pockets. The blue-green stitching matched the knit top whose short sleeves left her arms almost bare. With her hair falling unhindered to her shoulders and a smattering of freckles showing clearly on her upturned nose, she looked closer to eighteen than twenty-eight. It was only when she moved, and the snug fabrics slung to her curves, that the simplicity was replaced by a womanliness no young girl could match.

Feeling good about herself, Sara settled down to wait for Don. She had barely gotten through the first page of the morning paper when the low purr of his Porsche alerted her to his arrival.

She went to the door a bit nervously. After being with Joseph, how would she react to Don? Would there still be that spark of sensual awareness that had existed when they first met? And if it was still present, what did that mean about her feelings for the man in whose company she had just spent the most physically enthralling days of her life?

Catching her breath, Sara pulled the door open. Her eyes settled on Don climbing out of the low-slung sports car. She had her answer immediately. Dressed in chinos and a cotton shirt, he looked every bit as compellingly male as she remembered. His hair glowed like beaten gold in the sunlight. The beard that now neatly covered the bottom part of his face gave him a decidingly rakish air. His long, lean body moved gracefully as he walked toward her, a tentative smile curving his mouth.

The smile widened as he saw the look in her eyes. His voice was husky as he took her hand, his lips brushing hers. "How you doing, honey?"

The touch of his mouth against hers was undeniably pleasant. A little shiver of enjoyment ran through her even as she wondered how she could react so unmistakably to him after all she and Joseph had shared. No matter how she thought she ought to behave, her body had ideas of its

own. Don was an extremely attractive man, a fact she was clearly unable to overlook.

"I'm fine," she murmured, standing aside to let him in. As she did so, she was acutely conscious of his gaze moving over her appreciatively.

"You sure look fine." A mischievous grin lit his eyes. "I hope you're feeling the same way. I've got kind of a busy day planned for us."

Pouring him a cup of black coffee, the way he liked it, Sara glanced up at him. "Oh? Just what have I gotten myself into?"

"Nothing worse than a visit to Papago Park." He laughed as her face lit up. "Been a while since you were there?"

"Ages! Can we still rent bikes?"

"I sure hope so, since when I called this morning, there didn't seem to be any problem."

The park had been one of Sara's favorite places when she first moved to Phoenix. Its miles of trails wending through scenic desert and around several small lakes were a welcome refuge from the city. But since her return, and with all the pressures of the gallery, there had been no time for such excursions. She was delighted Don had remembered the place, and sure that she would enjoy it.

They had barely entered its boundaries when she began to feel herself relaxing. Parking at the far end, they walked passed the botanical gardens and the zoo, pausing to linger at one of the lakes where a cluster of children were fishing.

"I used to come here when I was a kid," Don said softly. "Didn't really matter whether we caught anything or not, it was fun just trying."

"I know what you mean. There was a sink hole on our ranch where I fished. The few times I hooked something I didn't know whether to be happy or sad. I always ended up tossing it back."

Don laughed, looking at her tenderly. "You're too softhearted. Anything we caught, we ate."

They walked on, eventually finding the stand where they rented a couple of bikes. Don strapped the hamper he had brought to the back of his, still resolutely refusing to

divulge its contents. The route they chose took them into one of the lesser used parts of the park, away from most of the weekend visitors and far from the stadium where the San Francisco Giants were holding spring training to the delight of a large, noisy crowd.

Following the winding trails for several miles, they eventually found their way to a secluded grove of citrus trees nestled next to a lake. The heady perfume of lemon and orange blossoms filled the air as they left the bikes and strolled down to the edge of the water.

A family of ducks swam by at a discreet distance, keeping an eye out for whatever might be in the hamper. Don spread a blanket under one of the trees and Sara helped him unpack what appeared to be a feast. By the time all the roast chicken, smoked ham, pâté, cheese, fresh baked bread, raw vegetables and small, perfect strawberry tarts were laid before them she was laughing helplessly.

"Who else is joining us?"

He shot her a guileless look as he uncorked a bottle of Chablis. "No one, I hope. I just didn't want you to go hungry."

"You've forgotten I keep meaning to diet."

"No I haven't, I'm just determined to discourage such a crazy idea." Flopping down beside her, he filled two of the long-stemmed glasses she had found carefully wrapped in the hamper and touched his to hers. "A toast." His eyes met Sara's over the crystal rims. "To friendship. Everything else has to begin there."

She drank slowly, postponing the moment when she had to answer. Finally, hesitantly, she said, "Is that what you decided since we saw each other last?"

Don nodded. "Yep, that's my big philosophical breakthrough for the year. Friendship is highly underrated."

"I agree," Sara said slowly. "It seems as though whenever a man and woman start getting to know each other, we spend all our time wondering if we should go to bed and ignore a lot of other things that are really more important."

Don's hazel eyes touched hers, holding them as he said, "What do you say we try those other things first and see where they lead?"

Sara's throat tightened. She could not escape the feeling that he was offering her both a rare gift and a reprieve. Softly, she murmured, "I'd like that."

His hand swept over the food laid out on the blanket. "Then let's dig in, before I feed it to the ducks."

Laughing, Sara reached for a chicken leg. The serious moment ended, but was not forgotten. The agreement they had struck dissolved the lingering uncertainty between them, and enabled them to fully enjoy both the picnic and what came afterward.

When they had eaten everything they possibly could, the ample leftovers were packed away, except for the bread which the ducks finished off. After the last of it was torn into pieces and tossed in the water, they strolled slowly around the lake. Sara's hand was in Don's, their legs brushing as they walked. They spoke little, content with the peace and with each other.

Back under the tree, they talked off and on about the Center and the gallery, until Sara broke off in mid-sentence, finding herself yawning.

Don grinned. "I feel the same way myself. How about a nap before we start back?"

"Sounds good," she admitted groggily. "I guess I didn't get as much sleep as I should have last night."

"Any reason in particular?" he asked as she settled into the crook of his arm.

Sara smiled reluctantly. "I was housecleaning."

"I thought the place looked different," Don teased.

She barely managed a halfhearted glower before the effort to keep her eyes open became too much. All that good food and exercise, coupled with the relief of knowing that their relationship was back on a solid, if still ambiguous footing, made her too relaxed to stay awake. She let him draw her to him without protest, knowing that Don was just as tired. They fell asleep together, her head on his chest and his arms wrapped around her.

Sara woke as the sun was slanting across the lake. Her body was stiff from sleeping on the ground. She grimaced slightly as she stirred. Her expression gave way to sur-

prise when she found Don already awake and looking at her.

Propped up on an elbow, he grinned crookedly. "You sure do look good asleep. All soft and warm, with your hair a little rumpled and your lips parted just the tiniest bit."

Blushing, Sara tried to sit up, only to be stopped by Don's hand, gentle but insistent on her arm. "Don't get jumpy," he murmured. "We're friends, remember?"

She did, only too clearly. She also remembered what it was like when he kissed and held her, how good his body felt against hers, how easy it was to want him. The imperviousness she had hoped her experience with Joseph would give her clearly did not exist. She desired Don every bit as much as she liked and respected him.

So why, she wondered as his mouth came down to hers, did she think she didn't love him?

Chapter Fifteen

"YOU TASTE good," Don murmured, "like flowers . . . and wine . . . and strawberries . . . all rolled together."

As he spoke, he dropped gentle, searching kisses on her mouth. Sara felt no urge to resist him. His touch was exciting without being demanding. Lying with him under the tree, still half caught in sleep, she was content to at least find out how far he wanted to go.

The pressure of his tongue probing lightly against her teeth provoked her to part her lips further. His kisses deepened, grew more passionate, and still she did not draw back.

Long, sweet moments passed before the conviction that she was somehow being disloyal to Joseph began to gnaw at her. But even then, she did not try to stop Don. Instead, she simply reined in her unruly conscience and stuck it away in a convenient corner of her mind.

After all, why should she feel guilty about what she was doing? Despite the intimacy they had shared, she and Joseph had no commitment to each other. The lack of any promises between them was exactly why she was lying there in the park, in Don's arms, trying to decipher the secrets of her own heart.

Yet, knowing all this, she still could not quite shake off the sensation that what she was doing was wrong. A little voice in the corner of her mind grew stronger and stronger, until finally she could no longer ignore it.

Don seemed to understand exactly where the line lay between her acquiescence and resistance. He drew back just short of it, leaving them both breathing hard.

Huskily, he muttered, "I think we'd better head home, friend."

Sara agreed. Her heart was beating uncomfortably fast and her knees were weak, normally good indicators that everything was going fine. But in this case she was afraid they were symptoms of something else.

Don't try to force it, she warned herself. Don't jump at what Don's offering because Joseph is too much of a challenge. Good advice, but hard to take, especially when she considered the deep affection she felt for the man who held her hand gently all the way back to the car and smiled at her warmly when he left her at her door.

"I'll call you soon, okay?"

Sara nodded. She wanted some time to herself to think things over, but she also knew she wanted to see Don again. She just wasn't sure exactly why.

She was no closer to finding out when the new week rolled around. Settling back into her routine at the gallery, Sara decided to explore the cost of repainting the interior. It was amazing how quickly the display walls collected smudges and cracks, no matter how careful she was to wipe up after careless customers. For an ordinary showing, they would pass without any problem. But for the first exhibition of new works by one of the country's leading artists, everything had to be perfect. So she got on the phone and started collecting bids.

The results weren't as bad as she had expected. The bid she finally accepted hardly made her gulp, although just a few months before the idea of spending so much would have horrified her. It pleased her to realize that the growing success of the gallery had changed her perspective on money and made it far easier to maintain the standards she wanted.

She could even see her way clear to making some further additions to her wardrobe, so when she closed the gallery up that evening she went over to Carrie's. The boutique was having a sale. With her friend's help, Sara found several outfits she liked.

Wrapping them up, Carrie shook her head teasingly. "What turned you into a drunken sailor on a spending

spree? It used to be a battle just to get you to buy one dress, let alone four."

Sara shrugged, not caring to examine her motives too closely. "I guess I'm just in an extravagant mood."

"Hmmm." Carrie looked at her steadily, her large blue eyes missing nothing. "Does that extend to having dinner out, or are you already busy?"

"Why no, I'd love to. But what about Bill?"

Bill Dawson was Carrie's lawyer friend and, unless Sara was very much mistaken, her likely husband. They had spent almost every evening together for the last few months. She was surprised there should be an exception.

"Bill's got a meeting tonight," Carrie explained. "He's started doing some free legal work for a couple of self-help groups, and the only time they can get together is in the evening."

"Do you mind?" Sara asked as she helped lock up the boutique.

"I can't say I do. Oh, I miss him and all that, but sometimes I think it's a good thing to have to do without someone from time to time. Stops me from taking him too much for granted. Besides, what he's doing is very important to him. I couldn't ask him to give it up."

"What if things were turned around? Do you think Bill would feel the same way?"

"That hasn't come up yet," Carrie acknowledged, "but yes, I'm reasonably sure he would. I've learned to trust Bill and have faith in him, otherwise we wouldn't be talking about marriage."

"Is it more than just . . . talking?"

"I guess we've progressed to planning," she admitted with an engaging grin. "We're thinking in terms of a small ceremony late this summer."

"Oh, Carrie, I'm so glad for you!" Sara exclaimed. Her pleasure was completely genuine, unaffected by any consideration of her own dilemma. She felt her friend was an exceptionally warm and giving woman who deserved the greatest happiness. And now it seemed that she had at least a chance at it.

"Tell me all the details. When did you decide? Was it terribly romantic? He didn't get down on one knee, did he?"

"Practically," Carrie laughed. Freed of any concern about how Sara would react, her pleasure shone unrestrainedly. "We were . . . uh, sitting on the edge of the bed one morning, and he started talking about marriage again—in very general terms, as we have before. But then . . . I'm not sure exactly what happened . . . but all of a sudden it wasn't so general anymore." A soft giggle escaped her. "It took me a couple of minutes to realize he was serious. But believe me, once I did, I didn't waste any time accepting."

"I should hope not. From what I've seen of Bill, he's a wonderful man. I just know you'll be happy together."

To celebrate, Sara insisted on buying them dinner at Nature's Cupboard, a popular restaurant that had opened recently. It was a refinement on the usual health food establishment, offering both fresh, nutritious entrees along with a modest wine list and even a few wholesome desserts.

Over a cracked wheat and bean sprout salad with tahini dressing, Carrie warned, "Now that I'm getting married, I'd like to see all my friends in the same boat. Not to sound unsubtle or anything, but are you seeing Don again?"

"You shouldn't beat around the bush like that," Sara countered good-humoredly. "If you want to know something, just come out and ask."

"All right, so maybe it isn't any of my business. But don't blame me for developing a belated matchmaking streak. I spent so long getting myself together with the right guy, that now I can't stop. I'll just have to switch my efforts to someone else. Want to be my first project?"

"No, thanks! I've got more than I can handle right now."

"Lucky girl. Tell me all about it."

Sara sighed resignedly. "If I do, will you stop fiddling with your salad and actually eat something? Getting married is hard work, you need to keep up your strength."

Carrie obligingly swallowed a forkful of bean sprouts, encouraging Sara to continue. "Yes, Don and I are seeing each other again. Or we have once, and I think we're going to continue, at least for awhile."

"And . . . ?"

A slight flush darkened Sara's high boned cheeks. "And

it's just the same. He's still a terrific, warm, sexy man whom I really enjoy being with. I don't feel any differently about him than I did a few weeks ago before I met Joseph. If anything, I like Don even more now that I've gotten to know him better."

Carrie nodded understandingly, which struck Sara as remarkable since she couldn't begin to fathom the situation for herself. She was staring down morosely at her stir-fried chicken when her friend asked, "So where's the but?"

"What do you mean?"

"The but. The 'he's a terrific man and I'm nuts about him, *but . . .*' It has to be there, or you wouldn't look so down in the dumps."

"Oh, *that* but . . ."

"Hmmm."

"It's there all right, though I sure can't figure out why."

"I can," Carrie informed her serenely. "I'll even give you a hint. It's two words, first one starts with a 'J,' second with an 'H' and they add up to one hell of a man whom you just can't get out of your mind."

"You're wrong," Sara insisted. "If I really cared as much about Joseph as I had hoped to discover, how could I still respond to Don so easily? Why, I came that close to going to bed with him . . ." She held up two fingers, nearly touching.

Carrie looked unimpressed. "You're not listening to yourself. You like Don, you respond to him, you *almost* went to bed with him. Honey, almost doesn't count. If we were liable for what we *almost* do, or think about doing, we'd all be in a hell of a mess."

"But I still may make love with him. I just don't want it to be for the wrong reasons."

"You mean as a stand-in for Joseph?"

Carrie's bluntness made her wince, but Sara couldn't deny that her friend had an accurate grasp of the situation. She nodded unhappily.

Sympathy filled the bright blue eyes fastened on her. "Look, let me tell you something I've discovered since I started dating Bill. In the beginning, we were still both seeing other people. A couple of the guys I went out with were really nice. I liked them and I found them very desir-

able. I *thought* about going to bed with them. If Bill hadn't existed, I might have. But I didn't, although I wasn't at the point where I could admit even to myself how I felt about him. Something stopped me. My guess is that the same thing's happening to you."

With equal frankness, Sara asked, "Do you still find other men desirable?"

"Sure do!" Carrie laughed unrepentantly. "Being in love isn't the same as being dead. There's no way I'll ever be unfaithful to Bill, but I can still look at an attractive man and wonder what he'd be like in bed. Heck, I can even feel tempted. The point is, when you really love someone you don't give in to the temptation, no matter how strong it is."

"And you think that's what's happening to me with Don?"

"You're the only one who can answer that, but it sure seems possible."

Carrie just might be right, Sara reflected several days later when she thought over their conversation. Maybe she wasn't in any real danger of trying to substitute Don for Joseph. Maybe her ability to like and desire another man had nothing to do with whether or not she could actually become physically involved with him. Maybe her heart was trying to tell her head something that just wasn't getting through.

There seemed only one way of finding out. When Don called again, she invited him over for dinner.

Sara smiled as she recalled an article she had read which speculated that the sexual revolution had made it more intimate to cook dinner for a man than go to bed with him. Certainly, it involved more time and thought.

It had been quite a while since Sara had done more in the kitchen than scramble a couple of eggs or toast a muffin. It took the better part of an evening to find her pots and pans, dig out a cookbook, decide on a recipe, and make a shopping list.

The following day was taken up with cleaning—which was becoming a discouragingly regular pastime—and cooking. Ruefully, she decided that if she couldn't keep her

life neat and tidy, she could at least straighten up her apartment. A bouquet of fresh irises and tulips added the final touch before she got down to the serious business of cooking.

Several hours later, she paused to rub the small of her back and look round rather dazedly at the debris of mixing bowls, utensils, empty packages, and her much-abused food processor. Besides artichokes stuffed with shrimp, veal piccata, and a vinaigrette salad dressing, she had concocted a white chocolate soufflé accompanied by ripe raspberries and lace cookies flavored with ginger. Only the knowledge that Don had both a healthy appetite and an appreciation for good food encouraged her to believe her efforts were worthwhile.

After a leisurely, jasmine-scented bath and a brisk body massage with similarly perfumed lotion, she slid into an apricot silk blouse with a high, ruffled collar, and a straight, ankle-length black skirt. Resisting the urge to put her hair up, she left heated rollers in it just long enough to turn the ends under, then brushed it smooth.

By the time Don arrived, she had sprinkled potpourri on the fire, which was burning gently, turned down the lights and lit some candles.

The elegantly tailored, gray suit he wore emphasized the breadth and strength of his lean body. He smelled faintly of sandalwood shaving lotion, and he looked almost too good to be true.

Pausing at the door for a moment, he took in Sara, the room, and the aromas wafting from the kitchen. The lazy smile he gave her sent a quiver down her spine.

"All this in return for my little picnic?"

Shutting the door behind him, Sara took the opportunity to get her breath back before she said, "I seem to remember a few dinner dates thrown in somewhere."

Don shrugged. "A man's got to eat." Holding out a bottle of wine, he added, "Although if those smells live up to their billing, I'm in for a bit more than barbecue and beans."

"Good thing," Sara informed him archly as she glanced at the excellent Pouilly-Fuissé he had brought. "This wouldn't do anything for barbecue." She brushed a light

kiss across his cheek. "Want to get comfortable while I put on a few last touches?"

He shook his head, following her into the kitchen. "I'll just keep you company."

He made himself useful mixing a couple of light gin and tonics as they chatted about nothing in particular. Sara glanced at him from time to time, discovering that she enjoyed having him lounging around her kitchen. He was easy to be with. He made her pleasantly aware of herself as a woman without unleashing the tidal waves of need she had experienced with Joseph. They could laugh together and chat amiably without being absorbed by deeper undercurrents.

But over dinner, which Don lavishly complimented, the relaxed atmosphere gave way to something more. It happened gradually, their talk drifting from one topic to another until, in a brief pause, he leaned back in his chair and regarded her thoughtfully.

"Sara . . . friends should be honest with each other, shouldn't they?"

The turquoise pools of her eyes darkened. The thought darted though her mind that it was going to be very ironic if after all her agonizing over her motives for desiring Don, he preempted her by announcing he wasn't interested.

"Uh . . . yes . . . sure."

"Good. Then suppose you start by telling me what happened to you while you were away."

"A-away?"

"Last week. I called the gallery twice and got no answer. So I drove by one evening after work and saw the sign on the door. Where did you go?"

Simple decency demanded that she answer him. "To see Bright Star."

Sympathy made his hazel eyes gentle. "So you were with her when she died?"

Sara nodded. She took a deep breath. Smack up against the subject she had known was inevitable, she could only hope to handle it honorably. "So was Joseph."

If she had expected Don to be startled, she was disappointed. He only looked at her gravely as he said, "I fig-

ured he had to be mixed up in this. The two of you spent some time together?"

"Yes . . . Don, this honesty you feel friends should share, does that extend to things that might be hurtful to one or the other?"

He grimaced wryly. "Sounds as though you're going to tell me something I won't like."

"I don't know how you'll feel, but I couldn't live with myself if I misled you or lied to you in anyway. Besides the fact that I like and respect you a great deal, you just deserve better. Joseph and I got very . . . involved while we were both out in the desert. But I came back here alone because neither of us was sure we could share anything lasting."

"And you thought seeing me would help you decide?"

It was Sara's turn to wince. "You have a right to be angry."

To her surprise, Don shook his head. "No, I don't think I do. You haven't done anything wrong, as far as I can see. I knew you were attracted to Highrock and that it was mutual. That was obvious. Oh, I admit I was hoping to stake a claim on you first, but it just didn't work out that way. The question is, what happens now?"

Deeply touched by his tolerance, which she knew could stem only from genuine regard and affection, Sara had difficulty answering. Her voice was low and thick as she murmured, "I don't know."

Don refilled both their glasses before he asked gently, "Are you in love with him?"

"I-I think so."

"You aren't sure?"

Unhappily, she shook her head. "I always thought that when I fell in love, it would blot out everything else. I wouldn't even be aware other men existed, much less want any of them. But instead I find that . . ."

"That what?"

"That I like you more than ever, and admire you, and that . . ."

A tiny grin lit his face. "That I still turn you on?"

Sara blushed painfully. She refused to look at him as she nodded.

Don was silent for so long that she was finally forced to glance up. When she did, her breath caught in her throat. His expression was so tender. Without speaking, he put his glass down, stood up, and held out a hand to her.

Sara accepted it mutely. She allowed him to guide her over to the couch in front of the fire, where he left her briefly as he poured two snifters of brandy.

"So," he said at last as he settled down beside her, "what's the problem? That you feel the same way about Highrock?"

"That's part of it," she admitted. Hesitantly, unsure of exactly what she was saying, she added, "but what really bothers me is that two sets of the same feelings don't seem to add up to the same total."

Very gently, Don touched a finger to her cheek. "Maybe that's because love is more than just the sum of various parts. It's something extra, something undefined. It can't be analyzed or explained; it just is."

Softly, because it was suddenly difficult for her to breath, she murmured, "It also hurts a lot."

"Is that why you're trying to deny it, even to yourself?"

"I'm not . . ."

"Yes, you are. You don't really want to think about your feelings for Joseph, because you're afraid he may not return them. So you tell yourself they can't be as serious as they appear or you wouldn't still be attracted to me. But, honey, that just doesn't wash."

More gently, he said, "Sara, we've got a lot going for us. We like the same things, we share a lot of the same perspectives, and we're very compatible physically. That's about the most anyone can ever hope for in a relationship. I can't pretend to understand what else there might be, since I've never experienced it. But I can tell that something very special is happening to you. You've found out you're capable of more than most people can ever feel. Do you really want to turn your back on that just because it hurts?"

Mutely, she shook her head. Tears shimmered in her turquoise eyes. She didn't deserve his understanding. "I . . . I thought you'd be angry at me."

He laughed grimly. "Oh, I'd like to be. It would be an

easy release for my own disappointment. But I didn't have any claim on you when you left here. You had a perfect right to get involved with someone else, and you were clearly able to do so. But you aren't anymore, are you?"

"No . . ."

Don stood up. Gently, he tilted her chin so that she had to look at him. "That should tell you something, honey."

It did. It told her what she'd needed to find out but had hesitated to admit even to herself. She loved Joseph in a way she had never known was possible—loved him to the extent that even with a man as kind and giving as Don, she could be no more than a friend, loved him so much that her very soul ached.

Because loving him wasn't enough. She needed his love in return, and she had no confidence that she would ever receive it.

Chapter Sixteen

"YOU WANT all the walls white, right lady?"

"Off-white," Sara said automatically, hardly hearing the man sent to repaint the gallery. In the last few days, she'd had trouble concentrating on much of anything. But she did make an effort when he stared at her blankly. Patiently, she explained, "Not a bright white. More like the color of an eggshell."

"Oh, yeah, right. Eggshells."

"Just let me see the shade before you get started."

He nodded affably and took himself off to the truck parked out in front. Sara finished removing the last hooks from the walls and checked to make sure the tarpaulins reached into the furthest corners of the floor. Only then did she retreat to her office, seeking some occupation that would get her through another day.

Joseph was back in town. She knew because he had sent a list of artworks over to the gallery, along with exact dimensions and display suggestions. Very professional. She told herself to be glad of that. He might have decided he didn't want her to represent him after all. Instead, he clearly intended to go ahead with the show despite the fact that he made no effort to get in touch with her to resolve their personal situation.

It was just as well. Having discovered the magnitude of her love, she was too shaken to face him bravely. Maybe in time her defenses would be sufficiently restored to endure the possibility of rejection. But for the moment, she wanted only to lie low and store up her courage.

Carrie understood. She had invited Sara over several times and, along with Bill, done her best to cheer her up.

Laughing with the couple over their adventures with caterers, orchestras, florists, and all the other paraphernalia of weddings, she was able to put aside her own concerns, at least for a time.

But later, alone in her bed at night, she could not escape the emptiness that threatened to consume her. Too often, she woke in the darkness to find her pillow wet with tears. Her appetite was gone, she found no enjoyment in anything, and a leaden sense of depression followed her everywhere she went. The phrase "unrequited love" was taking on a whole new depth of meaning.

"This the shade you want, lady?"

Sara turned, pulled from her thoughts by the sudden appearance of the painter holding out a color chip. She glanced at it absently. "Yes, that's it."

He turned to go, then apparently remembered something, because he asked, "That panel truck outside, is it yours?"

Sara nodded.

"Better get out there then. A cop's ticketing you for parking illegally."

It figured. Every single thing that could possibly go wrong in her life seemed determined to do so. Or maybe she was just hypersensitive these days, her strained nerves far more alert than usual to the petty inconveniences of modern living.

The cop was not about to be persuaded that she had only left the truck for a few minutes. "Doesn't matter," he said as he handed her the ticket. "Just pay the fine."

Walking away, he threw back over his shoulder, "And move the truck. My partner's just down the block. If he finds it here you can bet he'll write you up again."

Sara believed him. The way her luck was going, she had no choice. Muttering to herself, she moved the truck behind the row of stores, just managing as she did so to avoid a collision with a dumpster that she had passed a hundred times before without ever getting close to hitting. Pulling in at last to what looked like a safe spot, she sighed deeply. It was barely ten o'clock in the morning and already her day was a litany of annoyances, crises, and near-accidents.

The broken nail, torn stocking, and incipient cold that

had greeted her shortly after waking were only the opening salvo in a series of bombardments—the early arrival of the painters that left her scrambling to remove the last artworks from the walls, the rupture of a water pipe in the basement of the music store next door that had briefly threatened her own storage area, and the letter from the landlord announcing a rent hike.

When it rains, it pours, she thought glumly, glancing up at the thunderheads whose ominous appearance promised that Phoenix was in for a violent storm. The air fairly crackled with an electrical charge as she gave final instructions to the workmen before heading for the People's Center, where she was already overdue.

Despite all the problems he was facing, Don was bringing the project in on time, if not precisely on budget. Driving up, Sara could see that the final landscaping was underway and that the protective tape was being peeled off the last windows. Opening ceremonies were scheduled for the following week. Before they took place, her own contribution to the Center had to be set up.

The artworks she had selected ranged from modern to traditional and represented the most talented Anglo, Indian, and Hispanic painters and sculptors in the area. She still nurtured hopes of convincing Joseph to part with one of his works for the Center, but even if he did not, the level of artistic achievement would be very high.

Some of the pieces were already in place along the broad sweep of the Center's entrance hall. Sara paused to admire them before continuing on to the office where several members of the planning board were waiting.

With the gentlemen's help, her truck was unloaded and the half-a-dozen new pieces she had brought with her were carried carefully inside. As each was unwrapped, the exclamations of approval increased. Any doubts the board might still have harbored about her ability to fulfill such an exacting commission vanished as each member vied with the rest to express his thanks.

Sara should have been delighted. The Center was an outstanding showcase which could only help to build her professional reputation. But instead of the elation she hoped to feel, she could manage no more than mild relief

that the job was almost done. The struggle for achievement in her field which had once meant so much to her now seemed relatively unimportant. It wasn't that she no longer cared about her career; she did. But her capacity for enjoyment of any kind was severely deadened. Since realizing how she felt about Joseph, she had done little more than go through the motions of living. In the back of her mind, she knew that couldn't continue in this way indefinitely. But she had no idea how to stop it.

At least she didn't have to worry about facing Don. True to his word, he was proving himself a real friend. Since their last date, he had called twice, ostensibly to check on the positioning of artworks. But Sara suspected his actual motive was to be sure she was all right.

Don might not have ever experienced what she was going through, but he was astute enough to understand the toll it was taking. Any disappointment he felt at the way things had turned out between them was not sufficient to override his inherently compassionate nature. He was worried about her, and didn't try to hide it.

Glancing at herself in the mirror of the ladies room where she stopped after finishing with the board, she had to admit she looked less cheerful than her usual self. Although she had applied her makeup with particular diligence that morning, it didn't quite hide the effects of sleepless nights and skipped meals. There were mauve shadows under her eyes and her high cheekbones stood out more prominently than ever. The weight she had lost gave a fragile cast to her shoulders.

A rueful smile touched her mouth as she thought of rainy afternoons spent in the attic of her family home burrowing into trunks of old novels in which the heroines inevitably suffered a decline. In her pragmatic adolescence, the idea had seemed silly. Now she wasn't so sure.

Don apparently wasn't either. He was frowning as he greeted her at the door of the construction trailer. "Come in and sit down. You look like a puff of wind would blow you away."

"Thanks. There's nothing like flattery to make a girl feel good."

Pouring her a glass of orange juice instead of the coffee

she had asked for, Don stood by while she sipped it grudgingly. Only then did he flop down in the chair across from her, studying her so intently that she squirmed.

"Seriously, you've got to take better care of yourself. Not eating or sleeping properly isn't going to change anything."

"You think I don't know that? I keep giving myself pep talks, but somehow they don't seem to take."

Don smiled compassionately. His voice held a tinge of awe as he said, "You've really got it bad, haven't you?"

Sara shrugged. His sympathy threatened to overwhelm her. She still felt a bit guilty about the way she had turned to him to clarify her feelings for Joseph, even though he had made it clear he didn't hold a grudge.

"I'll survive. At least everything at work is going well. How about you?"

Leaning back in his chair, he propped both feet up on the desk, drawing Sara's attention to the fact that for once it was uncluttered by papers, blueprints, and hastily scribbled notes regarding all sorts of emergencies that had to be taken care of immediately.

With admirable understatement, he said, "We seem to be about through here."

A wide smile lit Sara's face. Truthfully, she said, "I knew you'd finish on time."

Don laughed. "You were about the only person who thought so. The board members are still going around peering into every nook and cranny as though they suspect the whole thing is jerry-built and will come down on their heads if they breathe too hard."

"They'll get over it. I'll bet by the time the opening ceremonies are held, everyone will have forgotten they gave you any trouble over the budget or schedule."

"Oh I don't doubt it. I'll have to sit up there on the podium and listen to them go on about how much faith they had in the project from the beginning. Sometimes the hardest part of any job comes right at the end, when I have to keep a straight face while the dignitaries spout their pieces." He shrugged lightly. "Won't be the first time, or the last."

Straightening in his chair, Don regarded her for a mo-

ment before he said, "I'm leaving for Santa Fe right after the opening. There's a new complex of solar-heated houses planned for there. I've been hired to build them."

Sara's throat tightened. She was going to miss him, and said as much. "You've been a good friend, better than I deserved."

Grinning crookedly, Don shook his head. "Don't sell yourself short, kid. You've got too much going for you to let this get you down."

They chatted for a few more minutes before Sara rose to leave. Don walked outside with her, his arm resting lightly around her shoulders. The thunderclouds were still gathering in the west, but the rain had not yet started. Sara hoped to be back at the gallery keeping an eye on the workmen before it did.

She was laughing at something Don had said when the sudden sensation of being watched swept over her. It began as a tingling near the base of her spine and spread almost instantly through her limbs, leaving her arms shaking slightly and her legs weak. Apprehensively, she glanced around, already half suspecting what she would see.

Joseph was standing a few yards away, looking at them. He was dressed much as usual in well-worn jeans and a shirt, his body as lean and powerful as ever. But her hungry gaze sweeping over him noted subtle changes. The sculpted planes and hollows of his face had a slight gauntness she knew was mirrored in her own features. His mouth was set in a hard, grim line and he held himself tensely.

Don did not remove his arm. Instead his stance became instinctively protective as he took in the silent confrontation. He shifted slightly, just enough to put himself between them.

"Highrock, what brings you out here?"

With difficulty, Joseph shifted his attention from Sara. His onyx eyes were flat as he said, "The Center, of course. I heard you were interested in having one of my pieces here, so I thought I'd look the place over."

"And does it meet with your approval?" Don demanded tautly.

Unbending slightly, Joseph nodded. "You've done a magnificent job. Better than I would have thought possible. Congratulations."

Taken aback, Don could only stare at him for a moment. With difficulty, he recovered himself enough to say, "Thank you. Considering the battle you waged to keep it from being built, I would have expected you to take a somewhat different attitude."

"I was never opposed to the Center," Joseph corrected quietly, "only to the initial plans. With the changes you made, I find it everything it should be and then some."

Sara listened to the two men with a growing sense of bewilderment, mingled with anger. Joseph had not so much as acknowledged her presence. She might have been a stranger he had no particular desire to meet for all the interest he showed. The faint glimmer of hope born in her when she saw the signs of strain in him flickered and died. Pain surged through her even as she told herself she was an idiot to care so much. She couldn't help how she felt, but at least she could salvage her pride by not revealing it.

Turning to Don, she said, "I'm sure you want to show Joseph around, so I'll be going."

Judiciously avoiding looking at him, she started to walk away, only to be stopped when he said, "Don't let me interrupt anything."

The indifferent blandness of his tone infuriated her. Whirling, she glared at him. "You couldn't. It just happens that Don and I were finished anyway." Beaming the architect a smile that cost her dearly, she said, "I'll call you later to find out what Joseph decides. I'm sure he's much too busy to remember to tell me."

Without giving either man a chance to reply, she stomped off, only just managing to escape before the sheen of tears overflowed her blue-green eyes. For several minutes, she sat in the truck, struggling to regain her composure. Her hands clenching the steering wheel trembled and the knuckles shone white against her tanned skin. She felt chilled to the bone, and almost welcomed the rain that began to fall in heavy drops. It matched her mood.

Chapter Seventeen

"Hey, lady, there's water coming in your basement. Got anything important down there?"

No, just a couple of dozen pieces of art worth tens of thousands of dollars and entrusted to me by people who put their hearts and souls into creating them.

"I'll go down and take a look. Do you think the walls are going to dry with all this rain?"

"Don't know, lady. They might."

Might. No guarantees, not even a hint. "What happens if they don't?"

The workman shrugged, managing to indicate without words but still quite eloquently that it was not his problem.

Ignoring the pounding in her head and the pain of her nails digging into her palms, Sara went downstairs. There was a small amount of water on the basement floor. As near as she could tell, it was coming from a blocked up storm drain and not from the burst pipe next door, where she could hear the plumber whistling cheerfully.

Must be adding up his bill, she thought nastily as she darted outside and across the short distance separating the two shops. Though she wasn't in the open more than a few seconds, she was wet through and through. Her hair clung to her head and her clothes drooped. She sneezed once, then again, as the music store owner looked at her dubiously.

"Don't drip on anything," he warned.

"I won't. I just want to talk to your plumber."

Minutes later she had arranged to get the drain repaired, after assuring the man that she understood he

would be working on his lunch hour and was therefore forced, against his natural inclination but in deference to the requirements of his union, to charge time-and-a-half.

"Fine, fine," Sara said wearily. "Just fix it before more water comes in. If you need anything, I'll be upstairs."

The gallery, smelling of paint, made her senses reel. She had to envy the workmen who seemed oblivious to the odor. At the stroke of noon, they put down their rollers and opened their lunch pails. Retreating to her office, Sara slumped at the desk, holding her head. She wanted to go home, get into bed, and never come out. She wanted to be held and cuddled and told everything would be all right. She wanted to be a child again; the stupidest thing she had ever done was to grow up.

A low whistle pierced her doldrums. Carrie stood at the office door, her brown eyes dark with concern. "Do you feel as bad as you look?"

"I don't know," Sara croaked. "I haven't seen myself in an hour or so. Maybe I feel worse."

"You couldn't. You'd be dead." Briskly, Carrie strode over to the desk. "Come on."

"What? Oh, no, thanks, but I just can't face any lunch."

"Of course not. You're going home."

"No, I'm not. I have too much work to do."

Carrie wasn't listening. She pulled Sara out of the chair, her petite frame proving suprisingly strong, and headed toward the door. "You won't accomplish anything sitting here feeling miserable. Except maybe get pneumonia."

"You're making a big deal out of nothing. I just have a little cold."

"Then how come you look as though the world ended and the rest of us just haven't found out yet?"

"Because I . . ." Sara swallowed back the tears that threatened again. ". . . I saw Joseph this morning."

"Oh. I didn't realize . . ." Carrie's face softened with understanding. "Did he come here?"

"No, we met by accident at the Center."

"And it . . . wasn't what you'd hoped?"

Sara tried to laugh, but the sound came out wrong, like a sob. "You could put it that way. He didn't leave much doubt about what he'd decided."

Carrie muttered something under her breath that suggested she seriously questioned Joseph's parentage. "I'm sorry."

"S-so am I . . ."

There was silence for a moment before Carrie took a deep breath and said determinedly. "But that doesn't change anything. You still have to go home and take care of that cold. Come on."

Too tired to fight any longer, Sara allowed herself to be led out of the gallery and deposited in her friend's car. She revived enough to protest taking Carrie away from her own business, only to be flatly told she was in no shape to drive and that Bill would bring the truck over later.

"It'll be there for you if you feel well enough to go back to work. But you really shouldn't push yourself. With the kind of emotional strain you've been under, your body needs a break."

It needed more than that, Sara thought sadly as she thanked her friend and let herself into the apartment. Her body, her heart, and her mind all needed Joseph. Dragging herself into the kitchen, she found a container of orange juice, stuck it in a bucket of ice, and hauled both into the bedroom. That left her with no more energy than was required to pull her clothes off, drop them on the floor, and crawl between the sheets. The splatter of rain hitting the ground outside, and the memory of when she had last heard that sound, followed her into her dreams.

She woke hours later and turned over gingerly. It was getting on toward dusk and for a moment she couldn't remember where she was. When she did recognize her surroundings, she had to think a bit longer to figure out how she had gotten there. Only gradually did she recall coming back from the Center, feeling so ill, and being sent home by Carrie.

Whatever had made her so sick seemed almost gone. Except for the same cold she had woken up with that morning, she felt fine. Better than fine, in fact, since she felt a sense of relief and almost elation which she couldn't quite pin down but which was still unmistakable.

Only as she brushed her teeth and washed her face did she remember the dream that had recurred throughout

her sleep. She was coming down the trailer steps with Don, Joseph was walking toward them, and she saw him look from her to the man at her side. In an instant that passed so quickly it had almost not registered on her mind, pain darted across his face. His expression became hooded, leaving only the fleeting memory of a revelation that turned her thoughts completely around.

She was so caught up in her own concerns that she had not realized what Joseph must have believed when he found her with Don. If he really did care, if he had come back to tell her he wanted them to be together, he must have thought she was no longer interested. Otherwise, how could she have appeared to take solace so easily in another man's company?

Well aware that she might be deceiving herself, Sara nonetheless dressed hurriedly and left the apartment. Before she could think too much and lose her courage, she drove to Joseph's studio.

The lights were off. Newspapers were piled upon the stoop and the mailbox overflowed with magazines and letters. She frowned, wondering why the place looked so deserted when she knew he was home.

Ringing the front bell brought no results; neither did knocking. She was tempted to go away, thinking that perhaps he was spending the evening out and not wanting to know for sure if that was the case. But having gotten that far, she forced herself to stay a little longer.

Walking around the back, she was surprised to find the terrace door open. Joseph was too conscious of the value of his works to be careless about security. He wouldn't go off without making sure everything was locked up.

She hesitated for just a moment before concern that he might be in trouble won out over respect for his privacy. Edging through the open door, she slipped inside.

At first, it was impossible to see anything. With the curtains drawn and the lights off, the room was in darkness. Only gradually did her eyes adjust enough to let her make out the form slumped low in a chair.

"J-Joseph . . . ?"

No answer. Hesitantly, she took a step closer, then jumped as a grating voice assailed her out of the darkness.

"What the hell are you doing here?"

"I-I came to see you." The words emerged as little more than a shaky whisper. She took a deep breath, steadying herself. More firmly, she asked, "Are you all right?"

He laughed harshly. "Oh, sure, I'm fine. What's the matter, are you worried I won't be in shape for the show?"

Sara flinched at the injustice of that even as she realized it bolstered the hope that had propelled her thus far. Determinedly, she sat down on a hassock near him. "No, I'm not worried about that. You're not the sort of person who backs out of commitments."

"I'm not?" he drawled bitingly. "When did you get to be such an expert on what I may or may not do?"

Sara's heart was thudding irregularly, but she forced herself to answer him calmly. "Out in the desert, that's when."

His head went up as though she had somehow wounded him. Tightly, he said, "I don't want to talk about that. You've done your duty and checked up on me. Now go away."

"No." The moment the word was out she stood up and turned on one of the lamps in a far corner of the room. It cast a soft glow without being intrusive. Keeping her back to him, she began moving around, picking up newspapers, fluffing pillows, running a finger over the collection of dust on the glass tables.

"What do you think you're doing?" he growled.

"Tidying. I've been doing quite a bit of it lately. Everytime I couldn't eat or sleep, I tidied." She paused, turning to face him. "You should see my apartment. It's ready for *House Beautiful*."

Stopping in the middle of the room, a throw pillow clutched in her arms, she forced herself at last to look at him. The gauntness she had noticed at the Center had not been an illusion. His features had always been sharply honed, but now the burnished skin was stretched even more tautly and the eyes that met hers were bleak.

She watched as he stood up, unfolding his long, hard body from the chair. The hands that could create such beauty, and such pleasure, were buried deep in the pockets of his jeans. His broad shoulders were hunched. He shook

his head slightly, as though trying to throw off his bewilderment.

"I don't understand. At the Center, it looked as though everything was going well for you."

"I know how it must have looked, Joseph, although it took me a while to realize it." Hesitantly, she added, "Don and I decided we were meant to be friends, that's all. He feels sorry for me because I'm in such a state over you, so he was trying to cheer me up."

"In a state . . . ?"

"In love."

"Oh . . ."

"Is that all you can say? Or are you so used to women admitting they love you that it doesn't make any impression?"

"I'm not . . . I never cared what any other woman said. You're different from everyone else. You drive me crazy. I've missed you so. Why are you crying?"

"Because," Sara sniffed, "you're still all the way over there."

But he wasn't. He had crossed the room in swift strides and stood right before her, smiling tenderly. His finger brushed her cheek, catching a shimmering tear. "I love you, Sara. I want to be your lover, your friend, your husband. Everything you'll let me be."

She swallowed tightly, feeling the happiness well up inside her. "Could we take those one at a time?"

"Yes. Where would you like to start?"

Sara laughed, a ripple of joy that could no longer be contained. She dropped the pillow. Her fingers went to the buttons of her blouse, before she suddenly hesitated. The mischievious light in her eyes warned him of what she was going to say.

"Unless you'd rather talk."

The hands that took hold of her shoulders, pulling her to him, were gentle but remorseless. The smile that curved his mouth was dazzling, but no more so than the light she saw glowing like the embers of a fire far in the back of his eyes where the path to the soul began.

"Talking," he muttered against her mouth, "is only one way of communicating."

Running her hands over the hard ridges of his back, she whispered, "How did you get so smart?"

He laughed shakily, making short work of the remaining buttons on her blouse before starting in on her skirt. "I had a lot of help."

"That's funny, so did I."

"Later," he muttered as he lifted her high against his chest and turned toward the bedroom. "Later, we'll tell each other all about it. But first . . ."

First there was a rapturous homecoming.

In the room furnished simply by a large platform bed, a discreet dresser, and recessed shelves shared by well-used books and small pieces of sculpture, they undressed each other slowly.

Her soft, pink-tipped fingers began at his broad forehead where the ebony hair fell in an unruly lock, and ran down along the sharply defined planes of his face, lightly touching the thick lashes shielding his eyes, moving nimbly over his strong, long nose and across the lips curved in tenderness and warm beneath her finger.

"Ouch."

He had bitten teasingly on the tip sucked into his mouth. His tongue soothed it, flicking round the sensitive pad, evoking shivers of pleasure that radiated all through her.

Sara closed her eyes. She wanted to learn him first by touch alone. Joseph sensed her need. He stood quietly before her, letting her hands stroke over the broad sweep of his shoulders and arms, down the rippling line of his chest and abdomen, over his taut buttocks and thighs, letting her savor him with a mixture of desire and tenderness that made his throat tighten achingly.

When it was his turn, his exploration was as thorough and as gentle. His sensitive artist's fingers lifted the heavy fall of her auburn hair and slid under it, down her back, to press lightly along the ridges of her spine. They lingered at the soft cushion of her haunches, came up to lightly caress the skin stretched tautly between her hipbones, cupped her breasts before resting on her shoulders, the fingers brushing the hollow at the base of her throat.

Shivering with pleasure, she dared a glance at him

through the thick fringe of her lashes. His eyes were still closed, his features at once more relaxed and more expectant than they had been just a short time before. Her lids dropped again as she whispered, "I can hear your heart beating."

Joseph's voice held a smile. "I can hear the breath moving in and out of you."

Touch . . . sound . . . the next step was inevitable. Sara moved closer, feeling her way, her tongue darting out to run lightly along his chest. She giggled softly. "You taste good."

"So do you," Joseph murmured, returning the caress, but with even greater effect. Sara moaned as warm wetness brushed repeatedly over her nipples. A tremor began deep inside her and reached outward, into the very air around her.

"You smell good, too," he murmured.

Did she? She didn't know. She was conscious only of the slightly musky scent of him mingling with the clean aroma of the soap he used. Her skin was getting hot. She could feel the flush rising along the path of his hands and mouth and tongue . . .

"Mmmm . . . Joseph . . ."

"Yes . . . ?"

"Let's go to bed."

They opened their eyes at the same moment, staring into each other. He grinned. "Race you."

From opposite sides, they pulled back the down-filled comforter and sheets, and fell on the wide, firm mattress, arms and legs tangling as they rolled toward each other laughing.

"I won," Joseph declared.

"No fair," Sara insisted. "You knew what you were going to say, so you had a head start."

"Want to try for two out of three?"

"No . . ." The big hands running over her caressingly and the warm press of his body against hers blocked out the ability to do anything except remain right where she was.

"Speaking of taking things one at a time," he murmured as he drew her to him.

"Hmmm."

"We can't."

Sara smiled. She didn't have to ask what he meant. This time was different. All the separate pieces of their feelings for each other—the affection and respect, and above all the desire—were coming together. The result was something completely new and vastly larger than the mere sum of the parts. In making love, they were also making friendship, security, commitment, and something else that was more than all the rest combined.

They were making a marriage.

The realization made her feel infinitely tender. Her hands stroked the dark head nestled against her breasts as her legs entwined with his. Even as her body opened to receive him, so did the future expand before them. She could imagine him years from now when the ebony hair would be streaked with silver and the big, powerful body would have lost some measure of its tautness. She could think of him as old without fear or regret, knowing that what they shared would be even better then. As easily as her mind could look forward, it could also shift into the past, wondering what he had been like as a child and at the same time cherishing the thought of the new being they might create together.

And then her mind could not think at all because it was exploding in pleasure.

Endless moments later, Sara stirred against him. Their bodies were damp with perspiration and their hearts still pounded in unison. The golden haze of languor enveloping her blocked out even fatigue. She was still so new to the realization of her love that she could not bear to part from it even in sleep. Fortunately, Joseph felt the same way.

He propped himself up on an elbow, smiling down at her. "You make me feel like I'm eighteen again."

Sara's eyes widened in pretended dismay. "That's what you were like at eighteen?"

"Well, no, not exactly," he admitted, then made her heart turn over by adding, "How could I have been? I didn't know you then."

"Good thing."

"How come?"

She smiled provocatively. "You would never have lived this long."

The laugh that broke from him was a release of pure, unshielded love that no longer had to be hidden or denied in any way. His eyes glowed warmly as he lowered himself back on top of her. "You think so?"

The blatant male challenge tickled her. He looked so mock-menacing that she couldn't help but giggle.

At the sound, Joseph groaned. "I knew it. You found out you can wrap me around your little finger, and now there'll be no living with you."

"On the contrary," Sara murmured, tracing a line of fire down his body that brought an immediate, highly gratifying result. This time their lovemaking was slower, the pleasure more sustained.

They slept lightly for a short time afterward, only to be awakened by the growling of their stomachs. "Even eighteen-year-olds have to eat," Joseph observed as they padded naked out to the kitchen and raided the refrigerator. Back in bed with a plate of cold chicken, a basket of rolls warmed in the microwave, and a chilled bottle of chablis, they ate in contented silence until the worst of their hunger was assuaged.

Only then did Sara venture a reminder of the world outside the love-filled room. "Joseph . . . none of the problems we were worried about have gone away."

He looked at her for a long moment before a tender smile curved his mouth. "I know. They're not going to, either." Lifting a hand, he placed it over her own. Burnished copper shone against sun-warmed ivory. "I'm still Navaho and you're still white. Some people will always be bothered by that. But I'm not one of them, and neither are you."

"What made you decide that what others think isn't as important as how we feel about ourselves?"

"Being without you. Alone in the desert after you left, I couldn't deny how much you mean to me. The place that had always been my refuge was suddenly barren and dismal. There was no comfort for me there, and certainly no inspiration. All that had gone with you."

"That's how I felt here," Sara acknowledged, a shiver of

remembered pain running through her. "At the risk of sounding very pragmatic, it came down to the fact that without you the world just isn't a very pleasant place. With you, there will be problems, times when we disagree and hurt each other or when we're hurt by the attitudes of others. But at least I'll know I'm alive, rather than simply existing."

"Oh, you'll know," Joseph promised softly. "I'll make sure of that." Drawing her into his arms, he was quiet for a moment before he said, "A few hours before Bright Star died, when I was alone with her in her hogan, she told me that at the end of her life she had finally come to one great conclusion. She had decided that love is the ultimate act of artistic creation. It's the most difficult and demanding challenge, and the most rewarding attainment."

He shifted slightly so that he could look at Sara. "I thought about that after you left. I realized that all the struggles I've waged were meaningless unless I could achieve that ultimate creation. It's not enough that I've been able to communicate something essential about the traditions and values of my people to the rest of the world. Unless I could share something with you that goes beyond the restrictions of any single race, I would have failed as both a man and an artist."

"Does that mean," Sara asked shakily, overwhelmed by the beauty of what he had just told her, "you may finally be able to paint me?"

Joseph didn't answer. Instead he stepped from the bed and held a hand out to her. Puzzled but compliant, she went back to the studio with him. He opened a sliding door to a closet and drew out a canvas.

"This," he said, gesturing at it, "is what I've been doing since I came back here."

Sara stared at the painting. Her own face looked back at her. Set against the desert at dawn, her features radiated an inner beauty and serenity she was only beginning to sense within herself. Her vivid, turquoise eyes were as timeless as the broad sweep of mesa and canyon behind her. The sun, just rising from behind the wind-carved cliffs, warmed her skin to an apricot glow. Her dark hair glistened with auburn rays. Her mouth curved slightly in

a smile that held a note of yearning. She was staring directly into the viewer, her expression at once evocatively sensual and far more.

The positioning of the woman against the desert and the play of light across her features combined to reveal the love shining from her eyes. In capturing her spirit, Joseph had transcended his own. Together, their hearts sang a prayer of eternal fulfillment vastly beyond the boundaries of human existence.

When she turned at last from the portrait, he was standing near her, his arms open. There was no shadow of hesitation in her step as she went into them joyfully.

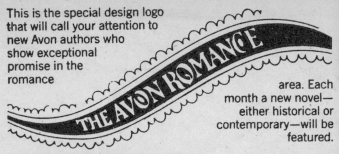

This is the special design logo that will call your attention to new Avon authors who show exceptional promise in the romance area. Each month a new novel—either historical or contemporary—will be featured.

A GALLANT PASSION Helene M. Lehr
Coming in February 86074-0/$2.95
The spellbinding story, set in New England in the mid-1800's, of a striking young woman who is torn between her yearning for the golden-haired man she loves—and her promise to the darkly handsome man who can give her wealth and social position.

CHINA ROSE Marsha Canham
Coming in March 85985-8/$2.95
In the England of 1825, eighteen-year-old beauty China Grant comes to Braydon Hall, promised in marriage to the eldest Cross brother, Sir Ranulf, who is only interested in her inheritance. Her love is won by his brother Justin, however, and the two must overcome deceit, lies and the threat of death before they can be united.

HEART SONGS Laurel Winslow
Coming in April 85365-5/$2.50
Set against the breathtaking beauty of the canyons and deserts of Arizona, this is the passionate story of a young gallery owner who agrees to pose for a world-famous artist to find that he captures not only her portrait but her heart.

WILDSTAR Linda Ladd
Coming in May 87171-8/$2.75
The majestic Rockies and the old West of the 1800's are the setting for this sizzling story of a beautiful white girl raised by Indians and the virile frontiersman who kidnaps her back from the Cheyenne.

BOLD CONQUEST Virginia Henley 84830-9/$2.95
FOREVER, MY LOVE Jean Nash 84780-9/$2.95
NOW COMES THE SPRING Andrea Edwards 83329-8/$2.95
RANSOMED HEART Sparky Ascani 83287-9/$2.95

Look for THE AVON ROMANCE wherever paperbacks are sold, or order directly from the publisher. Include $1.00 per copy for postage and handling: allow 6-8 weeks for delivery. Avon Books, Dept BP Box 767, Rte 2, Dresden, TN 38225.

Avon Rom 2-84